Trade Fair Design
Annual 2006/2007

Messedesign
Jahrbuch 2006/2007

International

Conway Lloyd Morgan

Trade Fair Design
Annual 2006/2007

Messedesign
Jahrbuch 2006/2007

International

avedition

 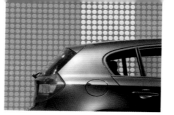 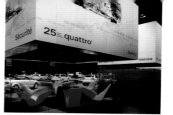 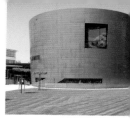

Contents

Inhaltsverzeichnis

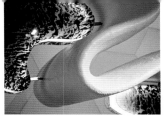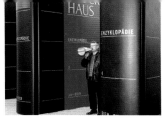

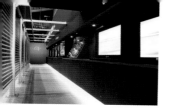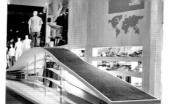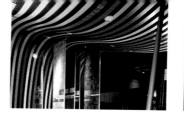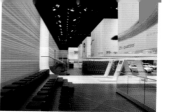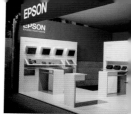

Pinball Wizard 112
Mauk Design für Sony PlayStation
E³ 2005

Sportliche Aktivitäten 118
Schusterjungen und Hurenkinder für Adidas
Outdoor 2005

Schwerpunkt 124
Remar Architecture & Decoration für ECA ELEKS
ISH 2005

Minimum an Aufwand 128
Dante Bonuccelli für Schönbuch
IMM 2006

Stilistische Erwägungen 134
Arno Design für Bäumler
Pitti Uomo 2006

Perfektion in Pink 140
Thomas Manss & Company für Vitsœ
100% Design 2004

Ganz in Weiß 144
EOOS für Walter Knoll
IMM 2006

Eiserne Bandbreite 150
Demirden Design für Nokia
CeBIT Eurasia 2005

Virtuelle Architektur 154
Atelier Brückner für Panasonic
IFA 2005

Auf Wanderschaft 160
Dieter Thiel für Adidas
ispo 2005

Transport 166

Himmelsschrift 168
Mauk Design für Duncan Aviation
NBAA 2005

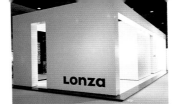

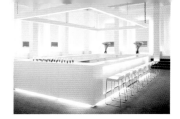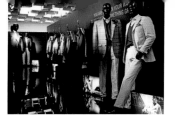

Introduction
Einleitung

"The report of my death was an exaggeration," Mark Twain wrote over a hundred years ago, when the story of a relative's illness in London turned into the tale of his own demise. Reports of the death of the trade fair are similar miscalculations, or rather, results of misunderstanding. Take the parallel example of the book: a decade ago many thought that the book would disappear in favour of electronic on-screen delivery. The American designer David Carson announced "The End of Print" – he announced it in a book that is currently in its second edition, and has sold at least sixty thousand copies. But Carson was right in one sense: the digital revolution has changed the conventions of print, and its primacy as a source for information, in fundamental ways, even if the book publishing industry has been growing, as has the number of titles published each year worldwide. Certain specialised forms of publishing – legal reference works and scientific journals, for example – have migrated to an electronic base, others – such as language education – have adopted a multimedia approach. Books remain a valid medium because what they offer: portable information that can be consulted anywhere, independently of other technologies, cannot be bettered: books have evolved in terms of design, production and distribution methods, thanks to digital technology, but the core concept is still there. Can the same pattern be discerned with the trade fair stand?

Consider the main fairs for the book trade. The Frankfurt Fair restarted, with tarpaulins and duckboards in the ruins, in 1946. By its 30th anniversary it was occupying seventy percent of the trade fair site, and was an essential port of call for any publisher dealing in international rights, whether for illustrated books in co-editions or for fiction and non-fiction in translation, for agents and authors, and for booksellers from around the world. (The equivalent London event barely filled a hotel ballroom.) As it reaches its 50th anniversary the Frankfurt Fair continues to grow, in numbers of visitors and exhibitors, even though a publisher can offer co-edition rights to colleagues by email and pdf all year round, and booksellers can consult most publisher's catalogues on-screen and order on-line, on any day of the week. And the London Fair is set next year to double its

„Die Nachricht von meinem Tod war stark übertrieben", schrieb Mark Twain vor über hundert Jahren, als sich die publik gewordene Erkrankung eines seiner Verwandten in London zu Gerüchten über seinen eigenen Tod verselbständigte. Ebenso unbegründet oder missverstanden sind Gerüchte vom Tod der Institution Messe. Schauen wir uns den Parallelfall Buch an: Vor zehn Jahren hieß es, Bücher würden in absehbarer Zeit von elektronischen Lesemedien völlig verdrängt werden. Der US-Designer David Carson prophezeite schon das „Ende des Buchdrucks", ausgerechnet in einem Buch, das derzeit in der zweiten Auflage vorliegt und von dem mindestens 60.000 Exemplare verkauft wurden. In einem Punkt hatte Carson allerdings Recht: Die digitale Revolution hat die Konventionen im Verlagswesen ebenso grundlegend verändert wie die Stellung des Buches als primäre Informationsquelle, auch wenn die Zahl der Verlage ebenso stetig wächst wie die der jährlich weltweit publizierten Titel. Bestimmte Sonderformen wie juristische Nachschlagewerke und wissenschaftliche Fachzeitschriften sind längst auf elektronische Medien umgestellt worden, andere wie z.B. der Fremdsprachenunterricht in den Multimedia-Bereich abgewandert. Dass Bücher trotzdem nach wie vor ein vollgültiges Medium sind, liegt daran, dass sie etwas Unübertreffliches bieten: handliche Informationen, die überall und jederzeit unabhängig von anderen Technologien abrufbar sind. Was Gestaltung, Herstellung und Vertriebsstrukturen angeht, haben sich Bücher dank digitaler Technik weiterentwickelt, doch ihr Kernkonzept ist unverändert. Lässt sich ein ähnliches Muster auch im Hinblick auf Messen ausmachen?

Kommen wir noch einmal auf das Verlagswesen zurück: Die Frankfurter Buchmesse wagte 1946 inmitten einer Trümmerlandschaft mit Abdeckplanen und Lattenrosten einen Neustart. Zu ihrem 30. Jubiläum belegte sie 70 Prozent des Messegeländes und diente als zentrale Anlaufstelle für alle Verlage, die mit Co-Editionen oder internationalen Lizenzen für Belletristik- und Sachbuchübersetzungen handeln, für Agenten, Autoren und nicht zuletzt Buchhändler aus aller Herren Länder. (Das Londoner Pendant füllte knapp den Ballsaal eines Hotels.) Auch in ihrem 50. Jahr stiegen die Besucher- und Ausstellerzahlen der Frankfurter Buchmesse weiter, obwohl die Verlage

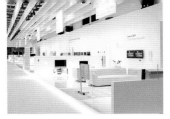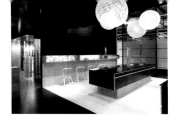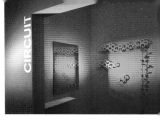

size from five years ago. Why the continuing success of the traditional fair?

The answer is that despite the bells and whistles of new technology, the basic offers of the trade fair – to see the product and to meet the people – remain the same. And the visitor can also compare different products or services on offer.

Beyond the Stand

The term "tail-end Charlie" comes from aerial warfare, and refers to the last fighter in a section whose task it was to fly behind the others and warn of an attack from the rear. It sounds a dismissive term, but in fact it was a key role, demanding special skills of the pilot who had to look both ways, as it were, all the time. This section, in earlier annuals, was the tail-end Charlie, but this time it gets to fly in front.

This is so that it can, perhaps, serve as a pathfinder (another aerial metaphor) in identifying trends and possibilities that the less structured contexts of the events selected here can make more visible. This is not to say that these are the most important stands in the book, as there are no criteria of importance that could meaningfully cover the range of work presented overall. Rather they suggest new opportunities and strategies that may in time flow into the mainstream of fair design. And for those who consider that trade fair stands need to be strictly defined, it's worth remembering that the tail-end Charlies were the ones most frequently shot down.

Business to Business

Time was when trade fairs were either "trade only" or "open to the public." Today many fairs have a dual system of restricted entry at the start and general entry at the end. Cynics might attribute the change to fair organiser's realisation that two streams of entry fees was better than one, but the reality is more likely to be that the "general public" has disappeared, in the sense of the public as spectators. We are all consumers

heute das ganze Jahr über Lizenzrechte per E-Mail vergeben und PDF-Dateien versenden und Buchhändler bei den meisten Verlagen jederzeit direkt online bestellen können. Die London Book Fair wird nächstes Jahr voraussichtlich doppelt so viele Aussteller haben wie vor fünf Jahren. Wie ist dieser anhaltende Erfolg einer konventionellen Messe erklärbar?

Die Antwort lautet, dass trotz aller klangvollen Verheißungen der neuen Technologien das Grundangebot der Buchmesse unverändert ist: Man geht hin, um sich das Marktangebot anzuschauen, sich mit Leuten zu treffen und nicht zuletzt verschiedene Produkte und Dienstleistungen direkt miteinander zu vergleichen.

Beyond the Stand

„Tail-End-Charlie" heißt im Luftkrieg derjenige, der hinter der Staffel herfliegt und sie vor Angriffen von hinten warnt. Auch wenn der Spitzname etwas abfällig klingt, erfüllt dieser Schlussmann eine enorm wichtige Aufgabe, die dem Piloten besondere Fähigkeiten abverlangt, denn er muss ständig Heck und Bug gleichermaßen im Blick behalten. In den bisherigen Jahrbüchern fungierte das Kapitel „Beyond the Stand" immer als Schlussmann – diesmal fliegt es allen übrigen voran.

In dieser Position kann es nämlich auch als Aufklärer fungieren (noch ein Begriff aus der Luftfahrt), Trends und Gelegenheiten aufspüren, die gerade in den weniger streng strukturierten Kontexten der in diesem Kapitel zusammengefassten Events sichtbar werden. Das heißt nicht, dass sie die wichtigsten Stände in diesem Band wären, denn kein Kriterium könnte die ganze Spannweite aller vorgestellten Arbeiten nach ihrer Bedeutsamkeit kategorisieren. Aber diese Stände zeigen neue Chancen und Strategien auf, die mit der Zeit Eingang in den Mainstream des Messedesigns Einzug halten könnten. Wer klar definierte Standkonzepte für unerlässlich hält, sollte auch daran denken, dass „Tail-End-Charlies" im Luftkrieg meist als Erste abgeschossen werden.

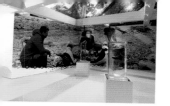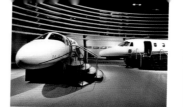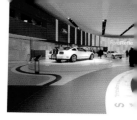

now, and engage with different levels of specialisation in different activities. What used to be hobbies – professional activities carried out by amateurs – are now increasingly professionalized at all levels: one only has to look at the complexity of equipment on offer to do-it-yourself enthusiasts or the market for gardening information and expertise to realise the extent of this change.

That said, there are a number of areas where the consumer is likely to encounter the product as end-user rather than first user: paper, for example, or dental equipment. Since such stands require a somewhat different approach from a general stand (for example in being able to use an established professional vocabulary) they are brought together here.

Lifestyle

One is sometimes tempted to ask what people did with their time before they had lifestyles. In fact that puts the question the wrong way up. In a mature industrial (or perhaps post-industrial) society, the individual has an increasingly large choice of ways in which to express his or her personality, values and interests, and the media for these choices are increasingly complex and professionalized. And the expressions increasingly cross contextual barriers. The guy in the club wearing a football shirt is not necessarily a footballer or even a dedicated football supporter: he is making a personality statement which needs to be read in a number of different non-sporting ways. Or, for example, one's choice of iPod (or of another MP3 player) is not at all about the amount of music one wants to hear or even about budget. We have become so accustomed to the mythologizing (in Barthes' sense – the philosopher not the goalkeeper) of everyday objects that we do not look too far beyond their implications. But to the stand designer this complexity of communication through personal choice, through accessories, through the design of personal space, offers a cornucopia of challenges and opportunities.

Business to Business

Früher gab es entweder reine Fachmessen oder öffentliche Schauen. Heute praktizieren die meisten Messen ein duales Prinzip, bei dem die ersten Tage dem Fachpublikum vorbehalten sind, die Tore anschließend aber jedermann offenstehen. Zyniker werden sagen, dass den Veranstaltern zwei Eintritt zahlende Zielgruppen lieber sind als eine, doch der wahre Grund ist eher, dass es eine „Öffentlichkeit" im Sinne reiner Zuschauer gar nicht mehr gibt. Heute ist jeder von uns Konsument und auf diversen Gebieten mehr oder weniger spezialisiert. Was man früher Hobbys nannte – von Amateuren ausgeführte Profi-Arbeiten –, spielt sich heute zunehmend auf professioneller Ebene ab. Das Ausmaß des Wandels erkennt man schon an der Riesenauswahl leistungsstarker Geräte für Heimwerker oder der Fülle an Fachinformationen für Hobbygärtner. In bestimmten Sparten allerdings kommt der Konsument nach wie vor nicht als Erstbenutzer, sondern eher als Endverbraucher mit den Produkten in Berührung. Ein Beispiel dafür ist Papier, ein anderes der Dentalbereich. Da solche Stände etwas anders angelegt sein müssen als normalerweise (beispielsweise indem sie mit der jeweiligen Fachterminologie vertraut sein müssen), haben wir sie in diesem Kapitel zusammengefasst.

Lifestyle

Man fragt sich manchmal, was die Leute eigentlich mit ihrer Zeit angefangen haben, bevor sie ihren „Lebensstil" pflegten, aber das hieße das Pferd vom Schwanz aufzäumen. In einer reifen industriellen (vielleicht schon postindustriellen) Gesellschaft hat der Einzelne die Wahl zwischen immer mehr Ausdrucksmöglichkeiten für die eigene Persönlichkeit, die eigenen Werte und Interessen. Auch die Medien für diese Entscheidungen werden immer komplexer und professioneller, und die Ausdrucksformen überschreiten zunehmend Kontextbarrieren. Wer im Fußballtrikot in der Disco erscheint, ist nicht unbedingt Kicker oder auch nur Fußballfan. Das Outfit sagt vielmehr etwas über die Persönlichkeit aus und ist auf eine Weise zu deu-

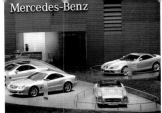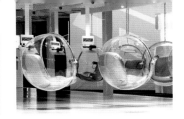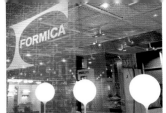

Transport

The major series of motor shows – Frankfurt, Geneva, Paris, Tokyo, Detroit – tended to be pace setters for trade fair design. The size of the stands, the large budgets, the importance of the events both in launching new products and maintaining brand and market position, gave these stands a stellar role. The competitive nature of the industry was its driving force (excuse the pun.) They became the environments in which new forms of presentation could be tried, tested and developed: the use of live actors, the integration of video and IT systems into stand design, the extension of time-based programming, are all examples of the innovatory role of motor show stands.

This is still true. But the competitiveness and complexification of other sectors in the consumer industries has led to equal investment by clients in stands and promotional events: one only has to look at the resources for computer gaming or mobile telephony. But stands in the transport sector retain, through their breadth of appeal, their iconic role, and as such bring this annual's selection to a close.

Conway Lloyd Morgan,
London, August 2006

ten, die mit Sport nichts zu tun hat. Entsprechend sagt die Wahl des iPod (oder eines anderen MP3-Players) gar nichts darüber aus, wie oft man Musik hört oder wie viel Geld man dafür ausgibt. Die Mythologisierung von Alltagsgegenständen – im Sinne von Barthes (des Philosophen, nicht des Torwarts, der schreibt sich mit z) – ist uns so in Fleisch und Blut übergegangen, dass wir nicht mehr allzu viel über solche Feinheiten nachdenken. Für den Messedesigner bietet diese komplexe Kommunikation, die bedingt ist durch individuelle Entscheidungen, Accessoires und die Gestaltung des persönlichen Umfelds, eine Fülle an Herausforderungen und Chancen.

Transport

Die großen Automobilmessen – Frankfurt, Genf, Paris, Tokio, Detroit – galten im Messebau immer als Trendsetter. Die Größe der Stände, die üppigen Budgets, die Wichtigkeit der Events für die Lancierung neuer Produkte und die Pflege von Marken und Marktposition hoben die Stände dort aus der Masse heraus. Der Antrieb (nicht nur der Autos) war dabei der intensive Wettbewerb innerhalb der Branche. Automessen galten als Plattformen, auf denen man neue Präsentationsformate testen konnte: Live-Auftritte Prominenter, die Einbeziehung von Video- und IT-Systemen ins Standdesign und die Ausweitung der zeitlichen Programmplanung sind Beispiele für die innovative Rolle von Automobilständen.

All das gilt auch weiterhin. Aufgrund des Konkurrenzkampfs und der wachsenden Komplexität investieren Auftraggeber von Messeständen heute auch in anderen Bereichen der Verbrauchsgüterindustrie insgesamt mehr in ihre Stände und Werbeevents. Dazu genügt ein Blick auf die Etats, die für Computerspiele oder mobile Telefonie bereitgestellt werden. Da die Stände im Transportsektor ihre Sonderstellung dank ihres so breiten wie attraktiven Angebots trotz allem behaupten, bilden sie diesmal den glanzvollen Schlussakt unseres Jahrbuchs.

Conway Lloyd Morgan,
London, August 2006

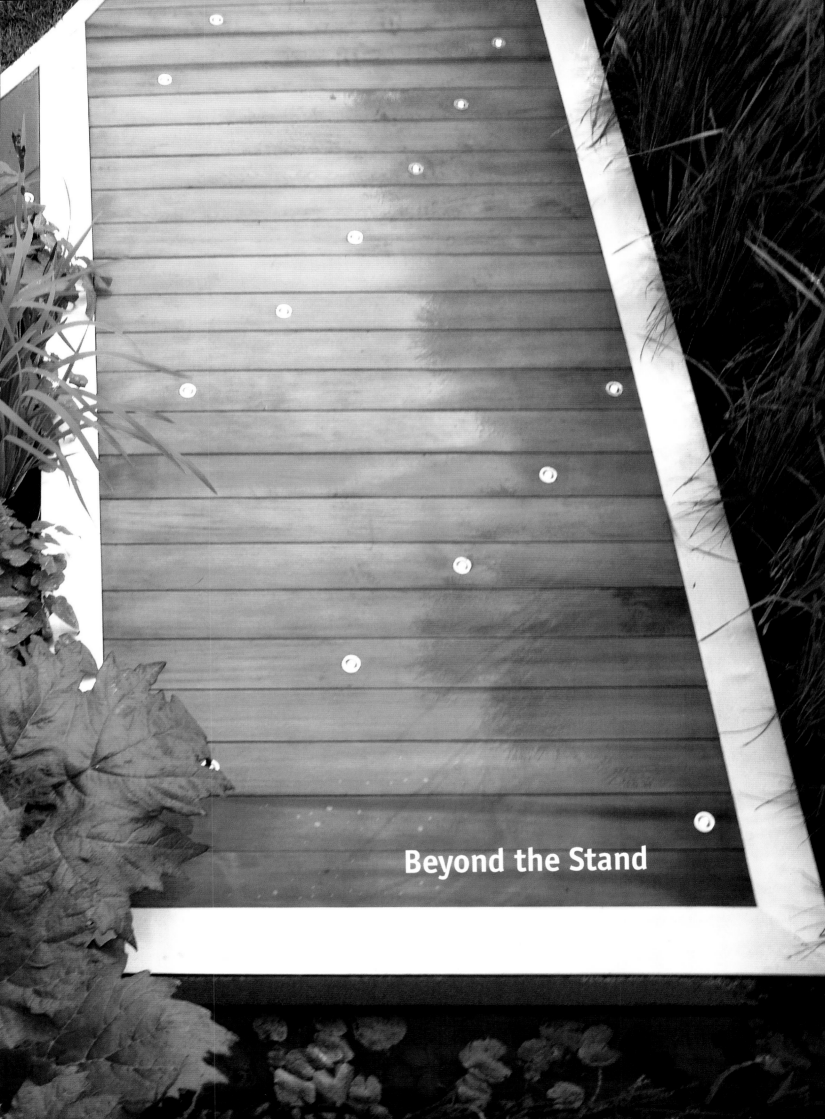

Beyond the Stand

Verbal Vocals

Stimm-Bände(r)

Milla und Partner
for Brockhaus

Milla und Partner
für Brockhaus

The Frankfurt Book Fair is a rights event for international publishers, and a trade event for German publishers and the German book trade. An ideal opportunity, then, to celebrate a major publishing event, such as the release of a new edition of the Brockhaus Encyclopedia, just under two centuries after the first edition appeared, edited by Friedrich Arnold Brockhaus.

The Agora at the Frankfurt Messe is an open space between the first four main fair buildings, and here Milla und Partner erected a ring of 30 three metre high models of the volumes of the new edition, forming a circle, and covered with a suspended white canopy. For the unveiling event before 800 guests, Theo Bleckmann and the Semiseria choir performed the premiere of a specially commissioned phonetic opera for 30 plus 1 voices: the singers of the Semiseria choir were each standing in the top of the volumes. The installation remained in place until the end of the fair and served as a meeting point for booksellers and other visitors to the fair.

Ausländischen Verlagen geht es bei der Frankfurter Buchmesse um den Einkauf von Urheberrechten. Für deutschsprachige Verlage und Buchhändler ist sie eine Fachmesse. Ein Grund mehr, um dort eine wichtige Publikation zu feiern, in diesem Fall die Neuauflage des Brockhaus knapp 200 Jahre, nachdem Friedrich Arnold Brockhaus die erste Auflage herausgab.

Auf der Freifläche zwischen den ersten vier Hauptgebäuden der Frankfurter Messe stellten Milla und Partner 30 drei Meter hohe Modelle der neuen Brockhaus-Bände im Kreis auf und spannten einen weißen Baldachin darüber. Bei der feierlichen Enthüllung vor 800 Gästen präsentierten Theo Bleckmann und der Semiseria-Chor die Uraufführung einer eigens in Auftrag gegebenen Sprechoper für 30 plus 1 Stimmen, wobei die Chormitglieder oben auf den monumentalen Bänden standen. Die Installation blieb bis zum Schluss der Messe stehen und diente Brockhaus als Treffpunkt mit Buchhändlern und anderen Messebesuchern.

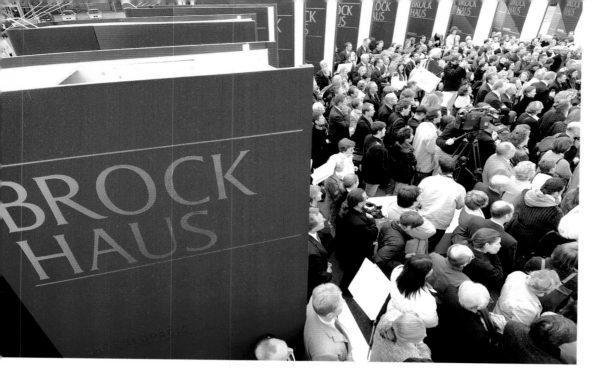

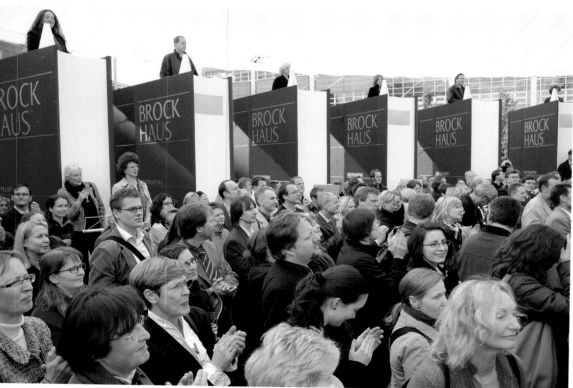

An event which becomes an installation, the installation a
record of the event: both work together to provide a simple,
and highly visible, reminder of the key fact that a new edition
of Brockhaus has been published. And by using the forms of
the volumes themselves to create the stand, the designers and
their clients were also arguing for the importance of the print-
ed word: singing it aloud, in fact.

Ein Event wird zur Installation, die Installation zur Dokumenta-
tion des Events: Beides zusammen wirkt als ebenso schlichte
wie augenfällige Erinnerung an ein Ereignis – das Erscheinen
der Neuauflage des Brockhaus. Dadurch, dass die Bücher
selbst den Stand bildeten, propagierten Designer und Verlag
„stimmgewaltig" die Bedeutung des gedruckten Wortes.

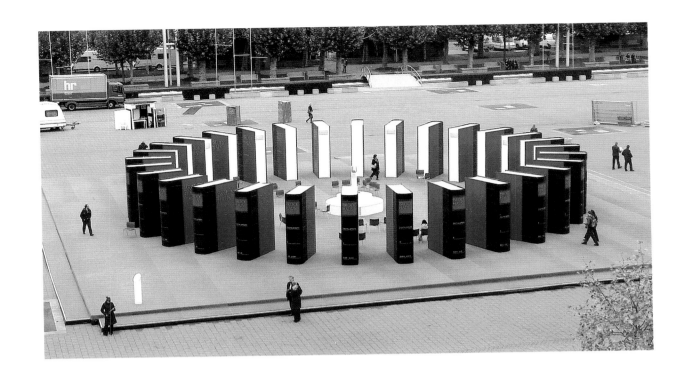

Year	**2005**
Location	**Frankfurt**
Trade Fair	**Frankfurt Book Fair**
Exhibitor	**Bibliographisches Institut & F.A. Brockhaus AG, Mannheim**
Concept	**Milla und Partner Agentur & Ateliers and BBDO Campaign, Stuttgart**
Design	**Milla und Partner GmbH, Stuttgart: Johannes Milla, Stefan Morgenstern; Director: Martin Wagner**
Size	**3,600 m²**
Realisation	**Milla und Partner GmbH, Stuttgart: Marion Kerckhoff**
Lighting	**Music & Light Design, Leonberg**
Composer/Soloist	**Theo Bleckmann, New York and the Semiseria Choir, Tübingen**
Production	**Marc Feigenspan**
Exhibit Construction	**WSV Group, WeimerSteinbergVega GmbH, Langenzenn**
Photos	**Arne Dedert, Alexander Kempf, Michael Steinle**

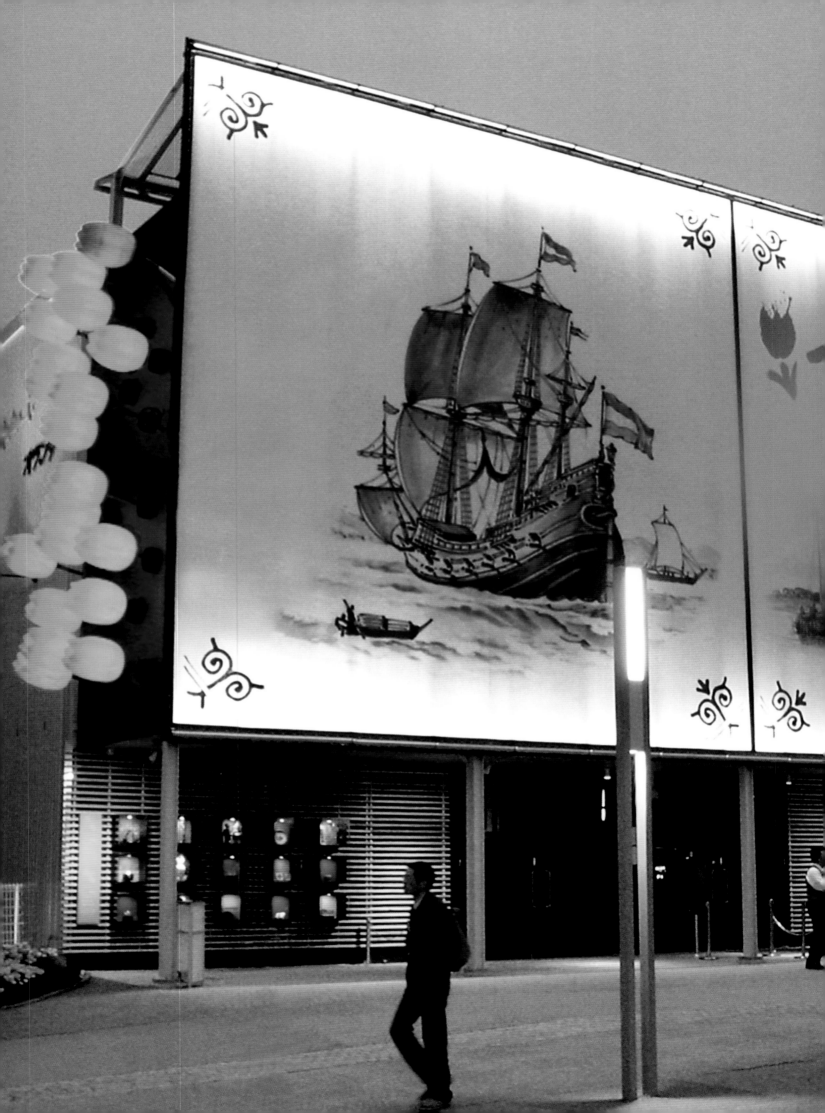

Land of Water

Land of Water

Totems | Communication & Architecture
for the Dutch Ministry
of Economic Affairs (EVD)

Totems | Communication & Architecture
für das Holländische
Wirtschaftsministerium (EVD)

Dutch seafarers first reached Japan at the beginning of the seventeenth century, an event which forms the starting point for this exploration of the Netherlands' relations with the Far East, and of the role of water in Dutch history and culture. The Netherlands, once described as "more coast than country," has always been a trading nation, both in its seaborne trade and internal and inter-European trade through the canal network that is a feature of its geography, alongside the history of the country's efforts to secure land from the sea.

The exterior of the EXPO 2005 building in Japan uses several familiar icons: two large designs, imitating the patterns of blue Delft tiles, show a sailing ship and a windmill, while giant yellow tulips protrude from the side of the building.

Zu Beginn des 17. Jahrhunderts gelangten holländische Seefahrer erstmals bis nach Japan. Dieses Ereignis bildete den Angelpunkt für die Beschäftigung mit den Beziehungen zwischen den Niederlanden und dem Fernen Osten und der Rolle, die Wasser in der holländischen Kultur und Geschichte seit jeher spielt. Die einst als „mehr Küste als Land" beschriebenen Niederlande sind seit Alters her eine Handelsnation und im internationalen Seehandel genauso zu Hause wie im inländischen und europäischen Warenaustausch auf dem ausgedehnten Kanalnetz, das zur niederländischen Topografie gehört wie die jahrhundertealte Tradition, dem Meer fruchtbares Land abzuringen.

Die Außenfront des Standes bei der EXPO 2005 in Japan setzt auf vertraute Wahrzeichen: zwei Delfter Kacheln nachempfundene, großflächige blaue Motive zeigen ein Segelschiff und eine Windmühle, gelbe Riesentulpen lugen seitlich aus dem Gebäude heraus.

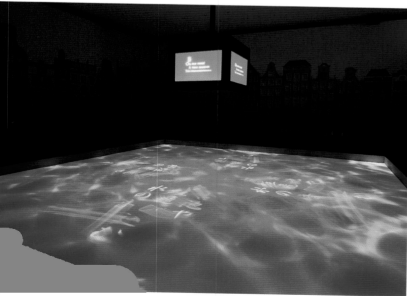

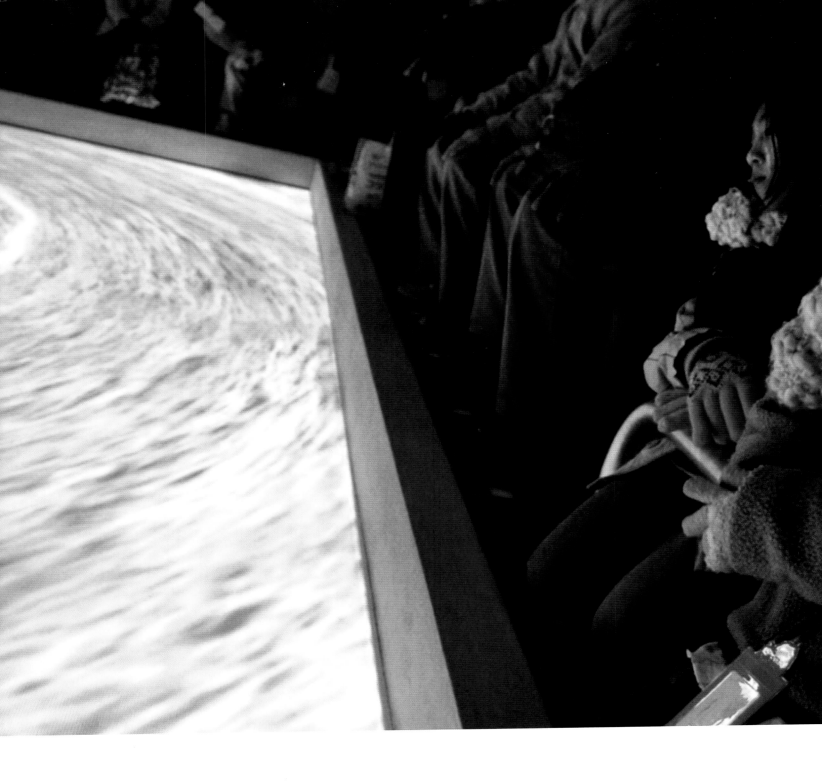

Inside, a static display on the walls, also in blue Delft tiles, carries a series of images of the history and the contemporary nature of Dutch life.

The unusual element is the 4 metre square pool in the centre of the building. This is a reminder of the central theme, and a reference to the natural theme of the EXPO as a whole. The water in the pool moves and swirls gently, until the lights are dimmed, the water calms to a still surface, and becomes the screen for a high-definition projection of a film celebrating the contacts between Holland and Japan, and the continuing cultural diversity of this small but outgoing European nation.

Im Innern zeigt ein statisches Display – ebenfalls aus Delfter Kacheln – Bilder der Niederlande von einst und jetzt.

Ungewöhnlich dagegen ist das vier Quadratmeter große Wasserbecken in der Gebäudemitte. Es verweist auf das zentrale Thema des Stands und zugleich auf die Natur als übergeordnetes Thema der EXPO. Das Wasser im Becken strudelt sachte, kommt dann zur Ruhe, während das Licht gedämpft wird. Der nun stille Wasserspiegel wird zur Projektionsfläche für ein hochauflösendes Video, das die Beziehungen zwischen Holland und Japan ebenso hervorhebt wie die auch heute noch spürbare kulturelle Vielfalt des kleinen, aber kontaktfreudigen europäischen Staates.

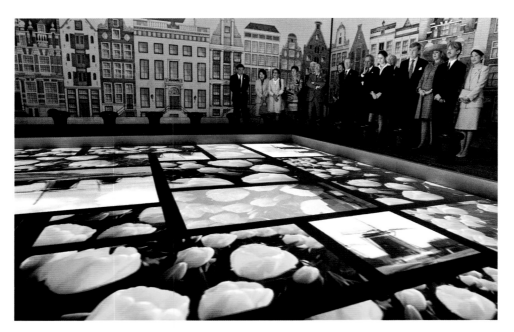

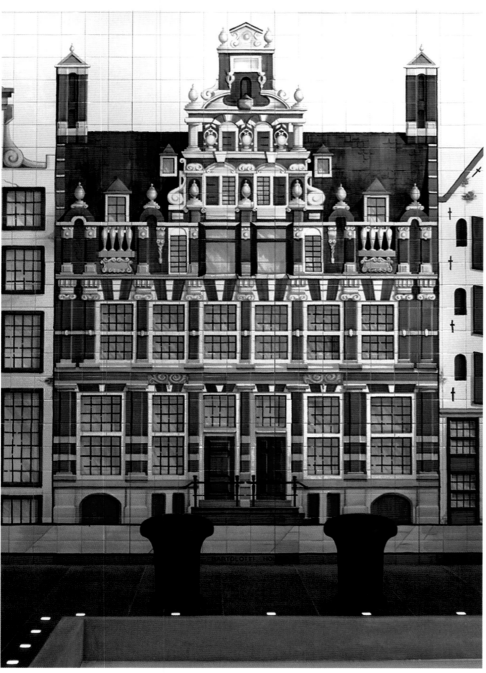

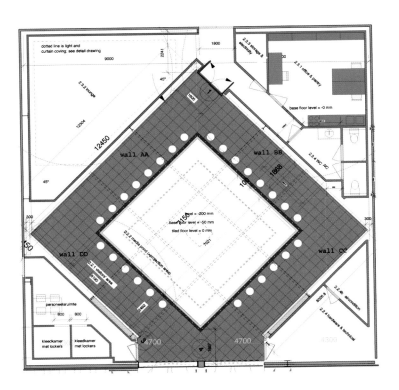

Year	**2005**
Location	**Aichi**
Trade Fair	**Expo 2005**
Exhibitor	**The Dutch Ministry of Economic Affairs (EVD),** **'s Gravenhage**
Architect	**Totems Communication & Architecture,** **Stuttgart & Amsterdam**
Size	**324 m^2**
Realisation	**Daimaru Design & Engineering Co. Ltd.**
Lighting	**Totems Communication & Architecture**
Graphics	**Totems Communication & Architecture**
Presentation Materials	**Totems Communication & Architecture/** **Metropolisfilm**
Photos	**Totems Communication & Architecture**

Being Tangential

Tangentialverhältnisse

Julie Zeldin Garden Design
Own Stand

Julie Zeldin Garden Design
Eigenstand

The pale barks of a row of trees may recall a moment in a Bergman film, Hobbema's The Avenue or a road trip through provincial France. We bring memories to gardens and take new memories away. This small garden design by Julie Zeldin achieves evocation through simplicity. White end and side walls, a row of trees, a rectangle of decking, a raised circular mound of lawn tangential to it, a mass of herbaceous plants in the end corner, the whole is a complete unit, graceful and formal. But each individual element is also a whole within the whole, the ferns abutting the lawn recalling a forest path, the tall grasses alongside the decking a river-bank, the sloping lawn Titania's magic bed, and so on. Putting the composition together is where the artistry lies.

Die helle Rinde einer Baumreihe vermag uns in einen Bergman-Film, Hobbemas Allee von Middelharnis oder eine Fahrt durch die französische Provinz zurückzuversetzen. Wir tragen alte Erinnerungen in Gärten und nehmen neue daraus mit. Julie Zeldins Gärtchen weckt sie gerade durch seine Schlichtheit. Weiße Rück- und Seitenwände, eine Baumreihe und ein rechteckiges Stück Holzboden, das die Tangente zu einem runden Grashügel bildet, in einer Ecke ein Beet voller krautiger Pflanzen, alles zusammen ergibt einen anmutigen, eleganten Garten. Jedes Element für sich bildet jedoch zugleich eine Einheit innerhalb des Ganzen. Die Farne am Rand des Rasens evozieren einen Waldweg, die hohen Gräser entlang den Bohlen ein Flussufer, die Böschung des Rasenstücks Titanias mittsommernächtlich verzauberten Schlafplatz und so weiter. Die Kunst besteht darin, diese Elemente zu einer kohärenten Komposition zu verweben.

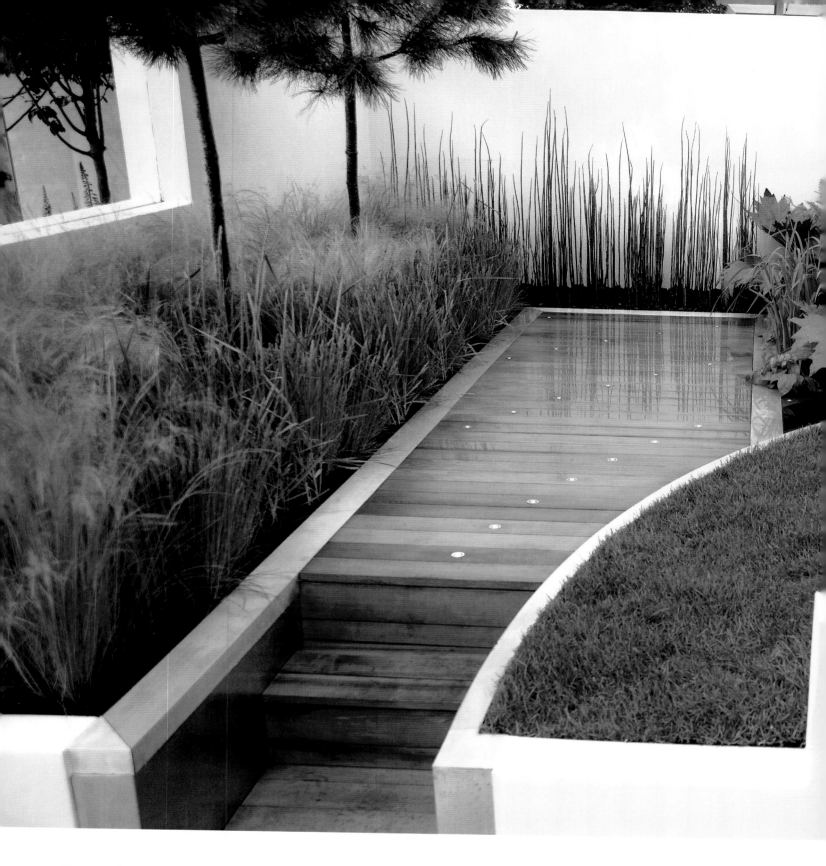

The use of a small range of colours in the planting, and modern, natural and almost invisible architectural elements combine to create a sense of contemporary timelessness. This garden won a prize in the Chic Gardens section at the 2005 Chelsea Flower Show. For all its elegant compactness, it might seem at first glance too simple to merit that sobriquet. But a moment's reflection and one recalls that the defining totem of chic has a similar timeless simplicity that masks its artistry – Chanel's little black dress.

Die begrenzte Farbpalette und die modernen, fast unsichtbaren organischen Architekturelemente schaffen gemeinsam ein Gefühl der Zeitlosigkeit im Hier und Jetzt. Bei der Chelsea Flower Show 2005 wurde der Garten in der Sektion „Chic Gardens" mit einem Preis ausgezeichnet. Bei aller eleganten Kompaktheit wirkt er auf den ersten Blick zu bescheiden, um „schick" zu sein. Bei genauerem Hinsehen besitzt er jedoch die gleiche zeitlose Schlichtheit, die auch Coco Chanels „Kleines Schwarzes" als Inbegriff der Eleganz besaß: eine Schlichtheit, hinter der sich große Kunstfertigkeit verbirgt.

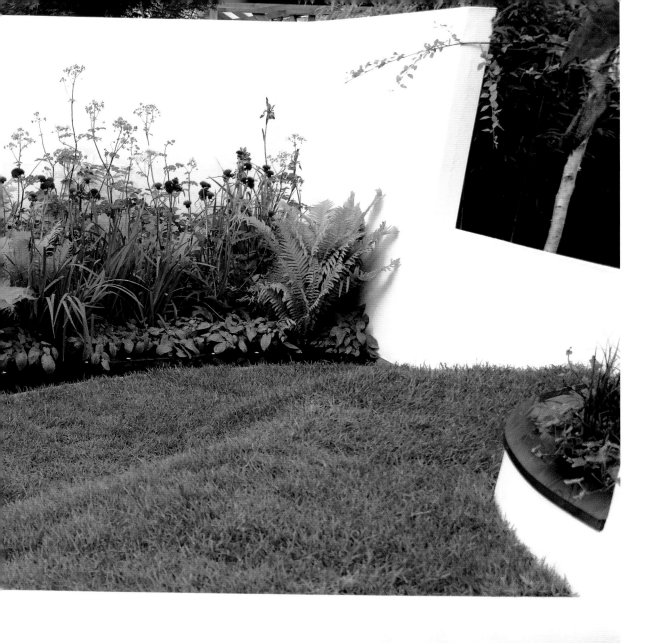

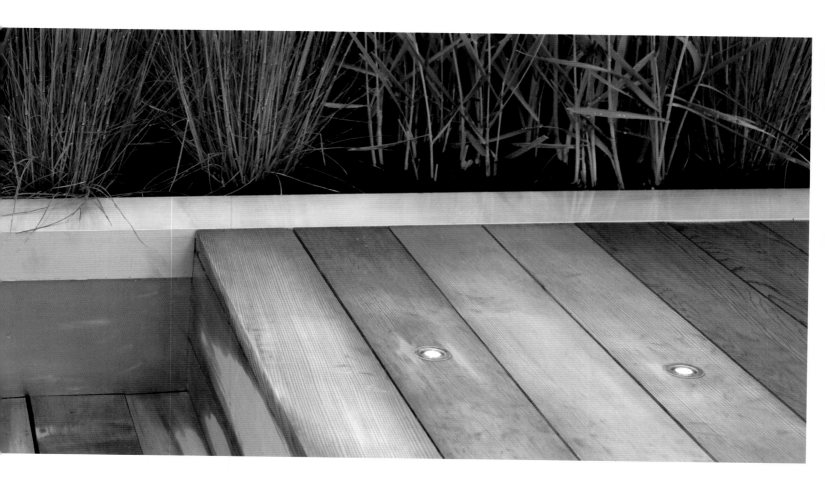

Year	**2005**
Location	**London**
Trade Fair	**Chelsea Flower Show**
Exhibitor	**Julie Zeldin Garden Design, London**
Architect	**Julie Zeldin**
Size	**20.25 m²**
Realisation	**Julie Zeldin**
Lighting	**Julie Zeldin**
Graphics	**Julie Zeldin**
Photos	**David Hiscock**

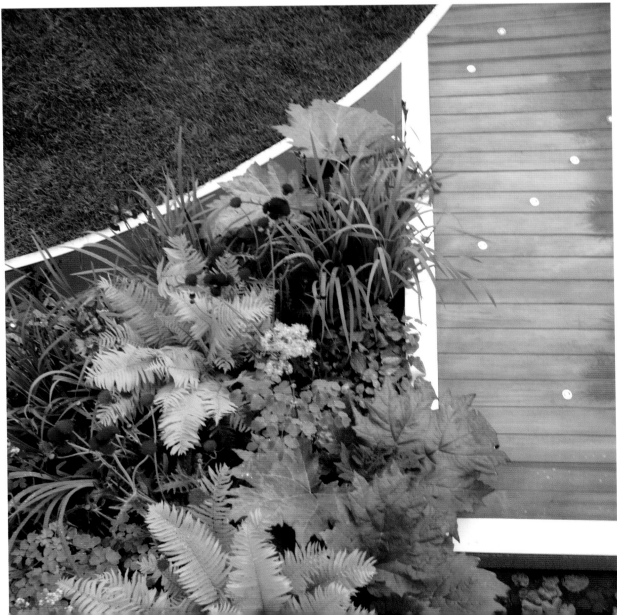

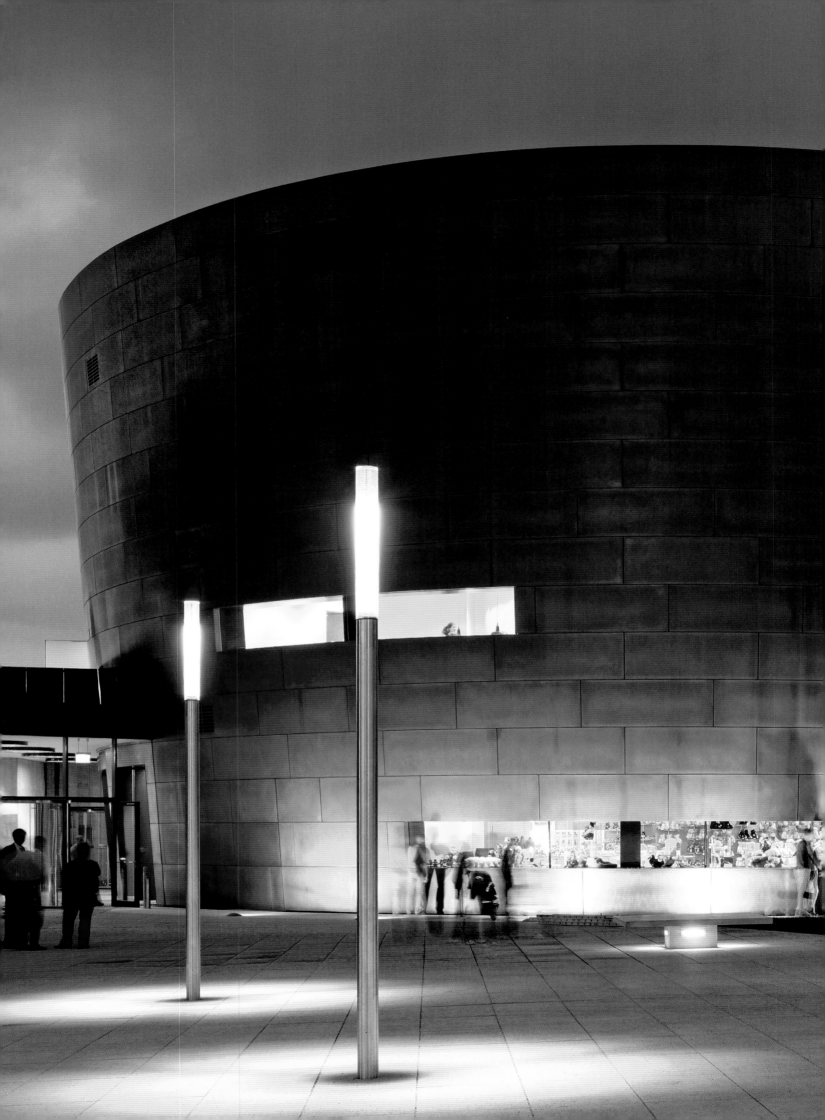

Teddy Bears' Picnic
Teddy & Co.

Milla und Partner
for Steiff

Milla und Partner
für Steiff

"If you go down to the woods today," the song used to say,
you'll see the Teddy Bears' picnic. Or you can go to Giengen
an der Brenz, where for over 125 years the Steiff family busi-
ness has been making teddy bears and toy animals for children
and for collectors, and visit the "world of Steiff," a brand cen-
tre designed by architects Ramseier & Associates with the in-
ternal exhibition being created by Milla und Partner. The build-
ing is a truncated three-storey cone finished in bronze with
one main opening showing the huge face of a welcoming
bear.

Kuscheltiere mit dem legendären Knopf im Ohr lassen jedes
Kinderherz höher schlagen, und das seit über 125 Jahren. So
lange produziert das Familienunternehmen Steiff schon in
Giengen an der Brenz Teddybären und Plüschtiere für Kinder
und Sammler. Das Architekturbüro Ramseier & Associates
schuf am Firmenstandort die „Welt von Steiff", ein Erlebnis-
museum mit einem Ausstellungsdesign von Milla und Partner.
Das Gebäude ist ein bronzeverkleideter dreistöckiger Kegel-
stumpf mit pausbäckigem Bärengesicht am Haupteingang.

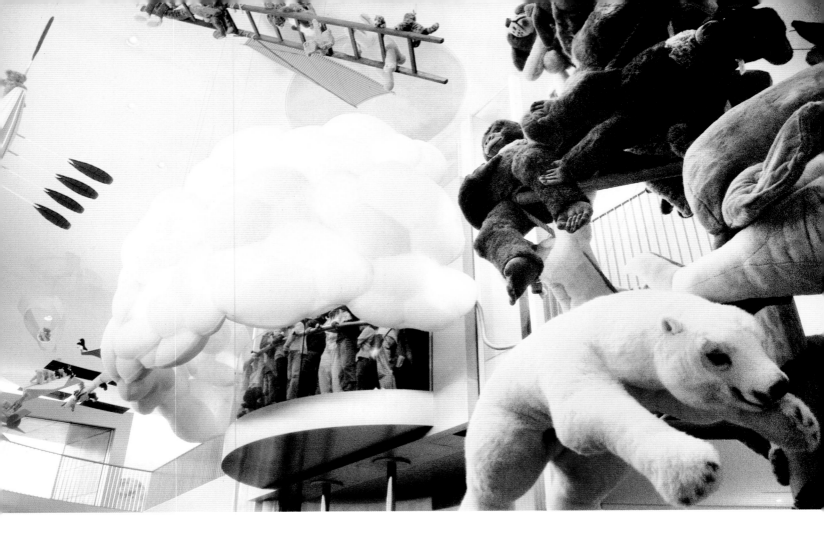

The exhibition plan embraces both adult and child markets, starting with a reconstruction of founder Margarete Steiff's simple Swabian workroom, then moving up – literally for twelve metres – on a lifting platform into a dream world of plush creatures exploring a range of themes, such as an underwater world and a polar world, before coming back to earth to see how the teddies are still traditionally made in a working studio, and to look at over one thousand examples of Steiff's work from the past. Then to look at the current product range, to cuddle and photograph same. By linking to historical and handcraft reality at these points on the tour, the designers have neatly avoided the risks of anthropomorphism or outright sentimentality that might bedevil such a project.

Die Ausstellung richtet sich an Kinder und Erwachsene. Von der rekonstruierten schwäbischen Werkstatt der Gründerin Margarete Steiff fährt man auf einer Panoramaplattform zwölf Meter hinauf durch eine Märchenwelt voller Plüschwesen, die zu diversen Themen von Tiefsee bis Polarkreis arrangiert sind. Danach geht es wieder hinunter, diesmal zur Schauwerkstatt, wo man zusehen kann, wie Teddybären heute noch von Hand genäht werden. Außerdem gibt es über tausend Modelle aus der Steiff-Geschichte zu bestaunen. Zum Schluss darf man noch die aktuelle Kollektion knuddeln und fotografieren. Dadurch, dass die Besichtigung sich zwischen Geschichte und handwerklicher Realität bewegt, gingen die Designer geschickt der Gefahr einer Vermenschlichung oder gar des Kitsches aus dem Weg, in die ein solches Projekt leicht abrutschen kann.

Year	**2005**
Location	**Giengen an der Brenz**
Trade Fair	**Permanent Brand World**
Exhibitor	**Margarete Steiff GmbH,** **Giengen an der Brenz**
Architect	**Andreas Ramsaier & Associates Ltd., Zurich;** **Patzner Architekten, Stuttgart**
Exhibition Design	**Milla und Partner GmbH, Stuttgart**
Concept	**Johannes Milla, Jean-Louis Vidière,** **Gitti Scherer**
Stage Design	**Anja Luithle, Gitti Scherer**
Stage Direction	**Martin Wagner**
Composition and Sound	**Floridan Studios**
Size	**1,000 m²**
Realisation	**Milla und Partner GmbH, Stuttgart**
Photos	**Peter Redlin, Hanspeter Schiess,** **Jean-Louis Vidière**

Forschungszentrum Karlsruhe
in der Helmholtz-Gemeinschaft

Forschungszentrum Karlsruhe
in der Helmholtz-Gemeinsch

Colani

ZEEH DESIGN
Exhibition Network

Freeform Tree Forms
Freiformbäume

Zeeh Design
for Forschungszentrum Karlsruhe

Zeeh Design
für das Forschungszentrum Karlsruhe

The central theme for EXPO 2005 in Aichi was the natural world. The research institute in Karlruhe and the Karlsruhe-based scientist Professor Claus Mattheck wanted to show how modern technology and cutting edge substances can be used to maximum efficiency by following the example of natural materials and forms. Zeeh Design invited the designer Luigi Colani to collaborate on the design of a freeform structure, which was fabricated from EPS blockware.

At the Expo the structure was integrated with a real tree, and LED displays were used around it to convey the central message of the continued relevance of the natural example. This relevance was highlighted almost a century ago in D'Arcy Thompson's magisterial work "On Growth and Form," and this tradition continues in the world of contemporary materials in the work of Claus Mattheck, whose presentations played a key role at the Expo.

Zentrales Thema der EXPO 2005 in Aichi war die Weisheit der Natur. Professor Claus Mattheck vom Forschungszentrum Karlsruhe wollte zeigen, dass man heutige Technologien und modernste Substanzen besonders effizient nutzen kann, wenn man sich natürliche Materialien und Formen zum Vorbild nimmt. Zeeh Design lud den Designer Luigi Colani zur Mitgestaltung einer Freiformkonstruktion aus EPS-Blockware ein.

Bei der Expo war in diese Konstruktion ein echter Baum integriert. Ringsum vermittelten LED-Displays die zentrale Botschaft von den heute nicht minder wichtigen Vorbildern in der Natur. Deren Relevanz legte D'Arcy Thompson schon vor fast einem Jahrhundert in seinem bahnbrechenden Werk *Über Wachstum und Form* dar. Im Hinblick auf zeitgenössische Werkstoffe setzt sich diese Tradition in den Arbeiten Claus Matthecks fort, dessen Präsentationen bei der Expo eine wichtige Rolle spielten.

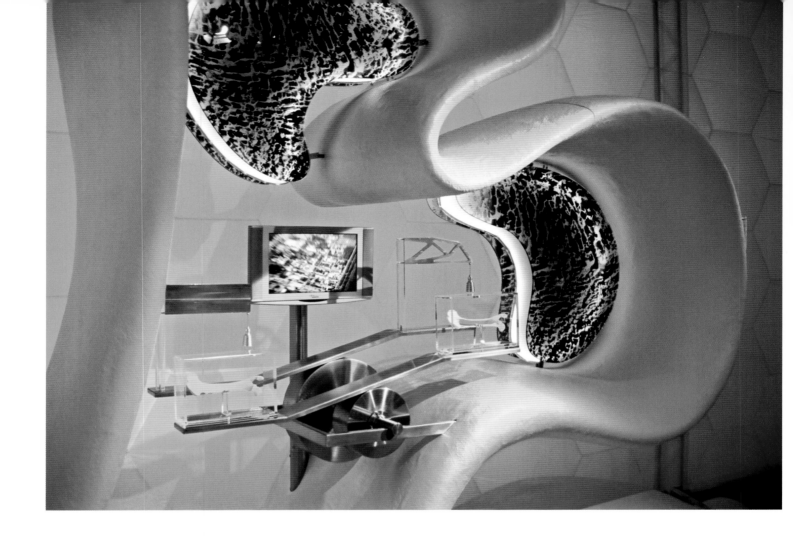

Year	**2005**
Location	**Aichi**
Trade Fair	**Expo 2005**
Exhibitor	**Forschungszentrum Karlsruhe**
Architect	**ZEEH DESIGN Messebau GmbH Karlsruhe; Concept: Irina Langel; Project Management: Rolf Ratz, Irina Langel, Harald Hüser**
Size	**36 m²**
Realisation	**ZEEH DESIGN Messebau GmbH Karlsruhe; Colani Design: Prof. Luigi Colani**
Lighting	**ZEEH DESIGN Messebau GmbH Karlsruhe**
Graphics/ Communication	**ZEEH DESIGN Messebau GmbH Karlsruhe: Irina Langel**
Video	**Forschungszentrum Karlsruhe: Willi Müller**
Photos	**Irina Langel, Karlsruhe**

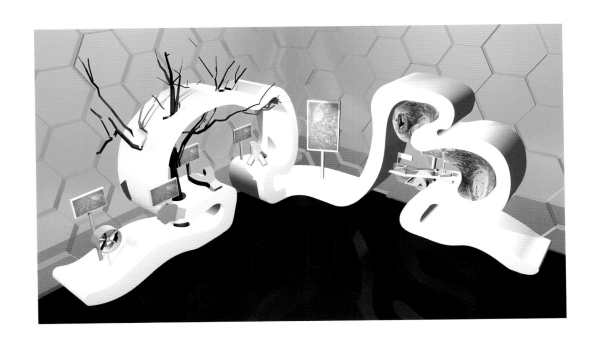

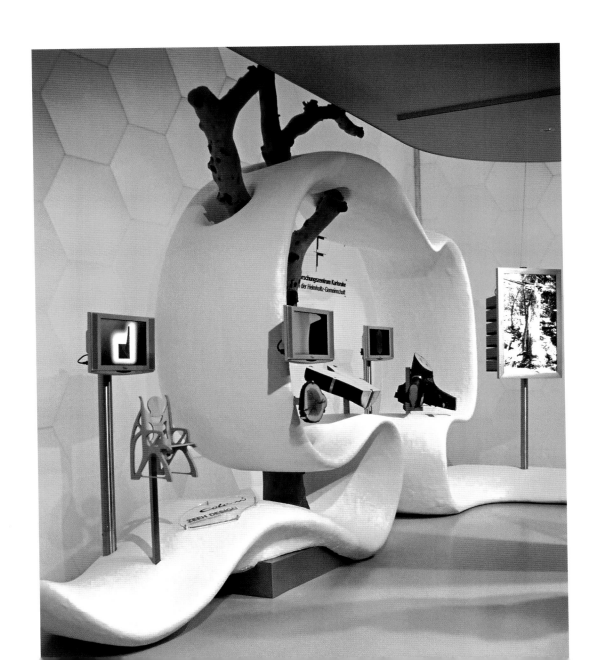

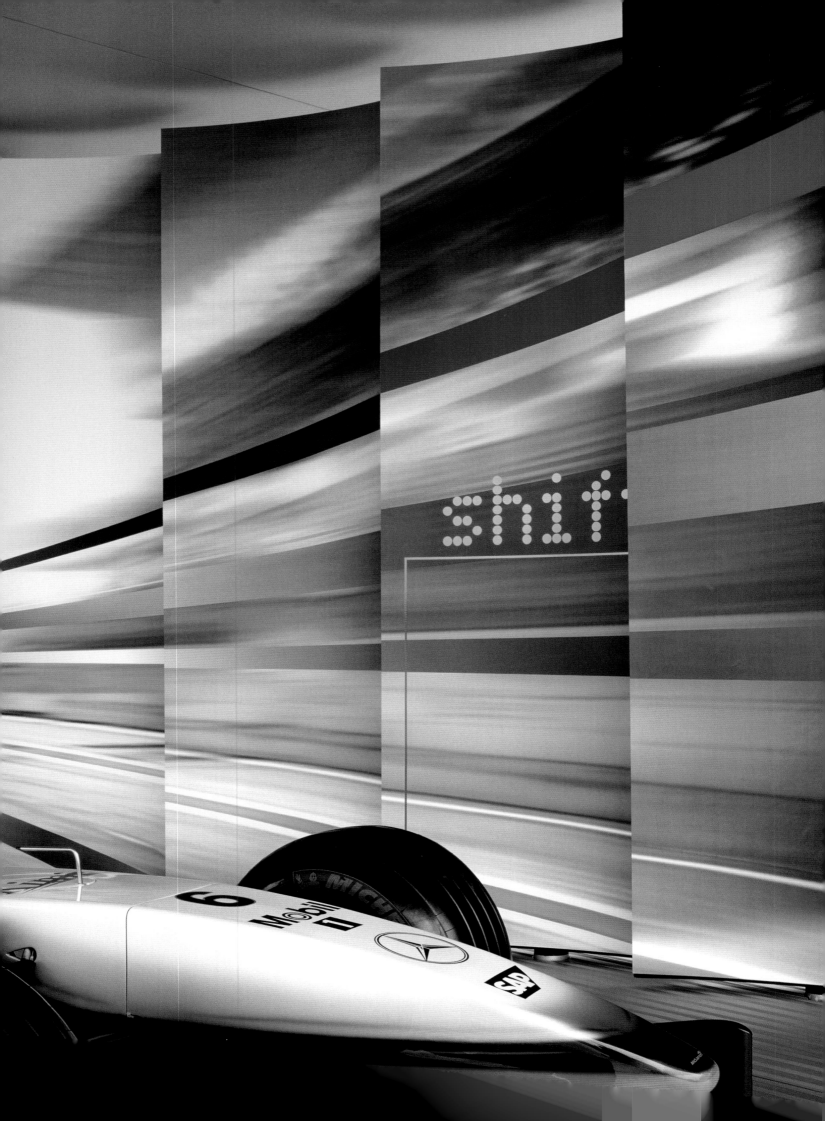

Going to the Races
Rennbahnluft schnuppern

3e
for Mercedes-Benz Motorsport

3e
für Mercedes-Benz Motorsport

Involvement in motor sport for car manufacturers, tyre makers and engine and component suppliers is a major way of proving product validity, extending development and research, and raising brand awareness through the global popularity of events such as the Formula One Grand Prix races. Elements from the Grand Prix circuit, including complete race cars often feature on motor show stands (as well as being used by other sponsors as brand reminders.) Why not reverse this logic, and take the motor show to the race track, and show visitors to the races what the street versions of the cars are like, as well as offering them a range of motor sport products as a souvenir of the day?

Für alle Unternehmen, die Autos, Reifen, Motoren und sonstige Autoteile herstellen, bietet der Rennsport eine hervorragende Gelegenheit, die Zuverlässigkeit ihrer Produkte sicherzustellen, Forschung und Entwicklung voranzutreiben und durch die globale Popularität von Events wie Formel 1 Grand Prix die Markenbekanntheit zu stärken. Grand-Prix-Elemente einschließlich kompletter Rennwagen sind oft auf Automobilausstellungen zu bewundern (und werden von anderen Sponsoren gern als Marken-Reminder genutzt). Kehrt man die Logik um, kann man genauso gut am Rande einer Rennstrecke dem Publikum an einem mobilen „Messestand" vorführen, wie die Straßenversion der Boliden aussieht und parallel dazu Motorsportaccessoires als Souvenirs anbieten.

The concept seems simple when stated like that: executing it would require a team with engineering and construction skills as well as design qualities. So Mercedes-Benz Motorsport turned to 3E, Werner Sobek's exhibition and entertaining engineering group, also based in Stuttgart. The challenge was not only to come up with a compelling design, but one which could be erected, dismantled, transported and re-erected up to fifty times in the racing year: in different locations with different space possibilities.

The 3E team came up with a modular system with two main elements. The Motor Sport Pavilion consists of two modules – M-box and U-nit – as well as the so-called WINGs. The WINGs, which are of modular design, create and structure the interior spaces and serve to communicate the image of the marque, and so enhance brand recognition.

Das hört sich sehr einfach an, doch für die Umsetzung braucht man ein Team, das in Automobiltechnik und -konstruktion ebenso versiert ist wie in Sachen Design. Mercedes-Benz Motorsport wandte sich deshalb an das Designbüro 3e Werner Sobek exhibition & entertainment engineering im heimatlichen Stuttgart mit der Vorgabe, einen attraktiven Stand zu konzipieren, den man obendrein im Laufe der Rennsaison rund 50 Mal an verschiedenen Orten in unterschiedlichen räumlichen Verhältnissen aufbauen, abbauen, transportieren und wieder aufbauen kann.

Das Team von 3e ließ sich ein modulares System mit zwei Hauptelementen einfallen. Das Motorsport-Set besteht aus den beiden Modulen „M-box" und „U-nit" plus modularen „WING"-Elementen, die Innenräume bilden und strukturieren, das Markenimage vermitteln und den Wiedererkennungseffekt verstärken.

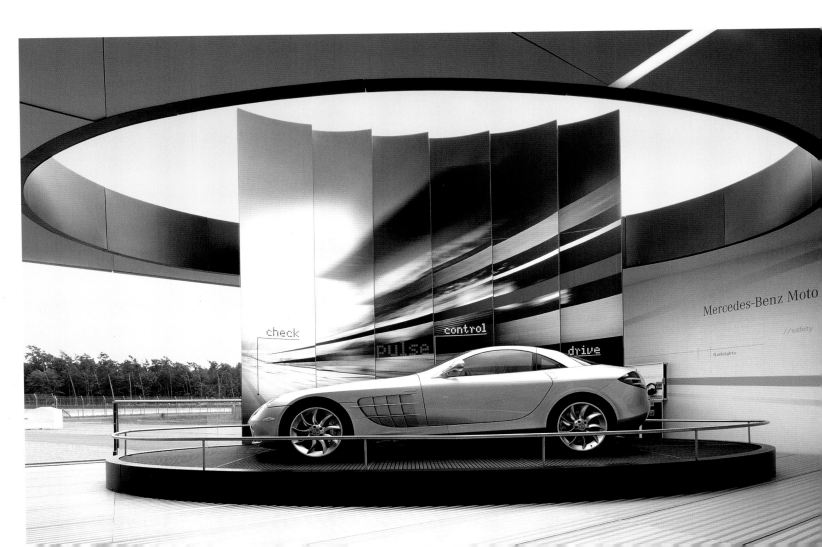

Mercedes-Benz Moto

check control drive

pulse

//safety

flashlights

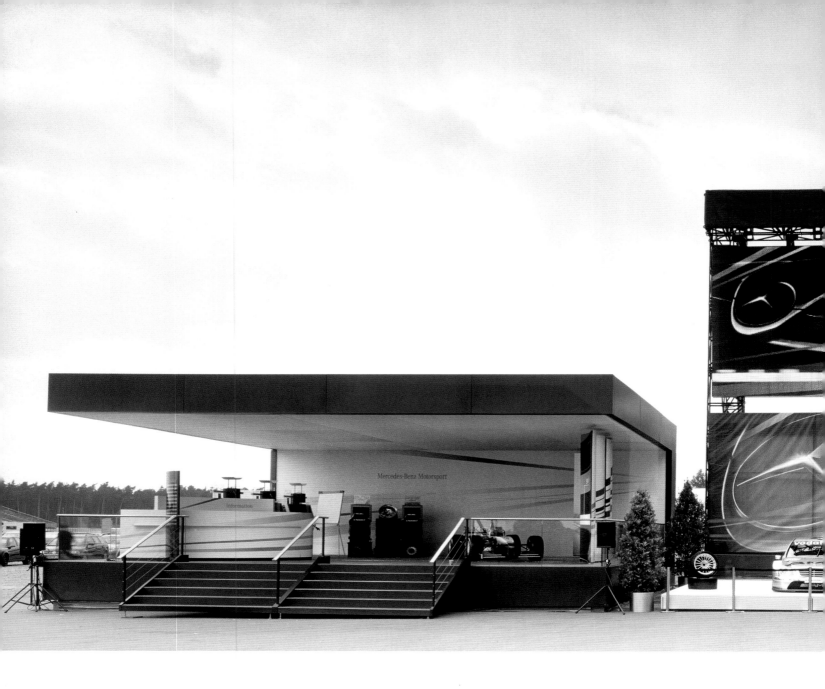

The M-box is a covered cubic exhibition pavilion whose roof features an elliptical opening. Through this opening stela-like WING elements project above the roof. In addition to the large WING elements, smaller WING elements are installed which serve to house thematic displays and other communication content.

The U-nit is an extension element featuring a roof structure of 9 metre projection, which can also be used as a separate exhibition area or as a stage. Overall, the display areas allow the presentation of vehicles and the sale of merchandise, while in addition the pavilion provides a stage for interviews, live music shows and other events.

Die M-box ist ein überdachter kubischer Pavillon. Durch die elliptische Öffnung im Dach ragen stelenartige WING-Elemente empor. Ergänzend zu den großen WING-Elementen gibt es kleinere, mit denen Displays zu Themenschwerpunkten und anderen Inhalten arrangiert werden.

Die U-nit ist ein Erweiterungselement mit einer neun Meter überstehenden Dachkonstruktion, die als separate Ausstellungsfläche oder als Bühne genutzt werden kann. Diese Module dienen der Präsentation von Fahrzeugen und als Merchandising-Shop sowie als Bühne für ein Rahmenprogramm mit Interviews oder Live-Musik.

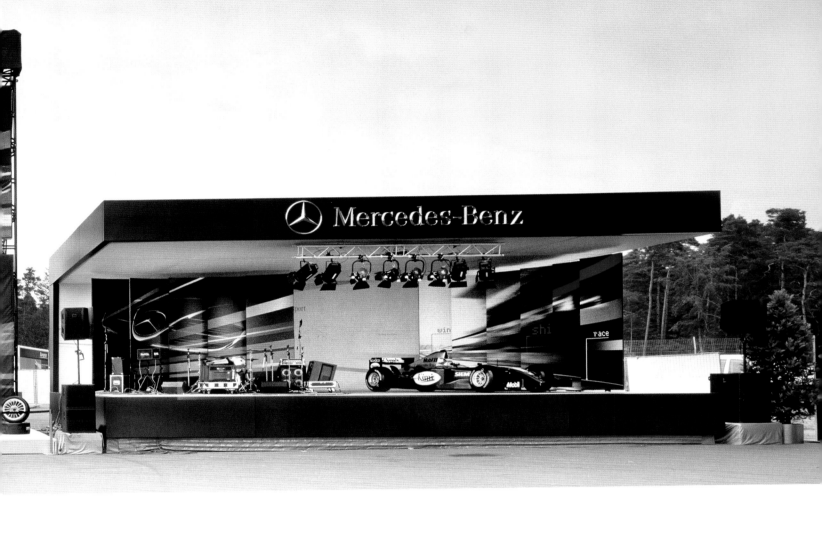

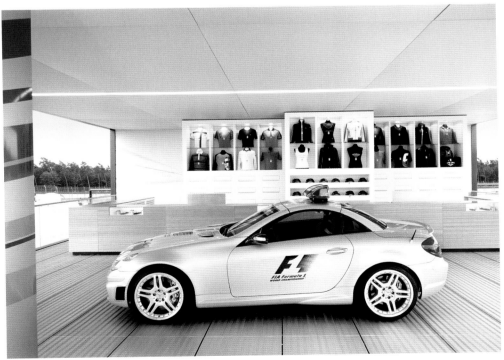

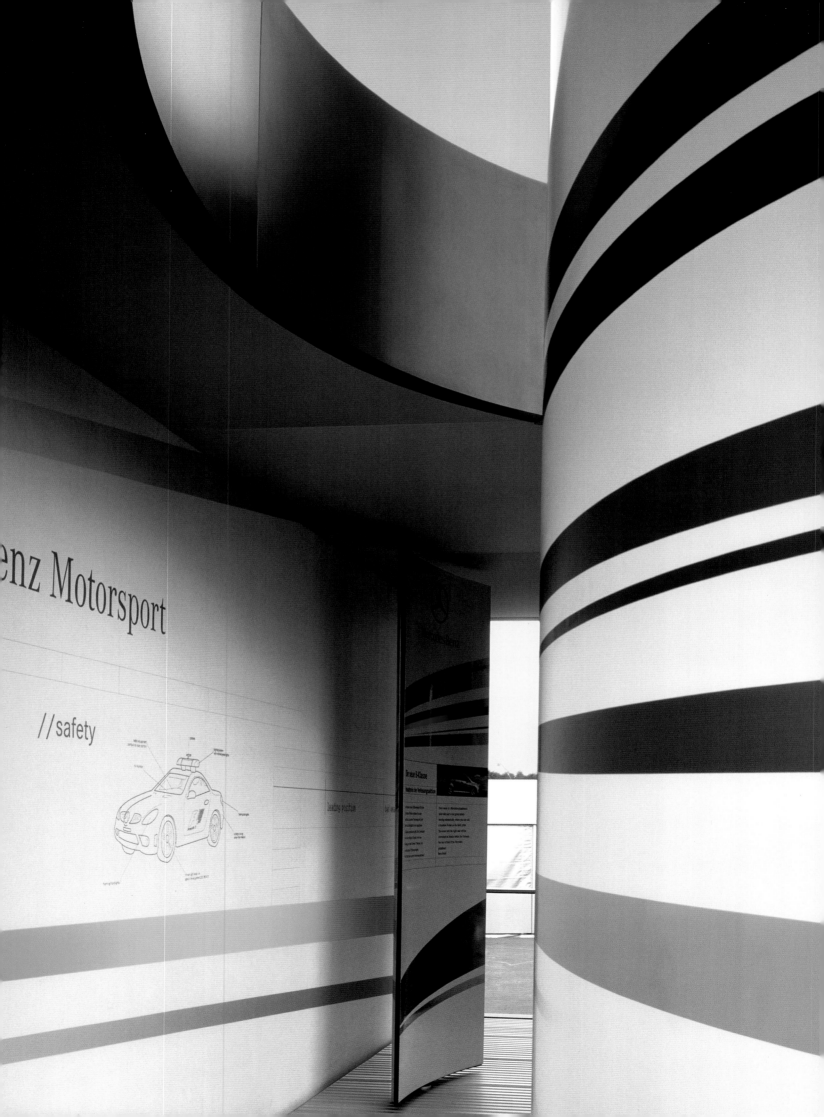

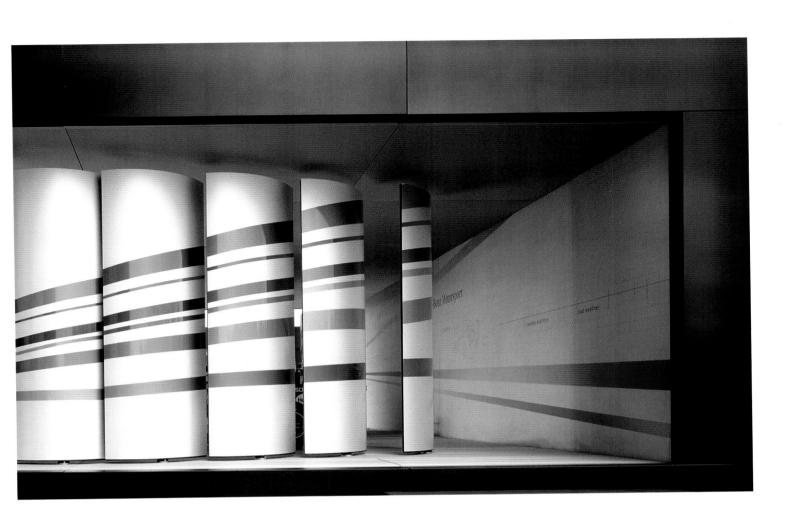

Year	**In use since 2005**
Location	**Worldwide**
Trade Fair	**F1/DTM Racetracks**
Exhibitor	**DaimlerChrysler AG, Stuttgart**
Architect	**3e Werner Sobek exhibition & entertainment engineering, Stuttgart**
Size	**200–700 m²**
Realisation	**NÜSSLI (Schweiz) AG**
Lighting	**3e Werner Sobek exhibition & entertainment engineering, Stuttgart**
Graphics/Communication	**Design³, Stuttgart**
Photos	**Zooey Braun, Stuttgart/Germany**

Business to Business

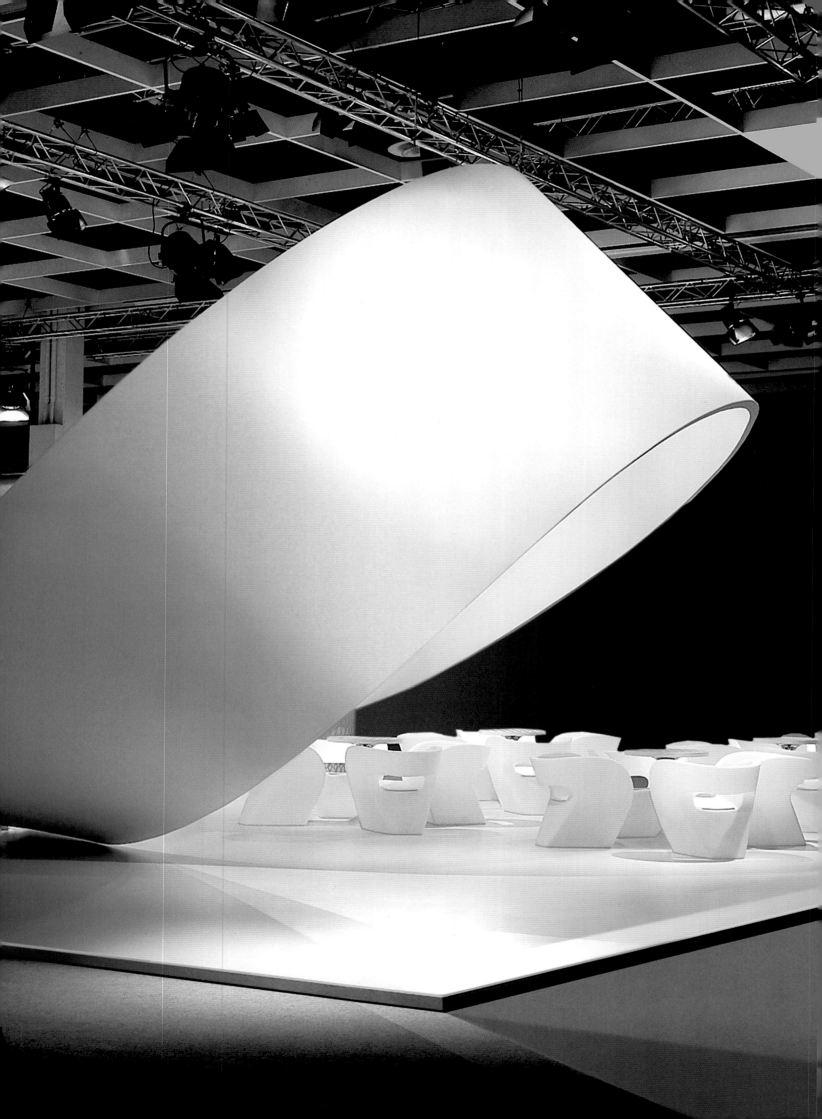

Improbable Delights

Herrlich unmöglich

häfelinger + wagner design
for Munksjö Paper

häfelinger + wagner design
für Munksjö Paper

A Moebius strip is a delightfully impossible object. In topographic terms, it is an object which has one planar surface and one edge. It's a concept you need a long drink (preferably from a Klein bottle) to understand fully, as it cannot exist in four-dimensional space-time, but you can get the idea by taking a strip of paper, twisting it through 180 degrees and joining the two ends. The result is an elegant, flowing circle with a twist in it.

Just how elegant can be seen in this stand design by Munich-based häfelinger + wagner for specialised paper manufacturers Munksjö. The pale band stood over five metres high at the top, sweeping down to the floor to allow entry within the circular wall it created. The visitor is thus invited "into the circle."

Ein Möbiusband ist etwas herrlich Unmögliches: ein Gegenstand mit jeweils nur einer Fläche und Kante. Wer ein solches Konzept nachzuvollziehen versucht, fängt am besten mit einem kräftigen Schluck aus der (vorzugsweise Klein'schen) Flasche an, denn so etwas darf im vierdimensionalen Raum-Zeit-Gefüge gar nicht existieren. Eine ansatzweise Vorstellung bekommt man, wenn man einen Papierstreifen einmal ganz um die Längsachse dreht und seine Schmalseiten aneinanderheftet. Das Ergebnis ist ein elegant geschwungener, in sich gedrehter Ring.

Wie elegant, das zeigt dieses Standkonzept der Münchner Designfirma häfelinger + wagner für den Spezialpapierhersteller Munksjö. Das helle Band schwang bis zu fünf Meter über den Boden hinauf und lud Besucher in die runde Innenfläche ein, sozusagen in den inneren Kreis.

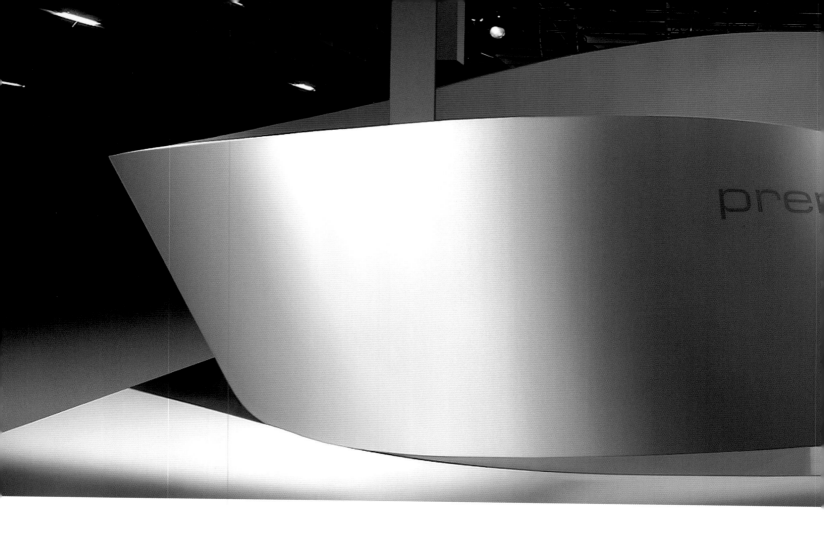

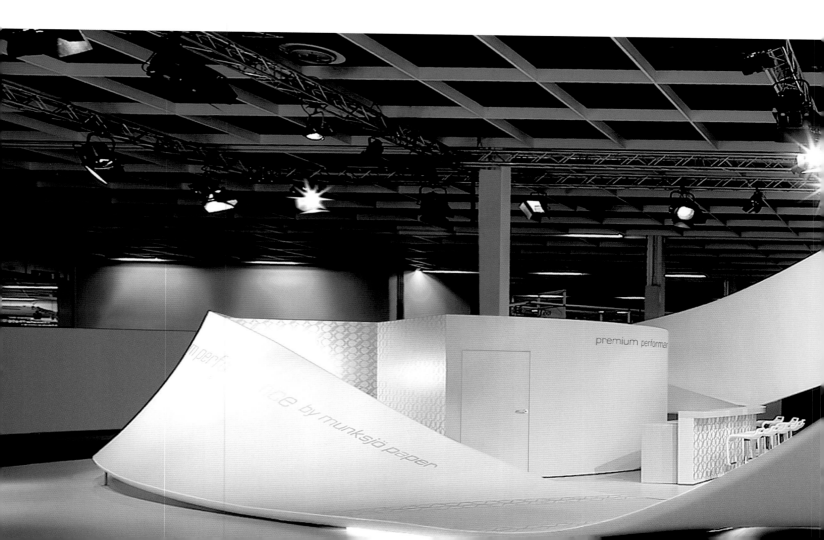

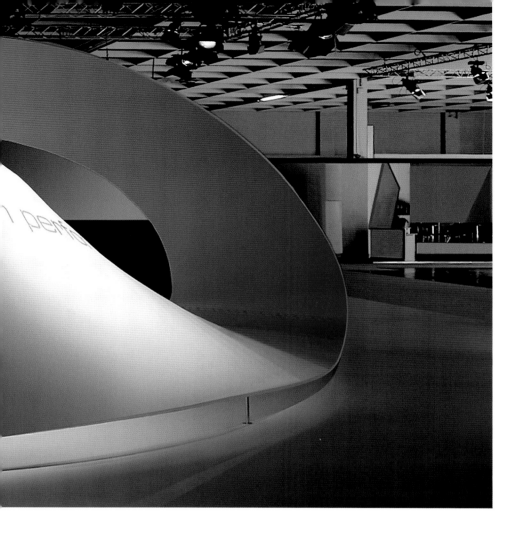

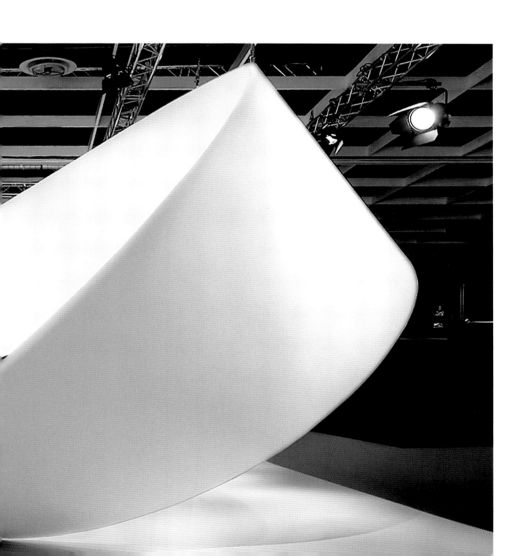

The shape symbolises paper: the twist is that making it into an architectonic element also symbolises Munksjö's main product, décor paper, which is white or coloured paper printed with decorative effects and impregnated with resin. It is then laminated onto a wood or chipboard base and used in furniture, in interior design and for flooring.

In a further twist, to maximise the visual impact and central message – premium performance by Munksjö – there were no product presentations as such on the stand. The colour palette was deliberately limited and pale, with a white floor and white furnishings except within the circle. This almost minimalist approach clarified the focus and engagement of staff and visitors with the central message, as well as reinforcing Munksjö's leading role in the industry through a powerful and simple design.

Die Form steht für den Werkstoff Papier. Durch die Drehung wird sie zum Architekturelement und verweist auf das Munksjö-Hauptprodukt: weißes oder farbiges Dekorpapier mit dekorativen Druckeffekten und Kunstharzbeschichtung, das auf Holz oder Spanplatte laminiert als Rohstoff für Möbel, Inneneinrichtungen und Fußböden dient.

Um den visuellen Effekt und die zentrale Botschaft (Spitzenleistung) noch zu verstärken, verzichtete man gezielt auf jede Produktpräsentation am Stand. Die bewusst helle, zurückhaltende Farbgebung beschränkte sich auf Weiß für Fußboden und Mobiliar mit Ausnahme des Innenkreises. Der fast schon minimalistische Ansatz sorgte dafür, dass sich Mitarbeiter und Besucher auf die Kernbotschaft konzentrieren und einlassen konnten. Zugleich stellte das kraftvoll schlichte Design Munksjös Position als Branchenführer klar heraus.

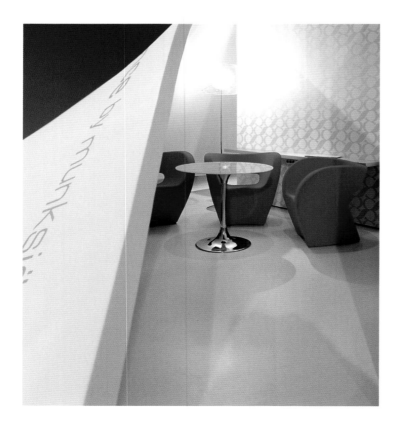

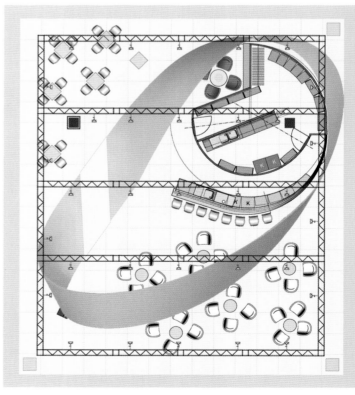

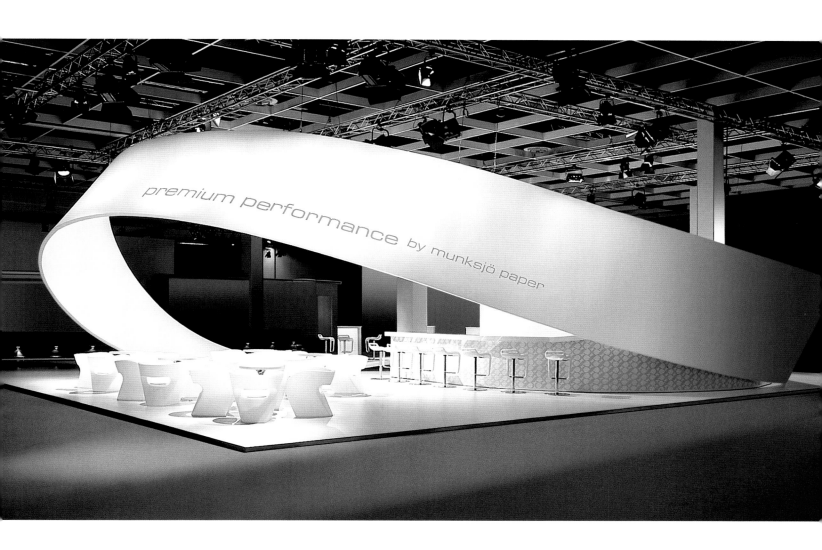

premium performance by munksjö paper

Year	**2005**
Location	**Cologne**
Trade Fair	**Interzum**
Exhibitor	**Munksjö Paper GmbH, Aalen**
Architect	**häfelinger + wagner design, Munich: Thomas Häussler, Frank Wagner**
Size	**255 m²**
Realisation	**WSV Group, WeimerSteinbergVega GmbH, Langenzenn**
Lighting	**WSV Group, WeimerSteinbergVega GmbH, Langenzenn**
Graphics/Communication	**häfelinger + wagner design, Munich: Thomas Tscherter, Frank Wagner**
Photos	**Tobias Kern, Cologne**

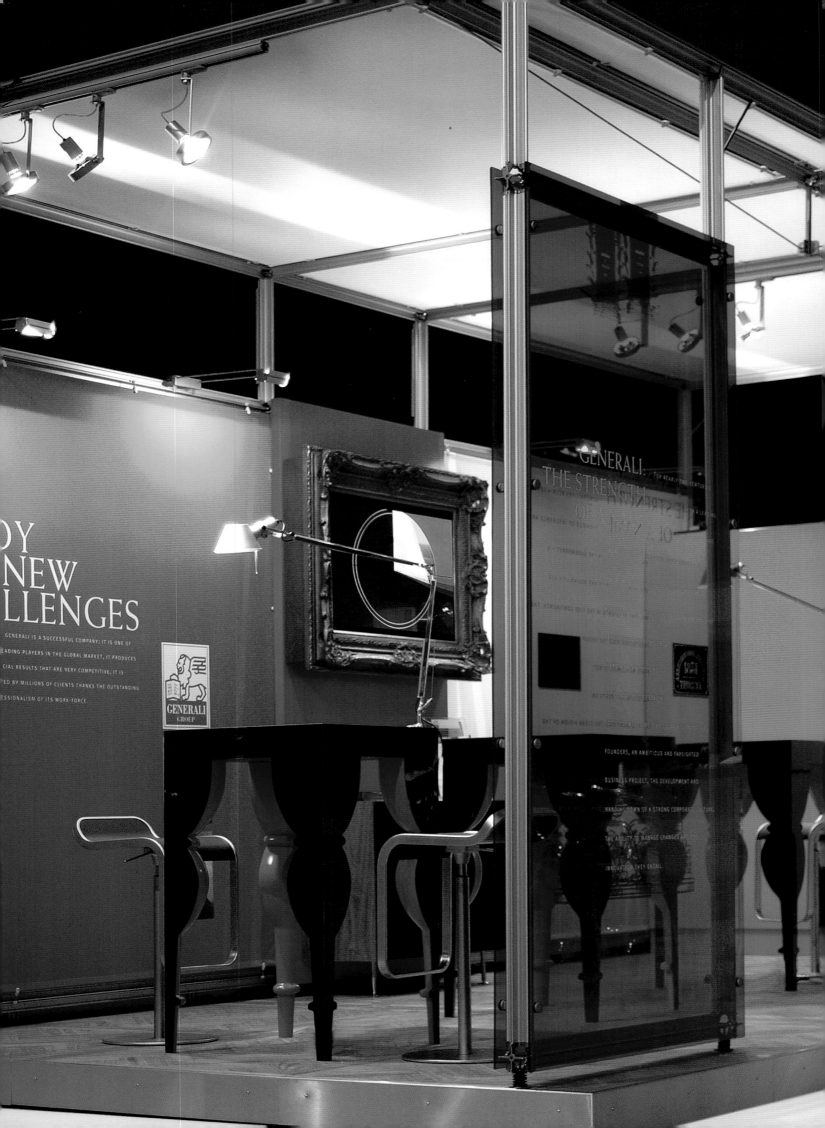

Simply Red

Geballtes Rot

Veenstra CCO
for Generali Verzekeringsgroep

Veenstra CCO
für Generali Verzekeringsgroep

This small stand for the Dutch subsidiary of the Italian insurance group Generali makes an individual statement as well as enshrining the core values of the parent: and making strong use of the corporate colour, a bold Venetian red.

Generali's main business is professional and corporate insurance and fund management, and it operates a sophisticated and professional dialogue with its business partners. These qualities are embodied in the stand through the ludic use of design elements, such as traditional picture frames encasing state-of-the-art screen displays, and postmodern meeting tables with traditional turned legs cut back to rectolinear externals. These visual jeux d'esprit are framed by clear statements of the policy and mission of the company. In this way the visitor is reminded of the continuity of the Generali brand and its continuing responsiveness to the contemporary world of insurance.

Der kleine Stand für die niederländische Tochter der italienischen Versicherungsgruppe Generali rückt neben eigenen Konzepten auch die Kernwerte der Muttergesellschaft in den Blick, insbesondere durch den massiven Einsatz der Konzernfarbe Venezianischrot.

Generalis Standbeine sind Berufs- und Firmenversicherungen sowie Finanzdienstleistungen. Mit seinen Firmenkunden pflegt das Unternehmen einen hochentwickelten professionellen Dialog. Am Stand spiegeln sich diese Qualitäten im spielerischen Umgang mit Designelementen, z.B. supermodernen Screenshots in verschnörkelten Bilderrahmen oder postmodernen Konferenztischen mit nach innen barock gedrechselten, außen geradlinig abschließenden Beinen. Diese visuellen Bonmots sind eingerahmt von klaren Aussagen zur Firmenpolitik und -mission. Den Besucher erinnern sie an die Kontinuität der Marke Generali und ihre Offenheit für die aktuellen Entwicklungen im Versicherungsbereich.

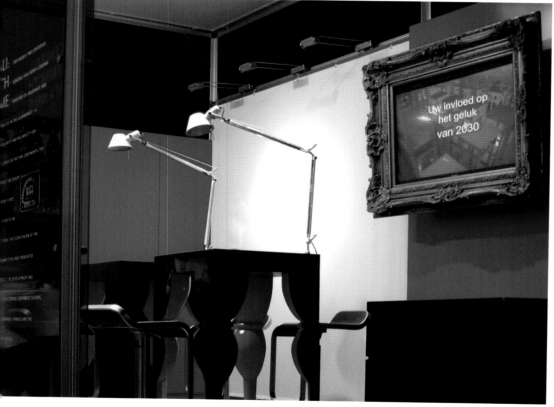

Year	**2005**
Location	**Apeldoorn**
Trade Fair	**Branchedag**
Exhibitor	**Generali Verzekeringsgroep, Diemen**
Architect	**Richard Schipper**
Size	**24 m²**
Realisation	**Veenstra CCO, Wolvega**
Stand Construction and Technical Services	**Veenstra CCO, Wolvega**
Presentation Systems	**Burkhardt Leitner**
Lighting	**Burkhardt Leitner/Lumiance**
Graphics/Communication	**TDM, Muiderberg**
Photos	**TDM, Willemken Schouten**

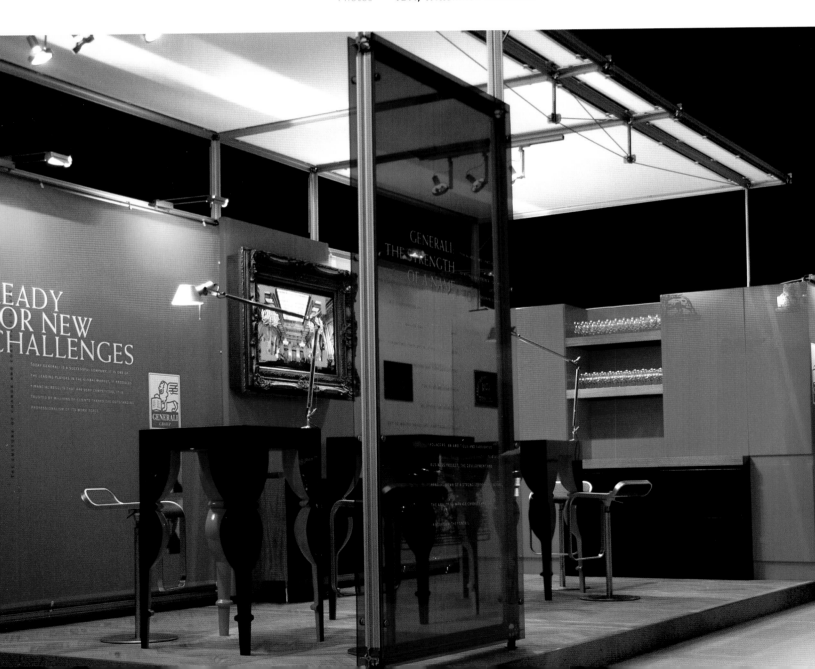

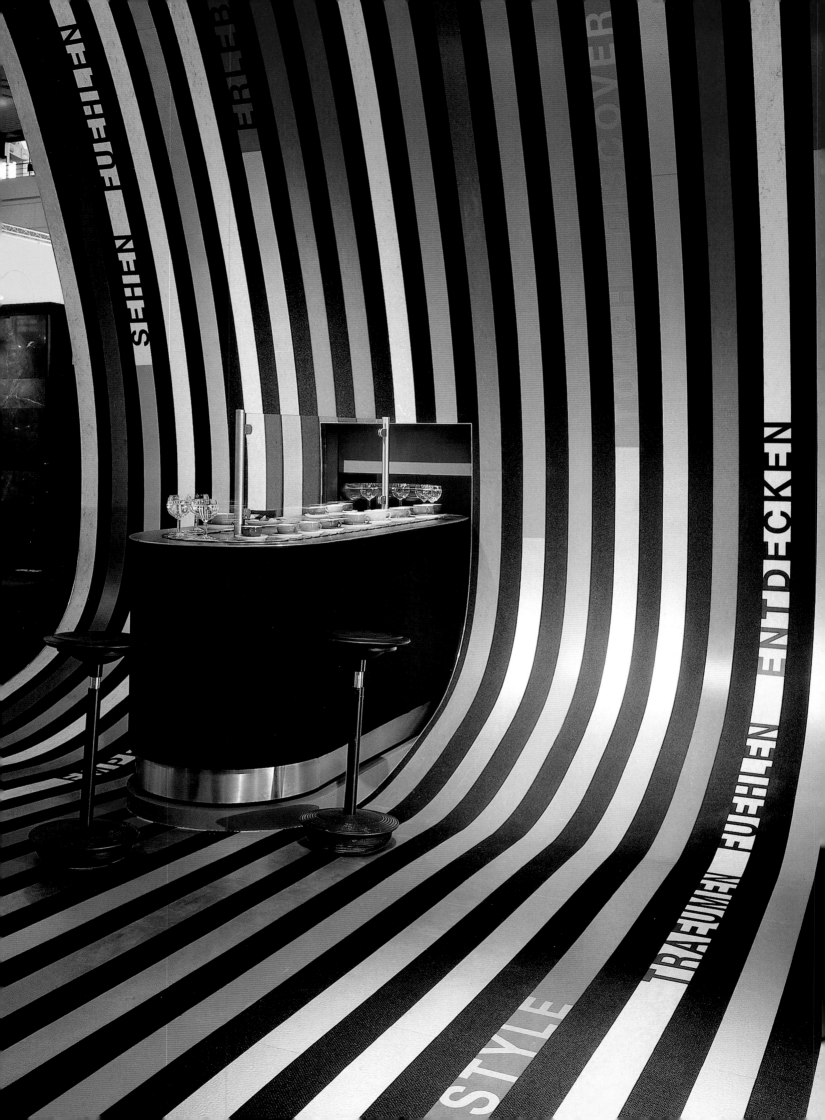

Riding the Wave

Wellenreiten

schindlerarchitekten
for Armstrong DLW

schindlerarchitekten
für Armstrong DLW

"Vasisdas" is the French word for a skylight or flap that allows the person inside to see who or what is outside without opening the door. The term comes from the German "was ist das?" and was probably coined in the seventeenth century when what was outside the door was probably foreign and unfriendly. In more peaceful times the opening merely offers a useful, completely private glimpse of the outside world, but something of the surprise and excitement in the word remains.

"What IS that?" was probably a question heard often enough at Domotex, from visitors to the Armstrong stand. This black box with a curving wave taken out of it makes a stunning visual statement, colourful, abstract, daring. It is a three-dimensional piece from a giant jigsaw, extraordinarily tactile, and wholly beguiling. In fact made of wood, it seems to have been shaped in a single scoop from some exotic substance.

Ein „vasistas" ist in Frankreich ein Oberlicht oder aber ein Klappfenster, durch das man sehen kann, wer oder was draußen steht, ohne die Tür öffnen zu müssen. Der Begriff leitet sich vom deutschen „was ist das?" ab und ist vermutlich schon seit dem 17. Jahrhundert in Gebrauch. Damals war das, was draußen vor der Tür stand, in aller Regel fremd und feindlich. In Friedenszeiten bietet so ein Fenster einen nützlichen, ganz privaten Blick in die Außenwelt. Allein der Begriff hat sich eine gewisse Aura der Überraschung und Spannung bewahrt.

„Was ist das?" dürfte auch die Frage gewesen sein, die Armstrong-Mitarbeiter bei der Domotex von Standbesuchern am häufigsten zu hören bekamen. Der schwarze Kasten mit der ausgestanzten Welle setzt einen verblüffenden optischen Akzent und vermittelt eine bunte, abstrakte, plakative Botschaft. Wie ein riesiges plastisches Puzzleteil reizt das Gebilde unwillkürlich zum Anfassen und fasziniert. Es besteht aus Holz, scheint jedoch in einem Stück aus irgendeinem exotischen Stoff gemacht zu sein.

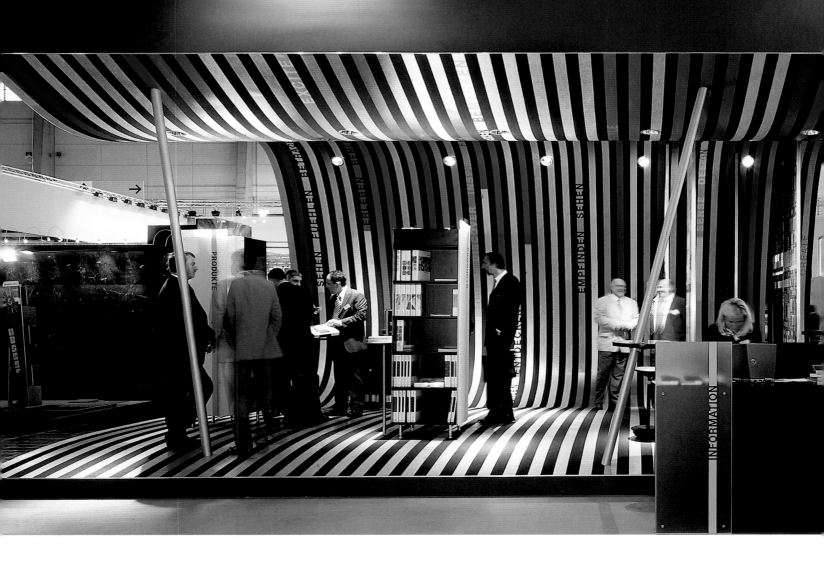

The bands of colour highlight the internal form, set off by the black exterior. One's immediate temptation is to climb inside, find out what it is all about.

Armstrong are in the floor coverings business, but it is almost a disappointment to find that such an expressive object is in fact about anything. Except of course, that a client who could have the boldness to commission such a breathtakingly original design is probably involved in creative and exciting products as well.

Die Farbstreifen heben das Innere gegen die schwarze Außenseite ab. Man bekommt sofort Lust, hineinzusteigen und zu erkunden, worum es eigentlich geht.

Armstrong stellt Fußbodenbeläge her. Mit einer gewissen Enttäuschung nimmt man zur Kenntnis, dass ein so ausdrucksvolles Objekt überhaupt für irgendetwas steht – bis man darauf kommt, dass eine Firma, die ein so gewagtes, atemberaubend originelles Design in Auftrag gibt, sehr wahrscheinlich selbst kreative, aufregende Dinge produziert.

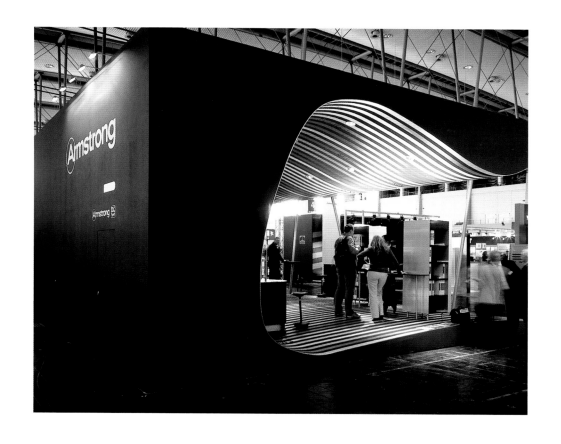

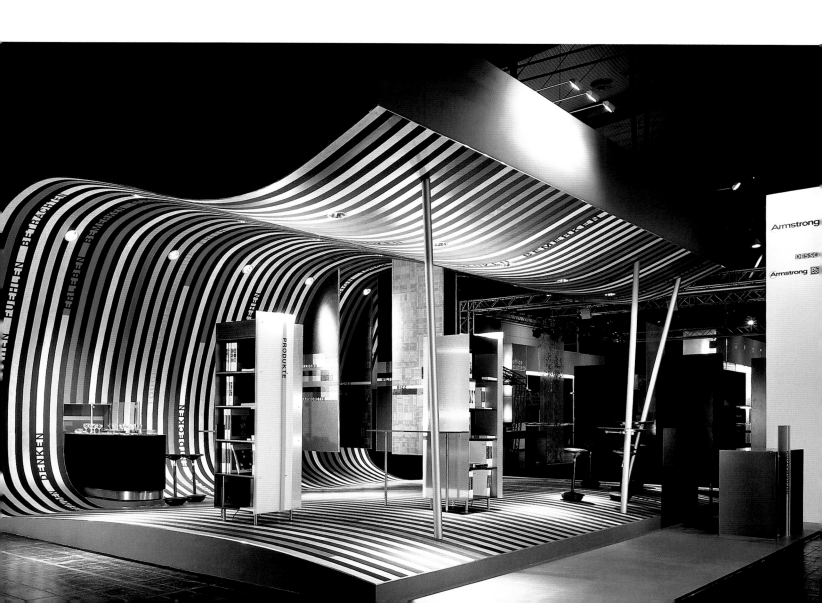

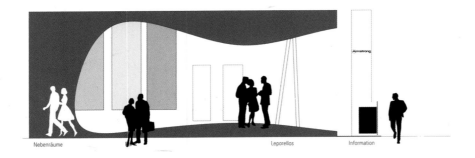

Nebenräume Leporellos Information

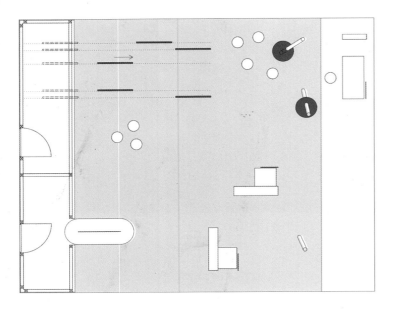

Year	**2006**
Location	**Hanover**
Trade Fair	**Domotex**
Exhibitor	**Armstrong DLW AG, Bietigheim-Bissingen**
Architecture/Design	**schindlerarchitekten, Stuttgart:** **Project Architect: Christine Witte**
Communication/Design	**Ine Ilg, Büro für Kommunikation und Gestaltung, Munich and Aalen**
Size	**80 m²**
Realisation	**MDL, Trebur-Grebenstein**
Lighting	**TLD Planungsgesellschaft, Wendlingen**
Photos	**Werner Huthmacher Photography, Berlin**

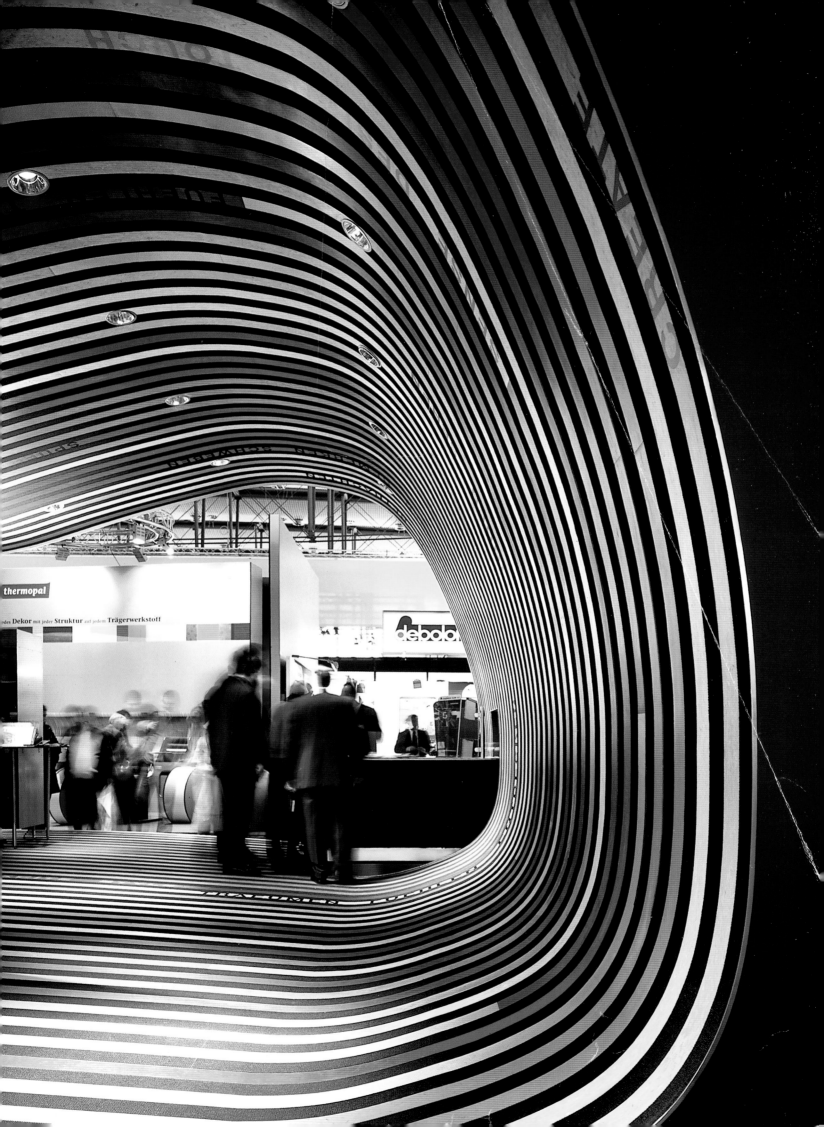

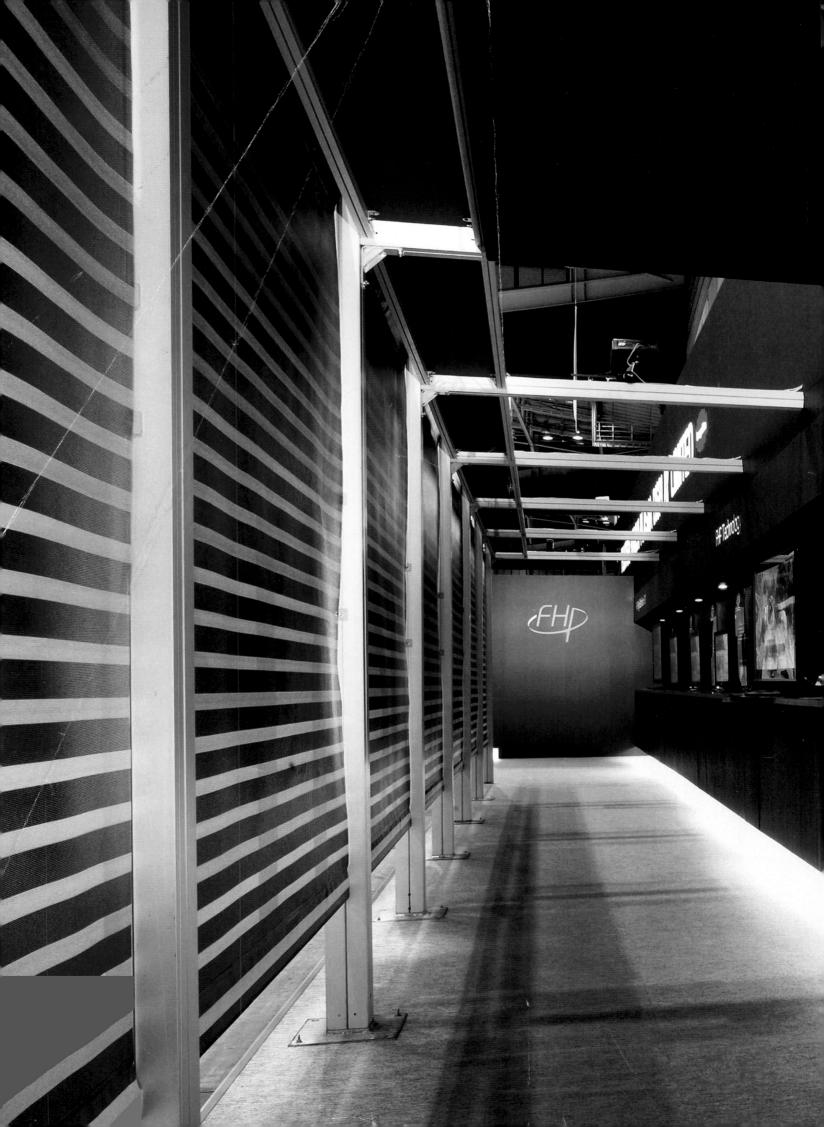

Wall to Wall

Von Wand zu Wand

Murayama
for Fujitsu Hitachi Plasma Display

Murayama
für Fujitsu Hitachi Plasma Display

When Elton John was touring in America some years ago he was invited to meet the legendary American actress Mae West. He and his entourage were shown by her butler into the all-white salon in her Los Angeles hotel, and invited to sit on a row of gilt chairs set along one wall. The double doors opposite then opened and Mae West appeared, dressed in a white ball gown, with a cry of "My, wall to wall men!"

The same idea, without the innuendo, lies behind Ai Minegishi's design for this simple longitudinal stand for FHP. The stand consists of two parallel walls. The outer one provides the visitor with general information about the products on a row of display screens, the inner one – the back of the stand – creates a working space for more detailed discussions and the presentation of more complex information.

Elton John erhielt vor einigen Jahren anlässlich einer Amerika-Tournee Gelegenheit, die US-Filmlegende Mae West kennenzulernen. Ihr Butler führte Elton und Gefolge in den komplett weiß ausgestatteten Salon ihres Hotels in Los Angeles und bat die Gäste, auf Barocksesseln Platz zu nehmen, die an einer Wand aufgereiht standen. Die Flügeltür gegenüber öffnete sich, Mae West erschien in einem weißen Ballkleid und rief aus: „Fabelhaft – eine ganze Wand voller Männer!"

Dieser Grundgedanke, wenn auch ohne den Hintergedanken, bildet die Basis für Ai Minegishis Design für diesen schlichten längsrechteckigen Stand für FHP. Der Stand besteht aus zwei parallelen Wänden. Die äußere bietet dem Besucher auf einer Reihe von Bildschirmen allgemeine Informationen über die Produkte, während die innere, die zugleich die Rückwand des Standes darstellt, einen Besprechungsraum für intensivere Diskussionen und die Präsentation komplexerer Informationen schafft.

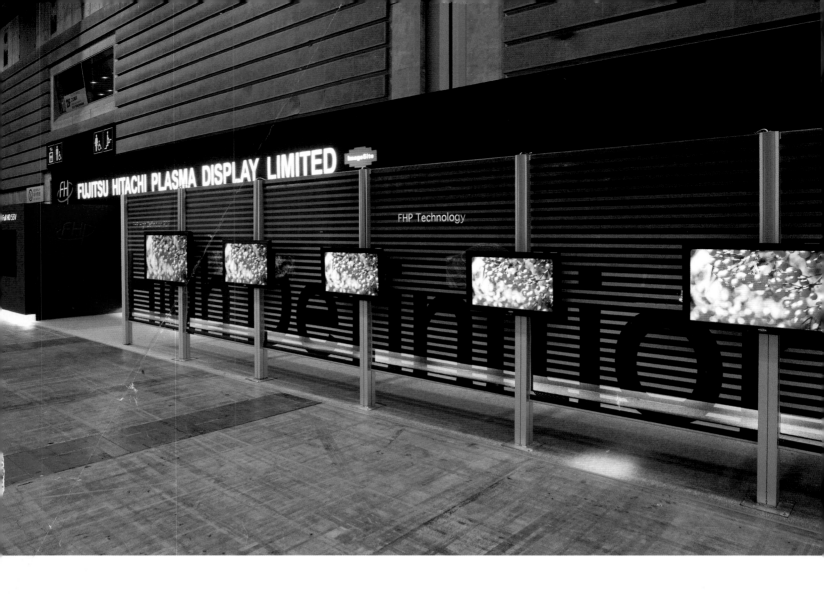

The black overall finish accents the professional nature of the products, and the absence of strong colours also enhances the viewer's appreciation of the quality of the images on screen putting them at the heart of the stand.

Die durchweg schwarz gehaltenen Oberflächen unterstreichen den professionellen Charakter der Produkte. Gerade aufgrund des Verzichts auf grelle Farben kommt die Bildqualität der Monitore besser zum Tragen; sie werden so zum Herzstück des Standes.

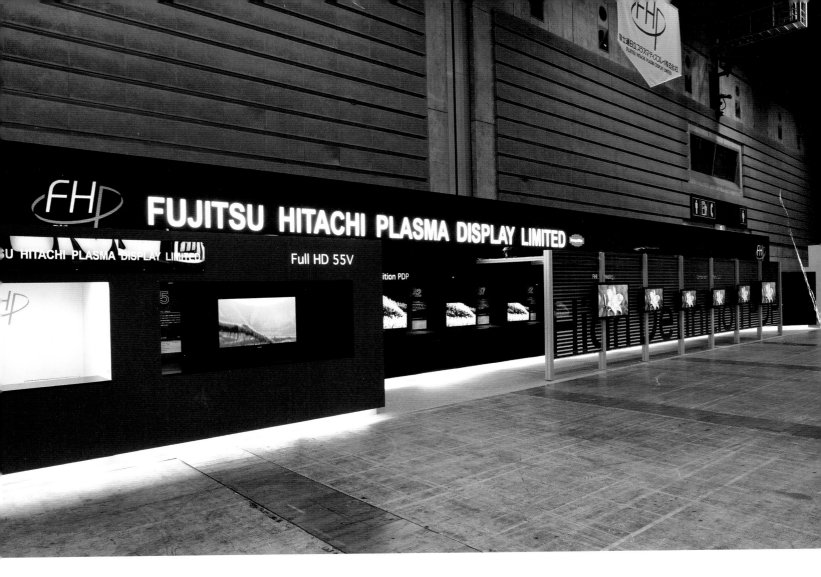

Year	**2005**
Location	**Yokohama**
Trade Fair	**FPD International**
Exhibitor	**Fujitsu Hitachi Plasma Display Limited**
Architect	**MURAYAMA INC., Tokyo: Director: Chiaki Hakata; Designer: Ai Minegishi**
Size	**90 m²**
Realisation	**MURAYAMA INC., Tokyo**
Photos	**Koichiro Itamura, J-Lights**

Getting Feedback
Intelligente Visionen

Schusterjungen und Hurenkinder
for Epson Europe Electronics

Schusterjungen und Hurenkinder
für Epson Europe Electronics

Feedback used to be a problem, an interference with the operation of a system. But today the positive qualities of feedback in electronic circuits is recognised, and it is a central constituent of many electronic devices, one of the key functions that merits many of them being given the name "intelligent." This seemingly straightforward stand focuses on such devices, including displays, quartz devices and semi-conductors. A blue and white colour scheme is used throughout, blue for walls and white for floor in general, with clear wall-mounted equipment on display. Except in the centre of the stand, where the theming in the lounge area changes from blue to orange, and a white sign on the orange wall above a meeting table asks "what's your vision?"

Feedback galt früher in der EDV als Problem, weil es den kontinuierlichen Systembetrieb behinderte. Heute ist man sich der positiven Seiten von Rückmeldungen durchaus bewusst, und bei vielen elektronischen Geräten bilden gerade sie eine der Schlüsselfunktionen, die manche davon als „intelligent" ausweisen. Dieser scheinbar geradlinige Stand konzentriert sich auf solche Geräte, darunter Displays, Quarze und Halbleiter. Die Farbstellung ist durchweg blau-weiß: blaue Wandflächen und weiße Böden, wandmontierte Ausstellungsgeräte in klaren Formen. Einzige Ausnahmen sind die Standmitte, wo das Farbschema von Blau zu Orange wechselt und der weiße Schriftzug an der orangefarbenen Wand über dem Besprechungstisch, der den Besucher fragt: „What's your vision?"

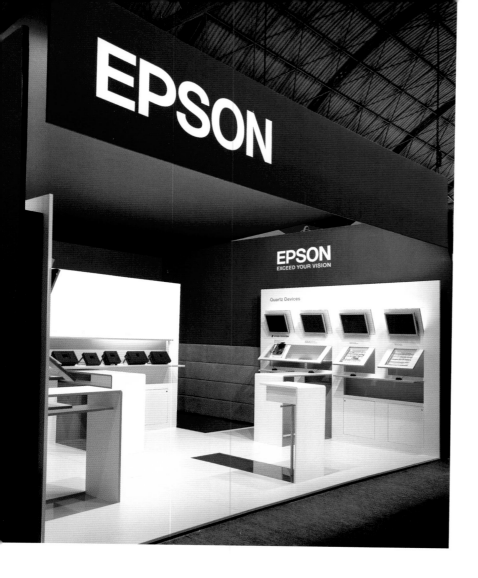

This simple device changes the stand from being an information source for visitors, important as that is, to becoming a centre for discourse between visitors and the client. By getting the visitor involved in dialogue, by providing a forum for feedback, the stand itself becomes an intelligent event.

Dieser einfache Trick verwandelt den Stand von einer – sicherlich wichtigen – Informationsquelle in einen zentralen Ort des Austauschs zwischen Besuchern und Aussteller. Indem er den Besucher in einen Dialog einbindet, schafft der Stand ein Forum für Feedback und ist insofern selbst ein „intelligentes" Konstrukt.

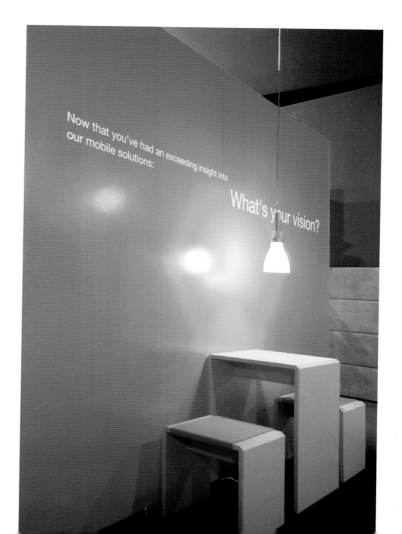

Year	2006
Location	Barcelona
Trade Fair	3GSM World Congress
Exhibitor	EPSON EUROPE ELECTRONICS GmbH, Munich
Architecture/Design	Schusterjungen und Hurenkinder GmbH, Munich
Size	36 m²
Stand Construction and Technical Services	stagegroup GmbH
Photos	Schusterjungen und Hurenkinder GmbH, Munich

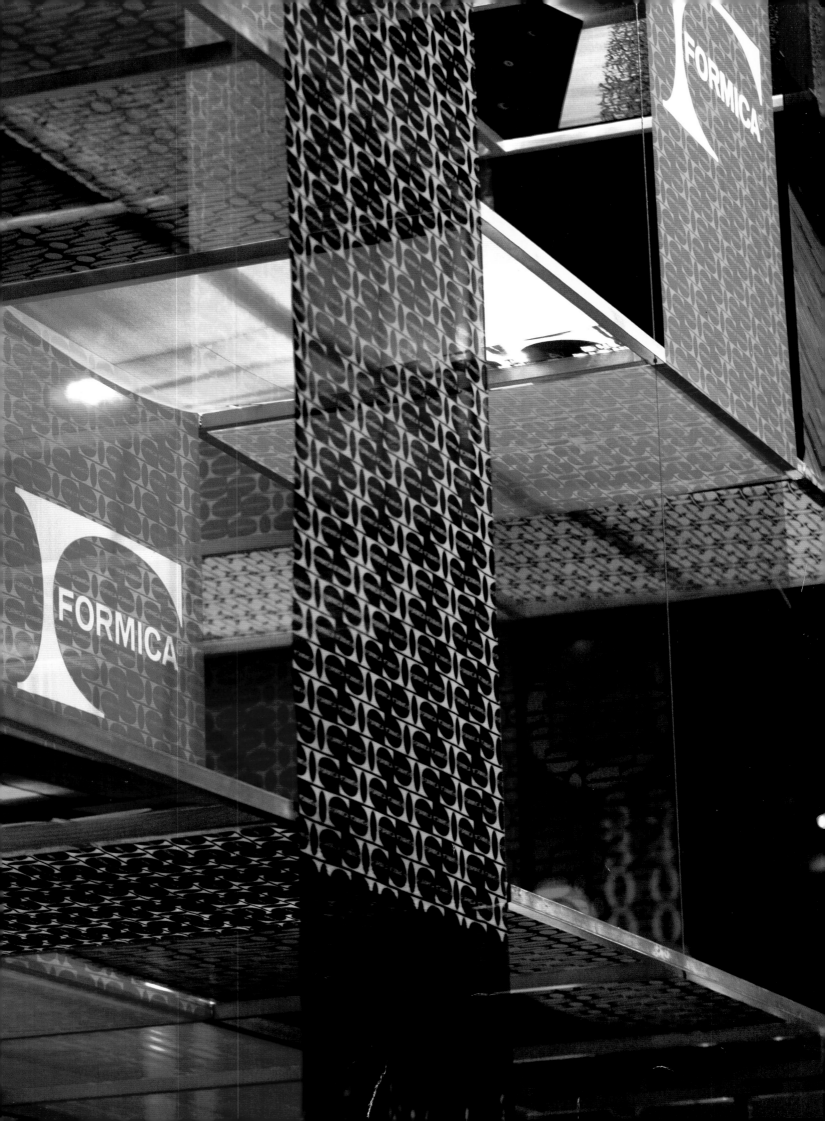

Caught in the Net

Netz-Werk

Kuhlmann Leavitt
for Formica Corporation

Kuhlmann Leavitt
für Formica Corporation

Formica is an established, robust and versatile surfacing product with a long history. It's a product widely used in the hospitality industry for its reliability and design range. It is so familiar that the name has almost become generic. That's the problem: reminding people about a familiar product is a lot harder than telling them about something new.

For the Hospitality Design Expo in Las Vegas, Kuhlmann Leavitt designed a stand to catch the visitor's eye and bring them in. The "working area," as it were, simply consists of two square table tops covered with a grid of photographs, texts and product samples.

Formica ist der seit langem etablierte Markenname eines widerstandsfähigen, vielseitigen Oberflächenmaterials. Wegen seiner Robustheit und breiten Produktpalette wird der Werkstoff vor allem im Gaststättengewerbe eingesetzt. Er ist heute so bekannt, dass sich der Name Formica im englischen Sprachraum für das Material an sich durchgesetzt hat (vergleichbar mit Resopal®). Doch gerade das macht die Sache problematisch: den Leuten ein vertrautes Produkt in Erinnerung zu bringen ist viel schwieriger, als ihnen etwas Neues vorzustellen.

Für die Hospitality Design Expo in Las Vegas ließ sich Kuhlmann Leavitt einen Stand einfallen, der den Besucher durch sein auffälliges Design anlockte. Die „Arbeitsfläche" besteht nur aus zwei quadratischen Tischplatten mit einem Gitternetz von Fotos, Texten und Produktmustern.

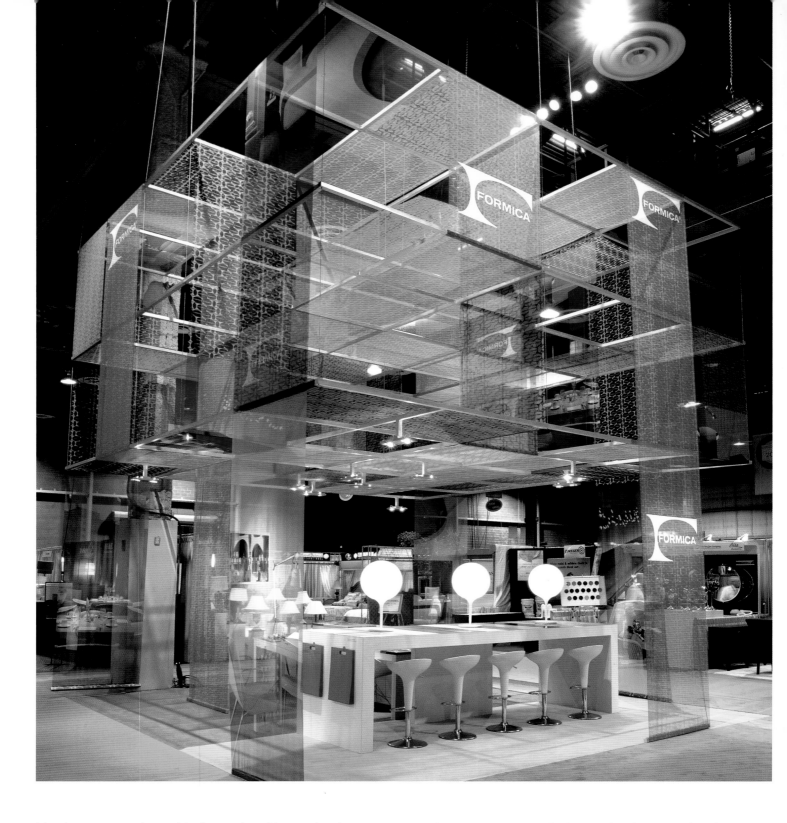

It's what goes on above this that makes this stand so interesting. An open lattice metal grid above the stand supports banners with the corporate logo and a series of mesh banners that are strung between different levels of the grid and the ground, creating a pattern of colour and movement that is entertaining and intriguing. The design is also contrived so that it appears different from each approach to the square stand, an aerial sculpture that marks out Formica's space, lit by downlighters within the mesh. This is one of a series of stands that Kuhlmann Leavitt have designed for Formica in recent years, and its maturity and assurance reflect the value of this ongoing relationship between designer and client.

Viel interessanter ist jedoch, was darüber vor sich geht: An einem offenen Metallgerüst waren Banner mit dem Firmenlogo gespannt, und zwischen dem Gerüst und dem Fußboden hingen in unterschiedlichen Höhen diverse Gittergewebebahnen, deren Farben und Bewegungen ein abwechslungsreiches, faszinierendes Muster bildeten. Der Stand ist bewusst so angelegt, dass er von allen vier Seiten anders aussieht, wie eine über der ganzen Standfläche in der Luft hängende Skulptur, die von Tiefstrahlern zwischen den Gewebebahnen angeleuchtet wird. Der Stand gehört zu einer Reihe, die Kuhlmann Leavitt in den letzten Jahren für Formica gestaltete. Sein ausgereifter, selbstsicherer Charakter spiegelt die hervorragende langjährige Beziehung zwischen Designer und Kunde.

Year	2005
Location	Las Vegas
Trade Fair	Hospitality Design
Exhibitor	Formica Corporation, Cincinnati
Architect	Kuhlmann Leavitt, Inc., St. Louis: Deanna Kuhlmann-Leavitt, Monica Goldsbury
Size	121.92 m²
Graphics	Kuhlmann Leavitt, Inc., St. Louis
Photos	Gregg Goldmann Photography

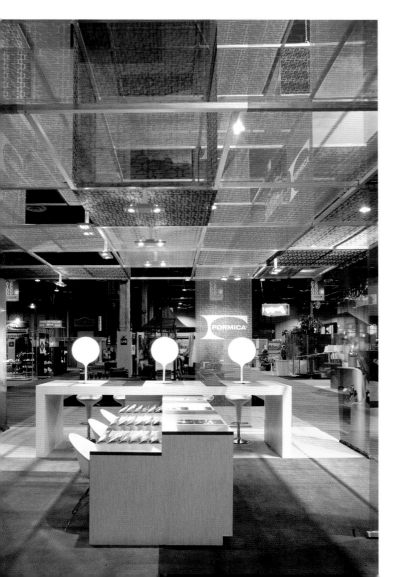

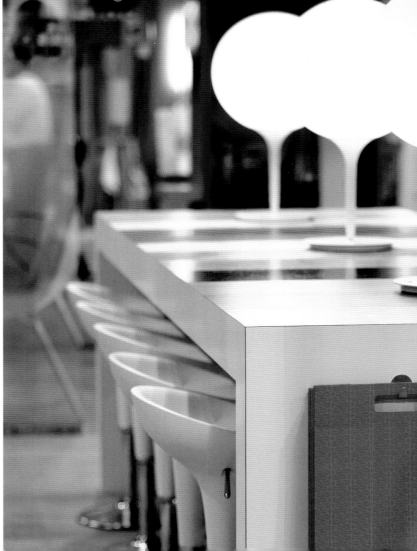

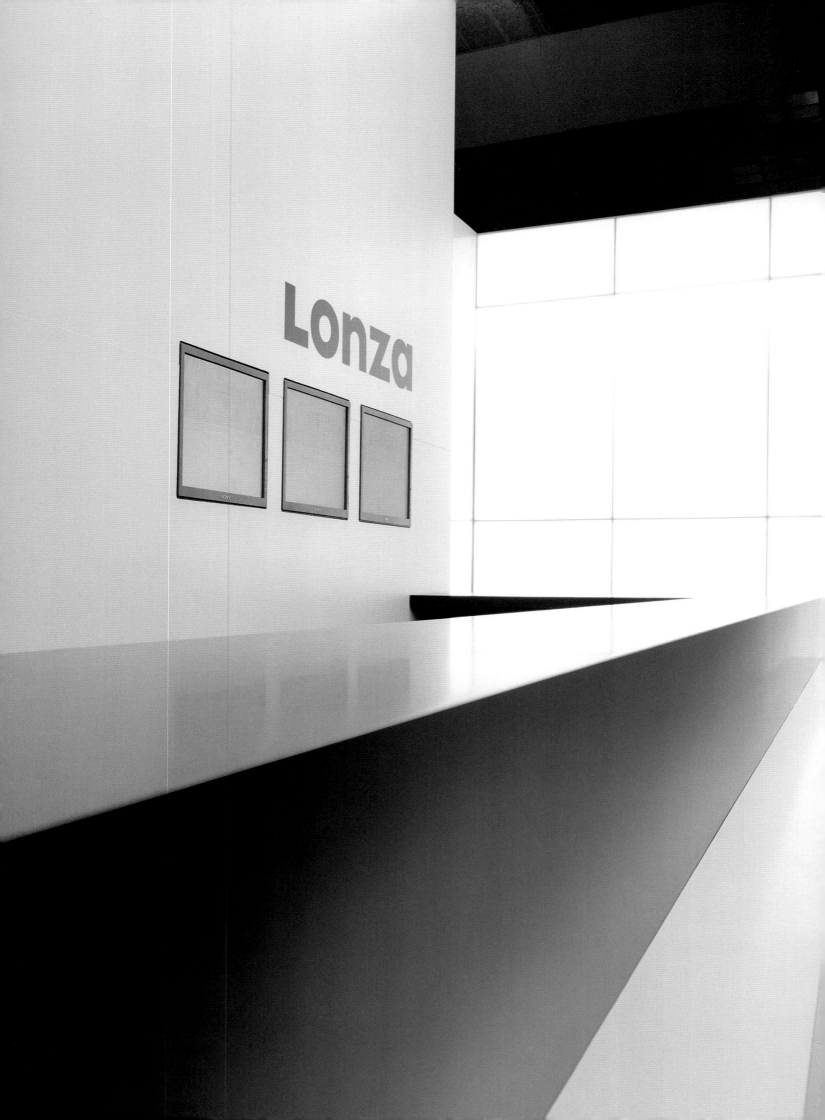

Clear Outlines
Klare Linien

Ueberholz
for Lonza

Ueberholz
für Lonza

The pharmaceutical and biotechnology company Lonza takes its name from the River Lonza in Switzerland, on whose banks the original company was founded in 1897. Independently listed on the Swiss stock exchange since 1999, the company plays an innovative and important role in the life sciences industry, with research facilities and plants around the world.

The stock images for such companies are researchers in white coats peering down microscopes, complex and sanitised equipment, or pictures of products. Such images are supposed to reinforce our ideas of rigour, research, awareness and responsibility on the part of the corporation involved. But it could be argued that such images have become banal through familiarity, and subverted by horror movies and science fiction stories in which the word scientist is commonly preceded by "mad".

Das Pharma- und Biotechnologieunternehmen Lonza ist benannt nach dem Schweizer Fluss, an dessen Ufer die Firma 1897 gegründet wurde. Die Lonza Group ist seit 1999 unabhängig an der Schweizer Börse notiert und spielt dank ihrer weltweiten Forschungslabors und Produktionsstätten eine wichtige innovative Rolle in der Biowissenschaftsindustrie.

Für Unternehmen wie Lonza bieten sich konventionelle Archivfotos mit weiß bekittelten, in Mikroskope spähenden Forschern, blitzsauberen komplexen Anlagen und Geräten oder den Produkten an. Solche Bilder sollen Vorstellungen von strengem Forschergeist, Umsicht und Verantwortungsbewusstsein des Unternehmens wecken, wirken jedoch gerade wegen ihrer Vertrautheit eher schon banal. Visionen von größenwahnsinnigen Wissenschaftlern, wie sie durch Horrorfilme und Science-Fiction-Romane geistern, machen solche Bilder noch zusätzlich heikel.

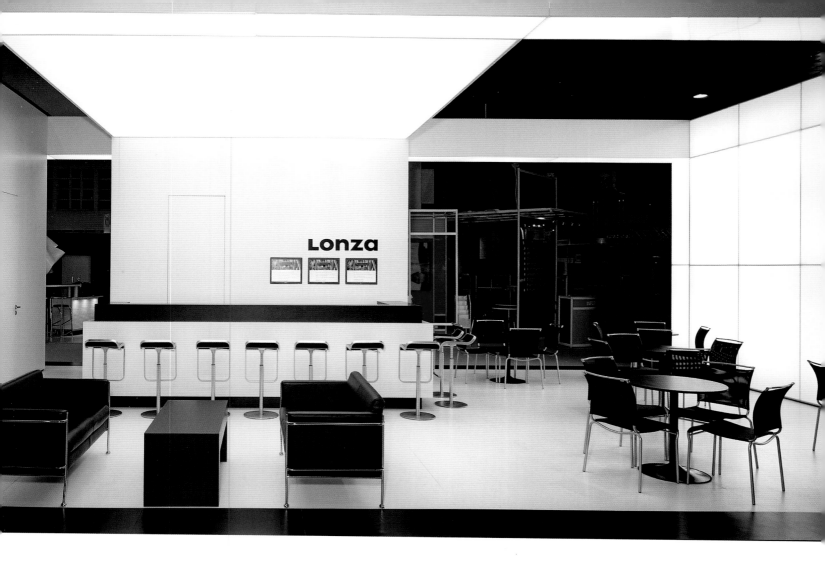

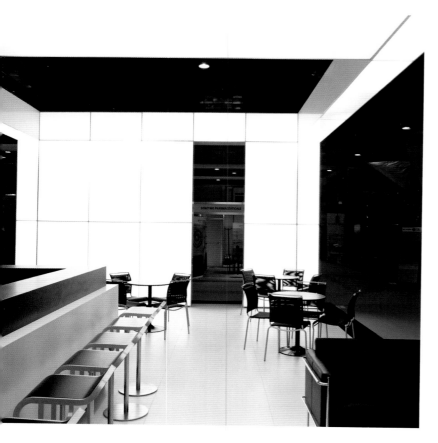

Ueberholz, in creating this small stand, used a different vocabulary to express the qualities of discipline, thoroughness and probity that are central to Lonza. The architect, Bernardo Tribolet, used the visual language of classic monochromatic Modernism to express the corporation's values: minimal decoration, no fuss, elegant and practical comfort in the seating, clear and well lit walls and well-proportioned entrances and other elements. More of a shell than a stand.

Um die Lonza-Qualitäten Disziplin, Gründlichkeit und Integrität zu vermitteln, setzte Ueberholz deshalb bei diesem kleinen Stand auf ein ganz anderes Vokabular. Für die Kernwerte des Unternehmens griff der Architekt Bernardo Tribolet auf die visuelle Sprache des klassisch monochromen Modernismus zurück, etwa mit einem Minimum an Dekoration, schnörkelloser Eleganz und zweckmäßiger Bequemlichkeit der Sitzgelegenheiten, hellen, gut beleuchteten Wänden und schön proportionierten Eingängen. Das Ergebnis ist mehr Rahmen als Stand.

Year	**2005**
Location	**Paris**
Trade Fair	**Convention on Pharmaceuticals Ingredients**
Exhibitor	**Lonza AG, Basle**
Architect	**Tribolet arch, Basle; Ueberholz GmbH, Wuppertal**
Size	**112 m^2**
Realisation	**Ueberholz GmbH, Wuppertal**
Lighting	**Tribolet arch, Basle; Ueberholz GmbH, Wuppertal**
Graphics/Communication	**Tribolet arch, Basle; Ueberholz GmbH, Wuppertal**
Photos	**Photoprop**

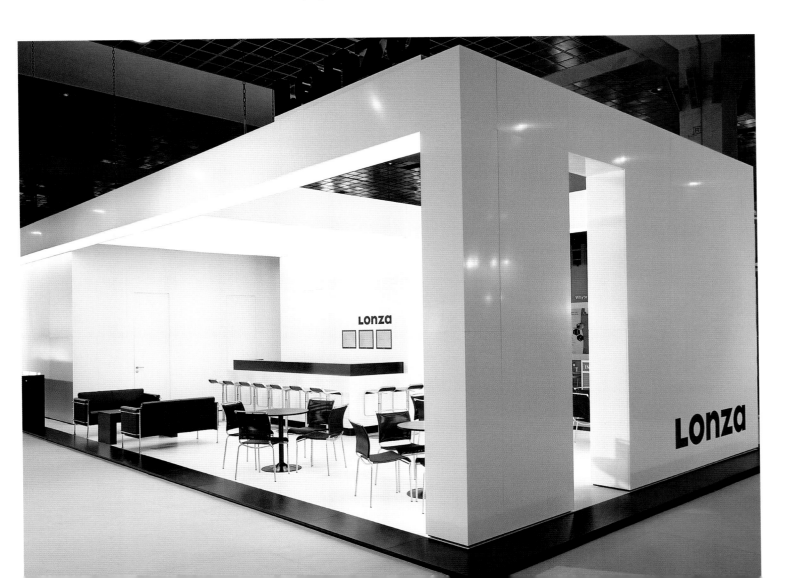

世界 ————————

MITSUBISHI
三菱電機
Changes for the Better

MITSUB
Changes for

Enter here

Bitte eintreten

Murayama
for Mitsubishi

Murayama
für Mitsubishi

Making a visitor feel welcome onto a stand is one thing, making the visitor feel special is another. The design team at Murayama dealt with this issue by making the entrance to the stand into a highly visible feature, a broad carpeted pathway across the whole width of the stand, past a row of display screens on each side to a wide screen at the end. The architectural form of the entrance itself is borrowed from traditional Japanese architecture, but finished in modern materials.

Within the curved cross-beams of the entrance, lights change in colour from blue to white, emphasising the strapline for the stand "changes for the better."

Standbesuchern das Gefühl zu vermitteln, willkommen zu sein, ist nicht schwer. Viel schwieriger ist es, den Besuch als besonderes Erlebnis auszuweisen. Das Murayama-Designteam löste dieses Problem, indem es den Standeingang zu einem weithin sichtbaren Signal machte. Der mit Teppichboden ausgelegte breite Gang zog sich quer durch den ganzen Stand zwischen zwei Reihen von Bildschirmen hindurch bis zu einer Breitleinwand am anderen Ende. Die architektonische Form des Eingangs selbst war an traditionelle japanische Bauweisen angelehnt, jedoch aus modernen Werkstoffen gefertigt.

Unter dem geschwungenen Holm schaltete die Lichtfarbe von Blau nach Weiß und ließ den Slogan des Stands –„changes for the better" – klar hervortreten.

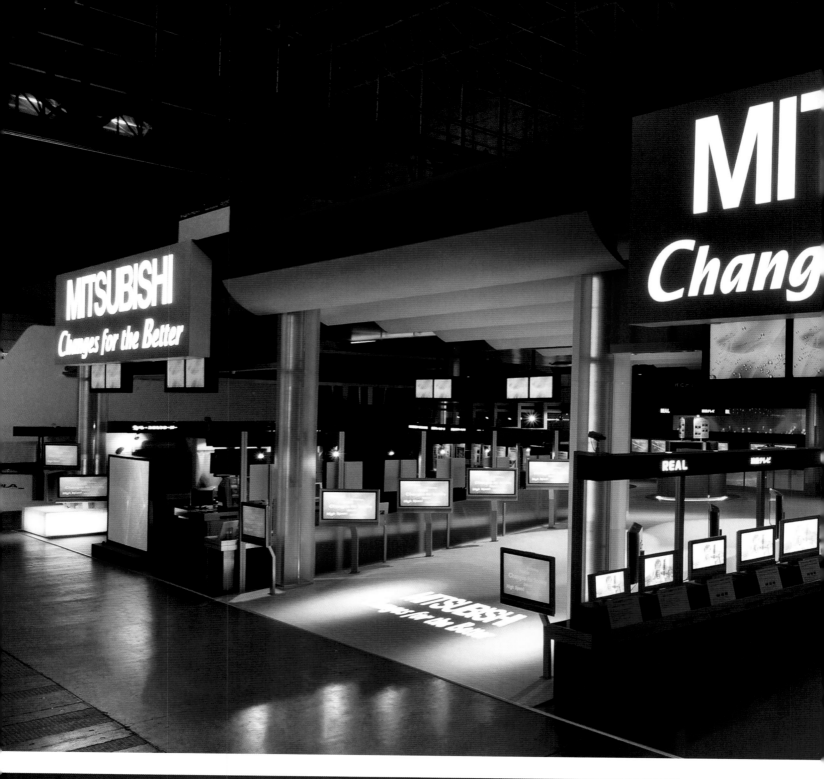
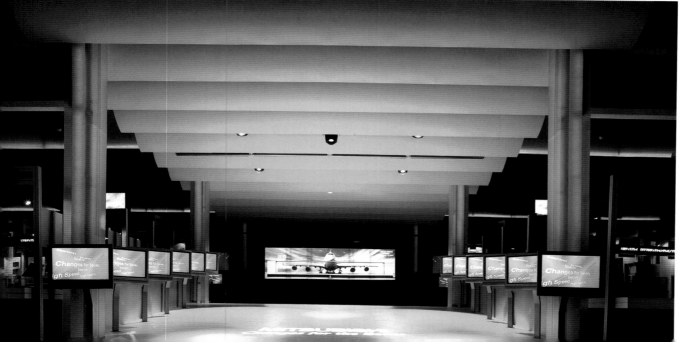

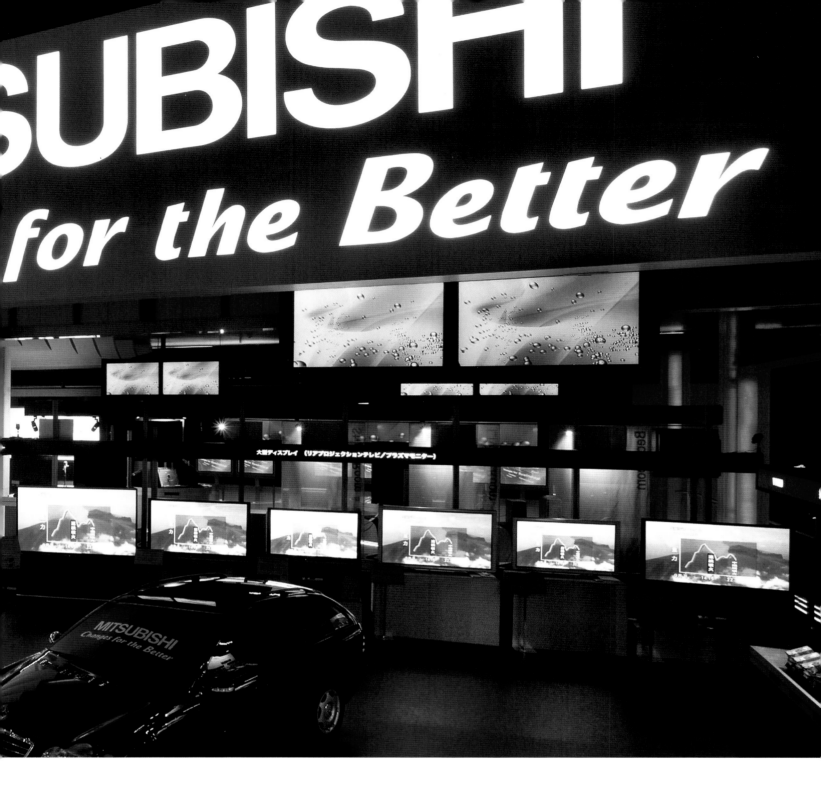

The rest of the stand is occupied by vehicle displays, lit in the main from a further series of large display screens mounted behind the vehicles. The combination of a traditional form with contemporary information technology makes an apt, positive and strong statement about the brand and its products.

Auf der übrigen Standfläche waren Fahrzeuge verteilt, die vorwiegend von einer weiteren Reihe Bildschirme dahinter beleuchtet wurden. Die Kombination aus traditionellen Formen und zeitgenössischer Informationstechnologie machte eine treffende, klare und prägnante Aussage über die Marke und die dazugehörigen Produkte.

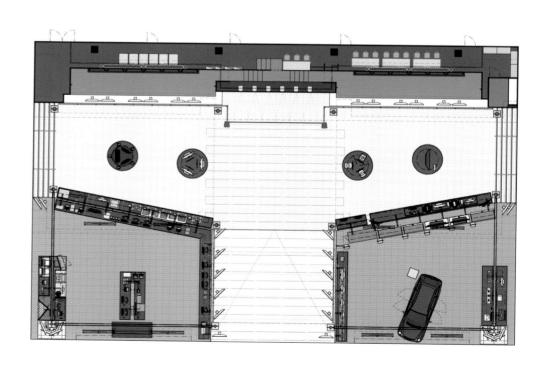

Year	**2004**
Location	**Makuhari Messe, Chiba**
Trade Fair	**CEATEC Japan**
Exhibitor	**Mitsubishi Electric Corporation**
Architect	**Murayama Inc., Koraku, Bunkyo-ku, Tokyo:** **Fumiyoshi Sato, Hiromi Murakami;** **Direction: Takaharu Kato**
Producer	**Hidehiro Katsumata**
Size	**540 m²**
Realisation	**Murayama Inc., Koraku, Bunkyo-ku, Tokyo**
Presentation Materials	**FUJIART, INC., Tokyo: Yusuke Konishi**
Photos	**Koichiro Itamura, J-Lights**

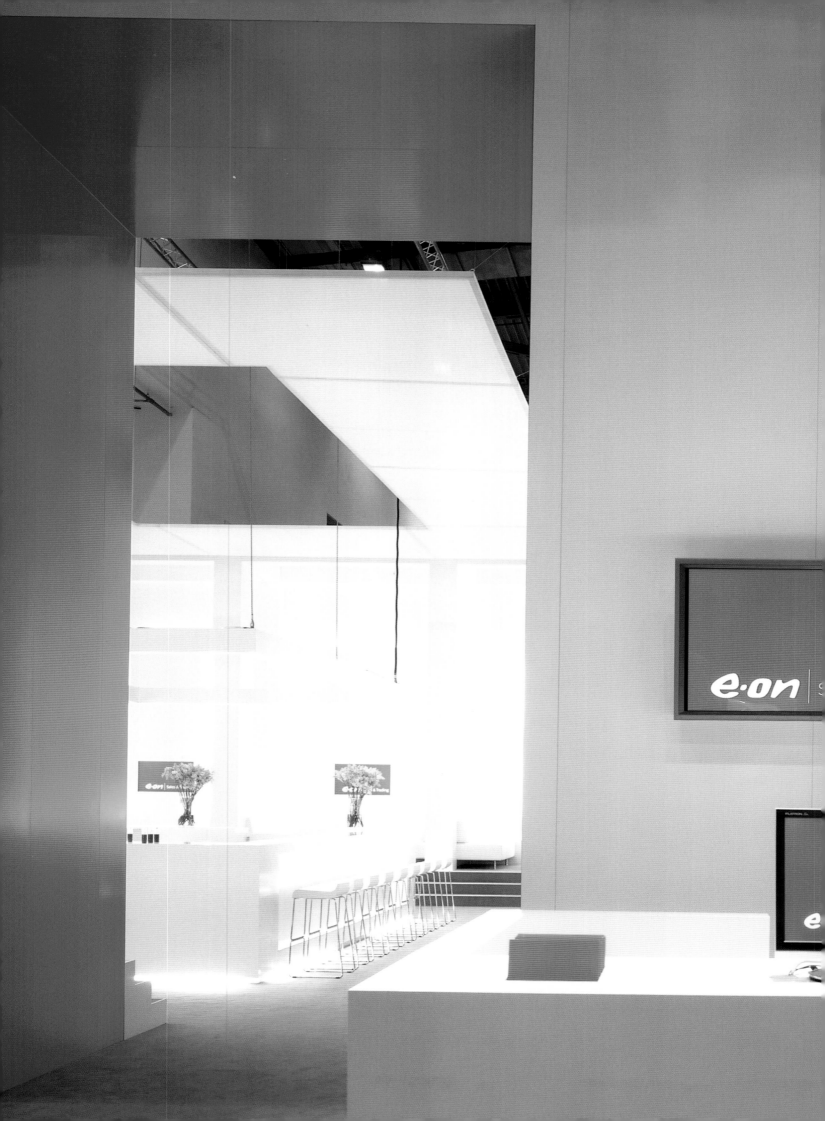

Making an Entrance

Rot und Weiß

avcommunication
for E.ON Sales & Trading

avcommunication
für E.ON Sales & Trading

Corporate colours can be a challenge or an opportunity for the stand designer. They can overpower a design or enhance it. E.ON, an energy company, uses white and a strong red as the colours on its logo: a neat statement of new energy appropriate to the brand. The aim for this stand at the E-world energy & water in 2006 was a forum for meeting existing and new customers, around a large bar area in the centre of the stand and in a suite of twelve meeting rooms around the edges of the stand. Access to the bar area was through a large rectangular entrance, set back from the leading edge of the stand alongside a reception desk. A further L-shaped desk at the corner of the stand created an information area for other visitors.

Konzernfarben können für den Messedesigner Herausforderung oder Chance sein. Sie können ein Design übertönen oder in seiner Wirkung unterstreichen. Der Energiekonzern E.ON verwendet bei seinem Logo Weiß und leuchtendes Rot, die für neue Energie stehen. Der Stand bei der E-world energy & water 2006 war als Forum für Gespräche mit bestehenden und neuen Kunden ausgelegt, sowohl mit dem großen Barbereich in der Standmitte als auch einer Folge von zwölf Besprechungsräumen entlang den Standrändern. Zur Bar gelangte man durch einen großzügigen rechteckigen Eingang, der sich hinter der Außenkante der Standfläche neben dem Empfangstresen öffnete. Ein zweiter, L-förmiger Tresen an der Ecke des Standes diente als Info-Zentrum für die übrigen Besucher.

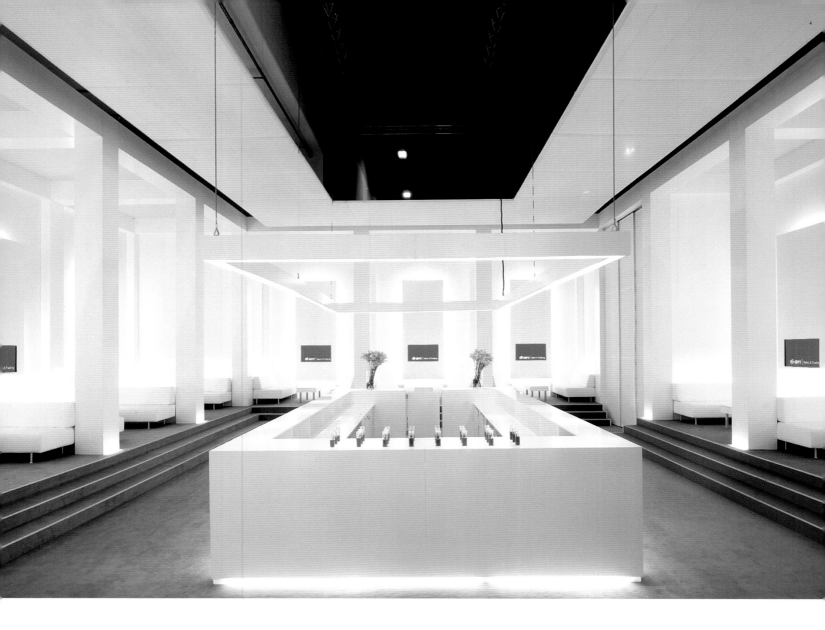

The stand is rectolinear, with high white exterior walls and red detailing. The entranceway is almost as long as it is wide, making it into a formal passage between interior and exterior, with a suitably imposing high ceiling. The ceiling and internal walls are painted in red, again a way of heightening the importance of the change from public to private space. This is a very effective use of the corporate colour scheme, as can be seen if one imagines the colours reversed – a red exterior and a white opening would not have sent the same message of presence and authority, indeed would have seemed rather flashy on the outside and dull on the interior. The white theme in the actual design is carried through into the interior for the bar and seating, and creates a sense of contemporary lightness.

Der Stand ist rechteckig mit hohen weißen Außenwänden und roten Details. Der Eingangsbereich ist fast so lang wie breit und wird dadurch zu einer imposanten Passage zwischen innen und außen mit eindrucksvoll hoher Decke. Decke und Innenwände sind rot gestrichen und betonen damit ebenfalls die Bedeutung des Übergangs vom öffentlichen zum privaten Raum. Die Umsetzung des konzerninternen Farbschemas ist in diesem Fall sehr gelungen. Das wird klar, wenn man sich die Farbstellung umgekehrt vorstellt – eine rote Außenseite mit weißem Eingang würde nicht in demselben Maße Präsenz und Autorität evozieren, sondern hätte von außen großspurig und von innen fade gewirkt. Das Thema „Weiß" findet sich im Innern auch bei den Tresen und den Sitzgelegenheiten wieder und schafft eine Atmosphäre moderner Helligkeit und Leichtigkeit.

Year	**2006**
Location	**Essen**
Trade Fair	**E-world energy & water**
Exhibitor	**E.ON Sales & Trading GmbH, Munich**
Architect	**avcommunication GmbH, Ludwigsburg/ Munich: Project Managers: Nikola Wischnewsky, Kerstin Dreibach; Architects: Adrian von Starck, Andreas Olbrich**
Size	**399 m²**
Realisation	**Raumtechnik GmbH**
Interactive/Communication	**avcommunication GmbH, Ludwigsburg/ Munich: Sonja Westfeld, Markus Mögel**
Photos	**Roland Halbe, Stuttgart**

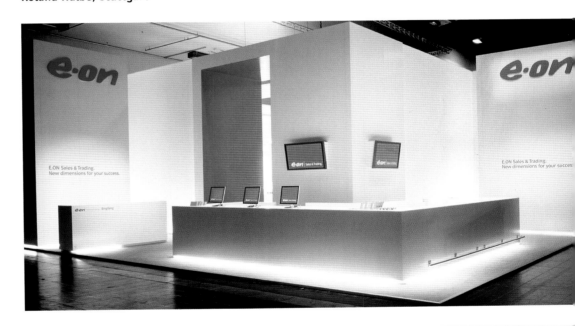

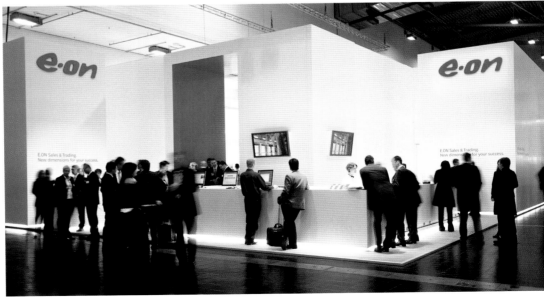

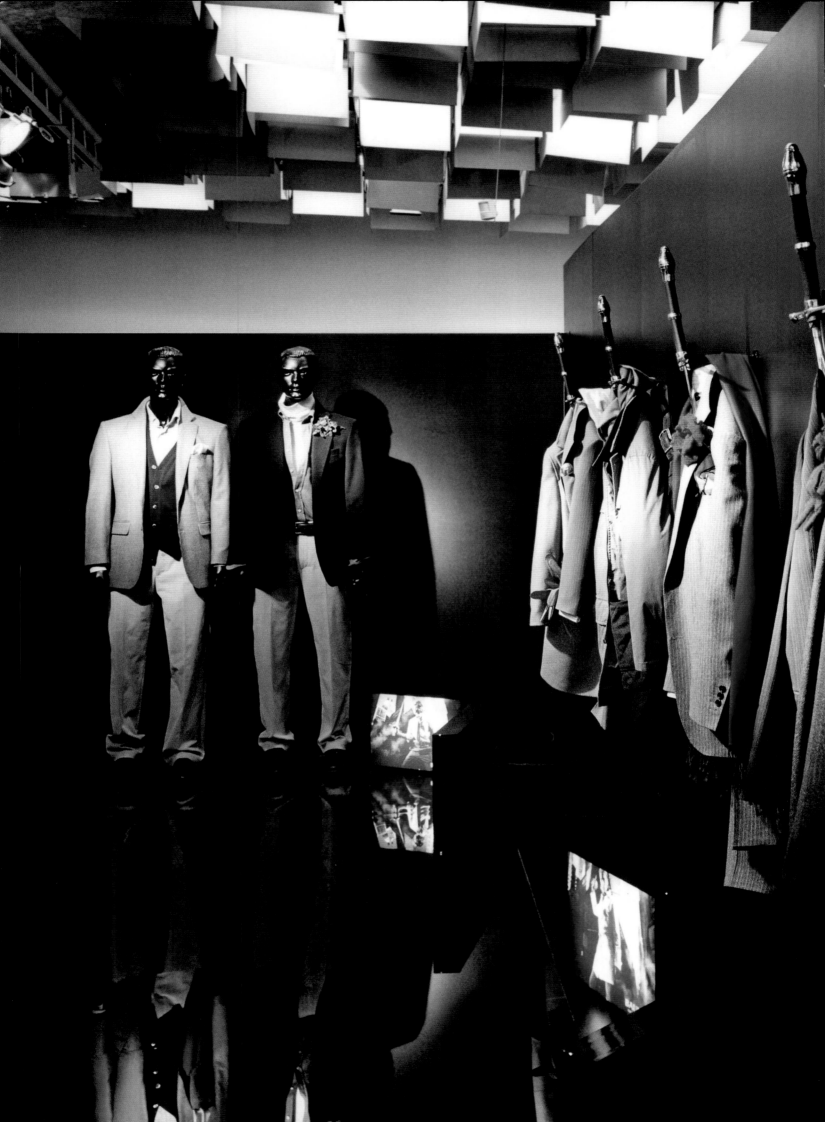

Lifestyle

"Se fossi la regina del paese della cuccagna, per me esisterebbero solo crêpes con la marmellata!"

Lisa, 4 anni

...queen of Lu...
only...

...here would...
...lade pancakes to eat!"

Lisa, 4 years old

«La sera prima del suo sessantacinquesimo compleanno il re Costantino Panciagrossa si tolse la corona davanti ai suoi tre figli, sbattendola sulla tavola rumorosamente approfondato per la cena. "Ne ho le tasche piene", esclamò scaramante afferrando al volo un pollo arrosto, addentandolo subito dopo con estrema voluttà. Ai tre principi caddero le posate dalle mani per lo stupore. "Di che?" chiesero meravigliati. "Di governare!", rispose Costantino Panciagrossa masticando rumorosamente.

Every Picture tells a Story
Individuelle Küchen

D'art Design Gruppe
for Alno

D'art Design Gruppe
für Alno

Markets that are highly structured require an in-depth approach. Kitchen equipment is layered from the basic and functional to the celebrity chef endorsed. Placing a range of new products therefore requires considerable preparation and groundwork. To present Alno AG at the prestigious Eurocucina event, D'art Design decided on a narrative approach. "A lot of the competitors," Freddy Justen explains, "rely on their established reputations and just show their products in a neutral context. We felt that would not be sufficient."

Instead, for each of the four kitchen systems on display the designers also described an owner, the kind of person who might have selected the kitchen, and whose interests and ideas were presented visually in an anteroom space to each setting.

Durchstrukturierte Märkte erfordern einen sehr umsichtigen Ansatz. Bei Küchenausstattungen finden sich alle Ebenen von funktionalen Basics bis zur Starkoch-Empfehlung. Um eine neue Produktpalette zu lancieren, ist deshalb einige Vorarbeit zu leisten. Für die Präsentation der Alno AG bei der renommierten Eurocucina entschied sich D'art Design für ein narratives Konzept. „Viele Mitbewerber", erläutert Freddy Justen, „verlassen sich auf ihren guten Ruf und zeigen lediglich ihre Produkte in einem neutralen Kontext. In unseren Augen reicht das nicht."

Stattdessen erfand man für jedes der vier ausgestellten Küchenprogramme einen Besitzer – jemanden, der sich genau diese Küche ausgesucht haben könnte und dessen Interessen und Vorstellungen man in einem Vorraum zu jedem Standbereich visualisierte.

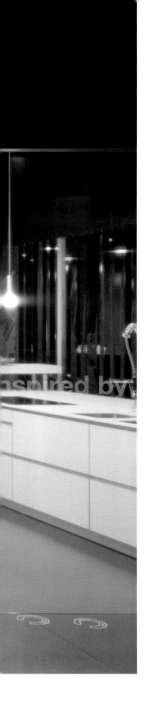

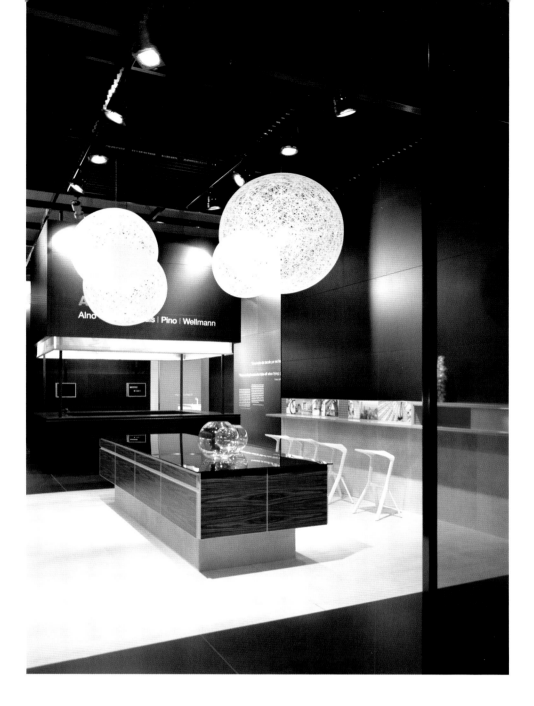

From the exterior of the membrane it was these keynotes that were visible: the mountain bike ridden by the architect, the children's brightly coloured Wellington boots, each leading into the appropriate space through marks (tyre or foot and dog in these cases) on the floor. (The other settings were for a music lover and an outdoor person.)

Von der Außenseite der Membran fielen diese Erkennungszeichen als Erstes ins Auge, etwa das Mountainbike des Architekten oder die bunten Kindergummistiefel. Auf deren „Fährten" auf dem Boden – in diesem Fall Reifenspuren bzw. Fußabdrücke von Stiefeln und Hund – wanderte der Besucher in die dazugehörige Küche (die anderen beiden Räume gehörten einem Musikliebhaber und einem Outdoor-Fan).

Giving each of the kitchens a personality in this way helped visitors create their personal narratives of the event, and provided a framework for their judgement of the products on show, by putting them into a credible social context. And this was achieved through a simple, established routine, of not taking your outdoor things into the kitchen.

Jede Küche erhielt so eine persönliche Rahmenhandlung, die der Besucher mühelos mit eigenen Geschichten füllen konnte. Die glaubwürdigen sozialen Kontexte der Küchen ergaben Bezugsrahmen für die Beurteilung der ausgestellten Produkte. D'art Design erzielte das durch den Rückgriff auf die gute alte Sitte, dass Fahrräder, Hunde und Gummistiefel draußen bleiben müssen.

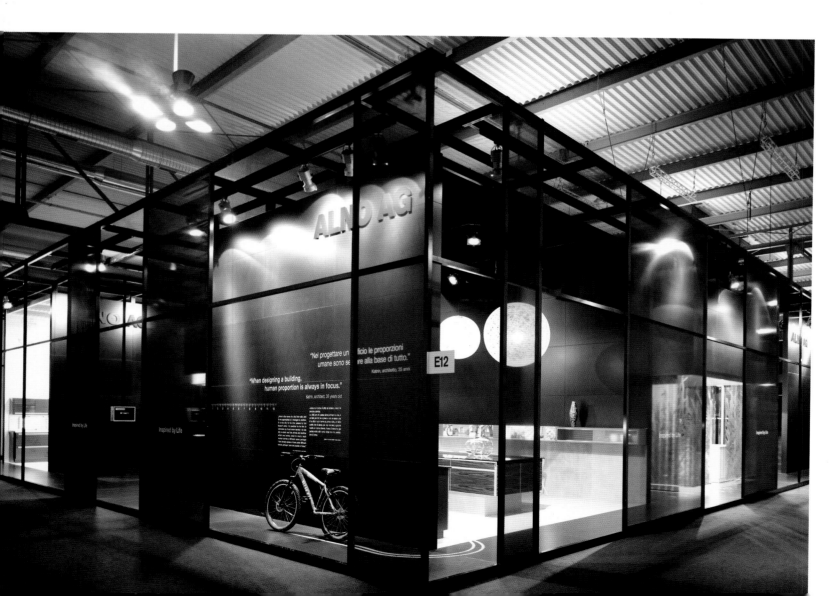

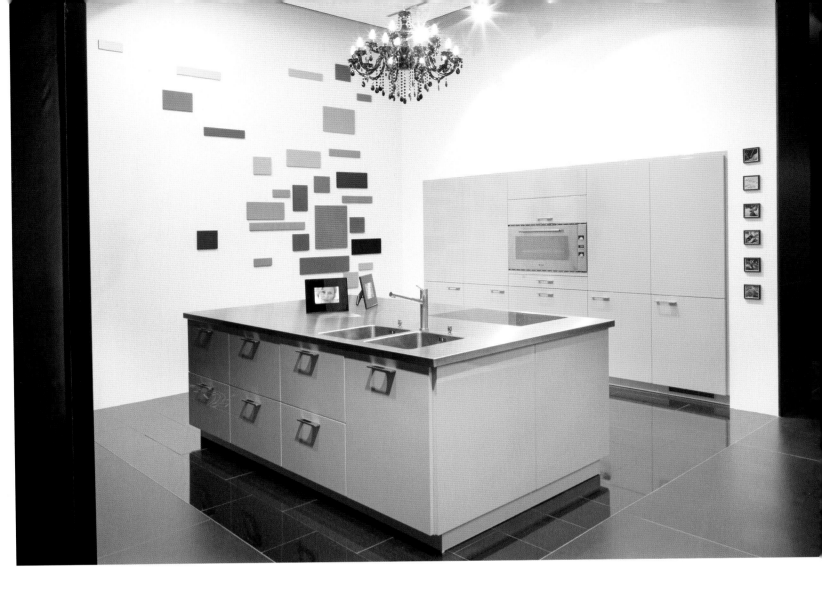

Year	**2006**
Location	**Milan**
Trade Fair	**Eurocucina**
Exhibitor	**ALNO AG, Pfullendorf**
Architect	**D'art Design Gruppe, Neuss**
Size	**478 m²**
Realisation	**ACES Realisation GmbH, Neuss**
Lighting	**D'art Design Gruppe, Neuss**
Graphics/Communication	**D'art Design Gruppe, Neuss**
Photos	**Jörg Hempel, Aachen**

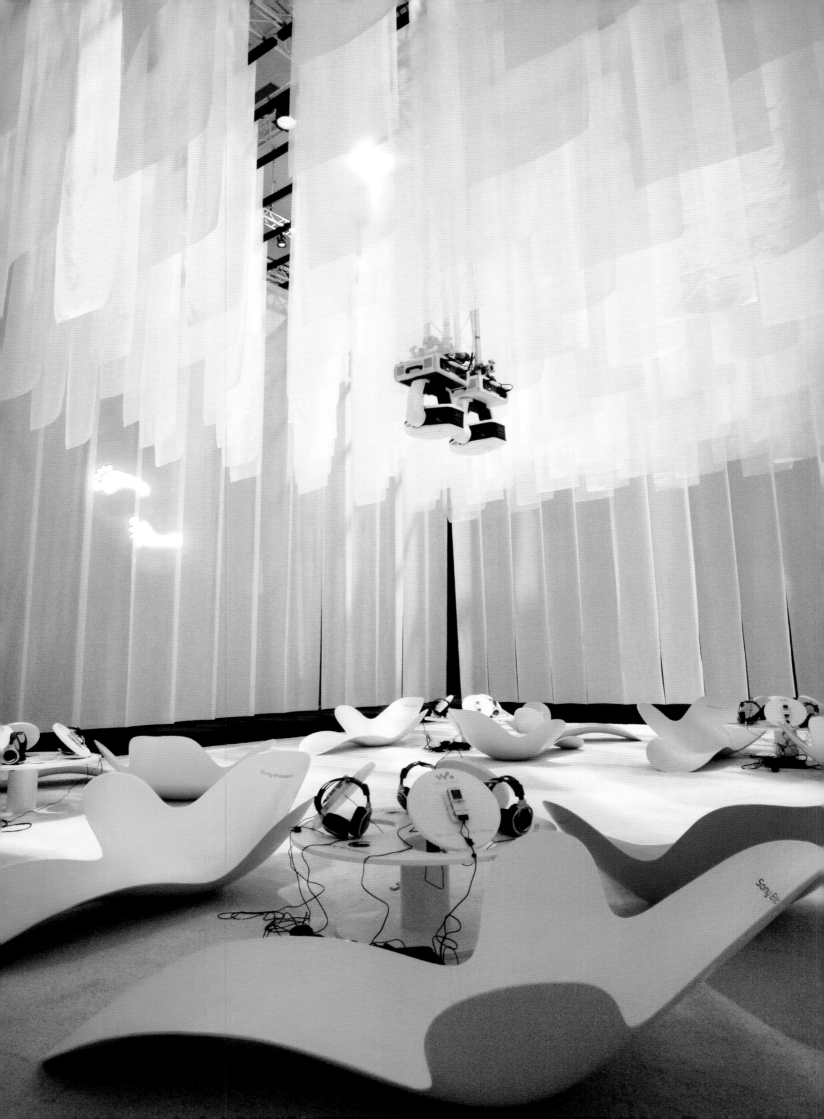

No Hands on Deck

Autonom

Design Company Agentur
for Sony

Design Company Agentur
für Sony

The task facing the Design Company for Sony's participation in the 2005 IFA fair was to set Sony apart from the competition, true to the motto "like.no.other". Instead of emphasising the technical side of things, the designers decided to put the focus on experiencing the brand – entertainment was the key here. The visitor was incorporated in a multimedia happening, different light moods and colours and of course music set the scene for the possibilities of digital technology. The central film room, which was devoted entirely to digital images, leads into another six rooms in which the visitor could, for instance, listen to music through headphones on a reclining chair or in "soundtubes".

Für den Messeauftritt auf der IFA 2005 hatte die Design Company die Aufgabe, Sony gemäß dem Motto „like.no.other" von seinen Wettbewerbern abzugrenzen. Anstatt den Schwerpunkt auf Technik zu legen, rückten die Gestalter das Erlebnis der Marke in den Mittelpunkt – Entertainment wurde großgeschrieben. Der Besucher wurde multimedial in das Geschehen einbezogen, unterschiedliche Lichtstimmungen und Farben und natürlich Musik setzten die Möglichkeiten digitaler Technik effektvoll in Szene. Um den zentralen Filmraum, der ganz den digitalen Bildwelten gewidmet war, gruppierten sich sechs weitere Räume. Hier konnte man beispielsweise auf Liegesesseln oder in „Soundtubes" über Kopfhörer Musik hören.

Access to the stand was also "different": from the exterior nothing was visible at all, except dense, suspended banners, to be traversed to reach the interior through a forest of strips, lit from overhead in different colours. On the inside the visitor could experiment hands-on with the products such as game devices, mobile phones, etc.

A big difference to the other stands was that there was not a single member of staff present. At first glance, creating an impenetrable, unmanned stand seems wholly unproductive. In fact precisely this concept turned out to be successful, for a number of reasons. By making the visitor penetrate the wall of the stand, the visit becomes a personal journey, more memorable for being undertaken alone. Letting the visitors find their own way to the different areas increases this sense of exploration, mirroring the way users interact with a new piece of equipment or accessories for the first time – by trying it out and seeing what it can do. And by letting the visitor try out the devices at his own pace the whole experience becomes an ultimate journey of discovery. And it is no surprise to discover that the stand design won a Gold iF Award as well as a red dot award.

„Anders" als üblich war der Zugang zum Stand: Von außen gab es im Grunde überhaupt nichts zu sehen als dichte, abgehängte Stoffbahnen, durch die man ins Innere gelangte – mitten durch einen ganzen Wald von Streifen, der von oben verschiedenfarbig angeleuchtet wurde. Innen konnten die Besucher mit den einzelnen Produktgruppen wie Spielkonsolen, Handys etc. hantieren und experimentieren.

Ein großer Unterschied zu anderen Messeständen bestand darin, dass kein einziger Mitarbeiter präsent war. Ein schwer zugänglicher, unbemannter Stand erscheint auf den ersten Blick eigentlich sinnlos, doch genau dieses Konzept erwies sich letztlich als erfolgreich, aus mehreren Gründen: Wenn ein Besucher erst durch eine Wand in den Stand eindringen muss, wird dies zu einem Erlebnis, das sich gerade deshalb besonders einprägt, weil er auf sich gestellt ist. Dass die verschiedenen Bereiche im Alleingang erkundet werden, vermittelt einen Hauch von Abenteuer und spiegelt genau die Art und Weise, wie sich Anwender mit einem neuen Gerät oder Zubehör vertraut machen (indem sie herumprobieren und schauen, was passiert). Und dadurch, dass der Standbesucher die Geräte ganz für sich im eigenen Tempo ausprobieren darf, wird das Ganze zur ultimativen Entdeckungsreise. Der Stand wurde mit einem iF Award in Gold und einem red dot award ausgezeichnet.

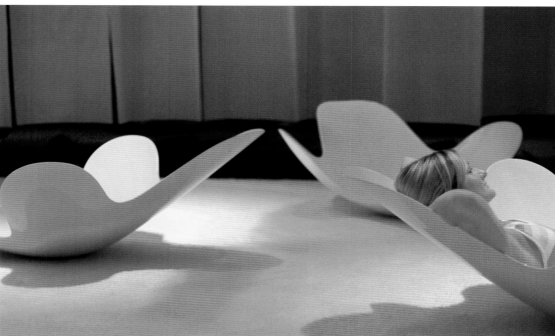

Year	**2005**
Location	**Berlin**
Trade Fair	**IFA**
Exhibitor	**SONY Deutschland GmbH, Cologne**
Architect	**Design Company Agentur GmbH, Munich**
Size	**3,800 m²**
Realisation	**Design Company Agentur GmbH, Munich**
Lighting	**Design Company Agentur GmbH, Munich**
Graphics/Communication	**Design Company Agentur GmbH, Munich**
Photos	**Michael Ingenweyen Fotografie, Munich**

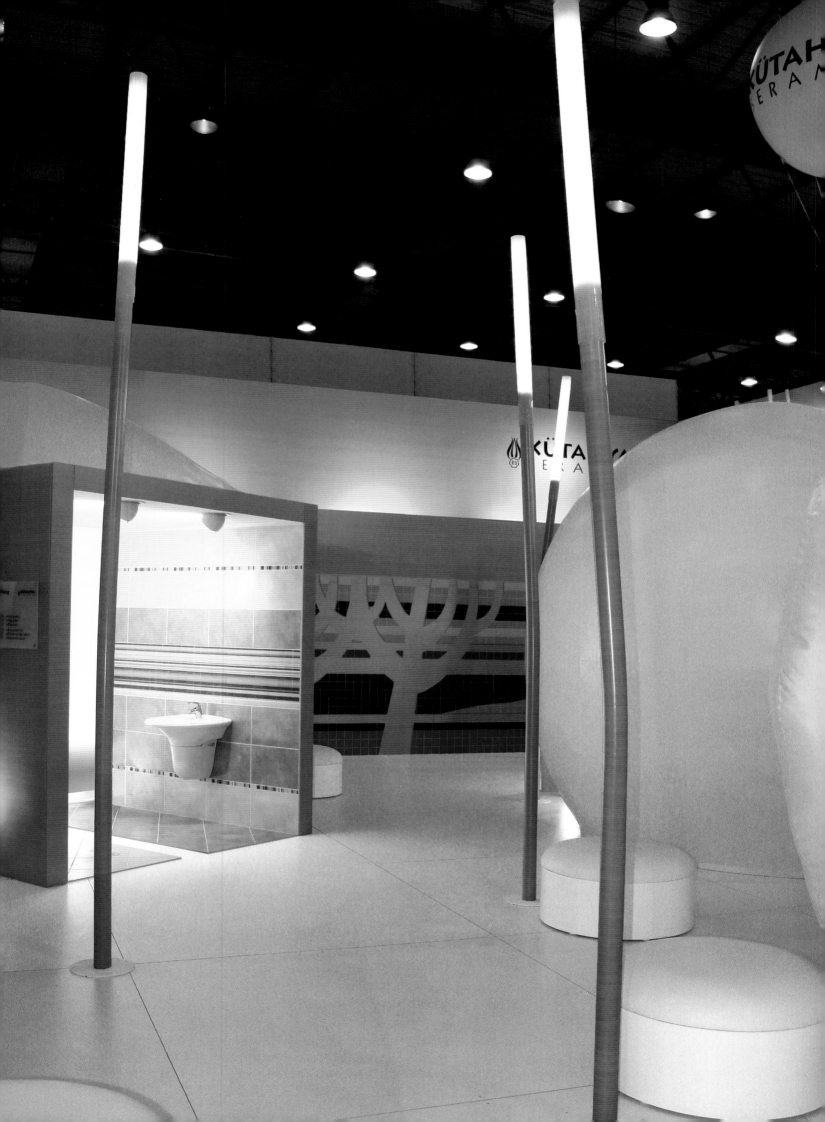

Play with Clay
Ton in Ton

Demirden Design
for Kütahya

Demirden Design
für Kütahya

Clay vessels are among the earliest artefacts of humankind, and clay was also the substrate for the first Sumerian marks that later developed into letters. It is thus a modest but potent substance. Clay pots have been made in Anatolia for millennia, and if today pottery manufacturing is an industrial process, it still retains a connection with the real and with the mysterious simplicity of putting fire to earth to create utility.

Demirden's stand for Kütahya uses a vocabulary of modern materials to convey these values. The all white exterior of the stand features formal tree shapes, also in white, together with natural wood light poles, under an external awning, while the main feature is the group of four domed structures, also in white with entrances faced in natural wood.

Tongefäße gehören zu den frühesten Handwerkserzeugnissen der Menschheit. In Tontäfelchen drückten die alten Sumerer ihre Keilschriftzeichen ein, aus denen später unsere Buchstaben wurden – ein bescheidenes Material mit großem Potential. In Anatolien stellt man seit Jahrtausenden Keramik her, und obwohl Töpferwaren heute industriell gefertigt werden, hat man dort den Bezug zu den Ursprüngen und zur ebenso simplen wie geheimnisvollen Praxis, aus Erde und Feuer Nutzgegenstände zu schaffen, noch lange nicht verloren.

Diese Werte setzte Demirden Design beim Kütahya-Stand in ein Vokabular moderner Materialien um. Der außen ganz in Weiß gehaltene Stand wies unter einer äußeren Markise stilisierte weiße Bäume in Verbindung mit hölzernen Lichtstelen auf. Hauptelement waren jedoch vier weiße Kuppelbauten, deren Eingänge mit Naturholz gerahmt waren.

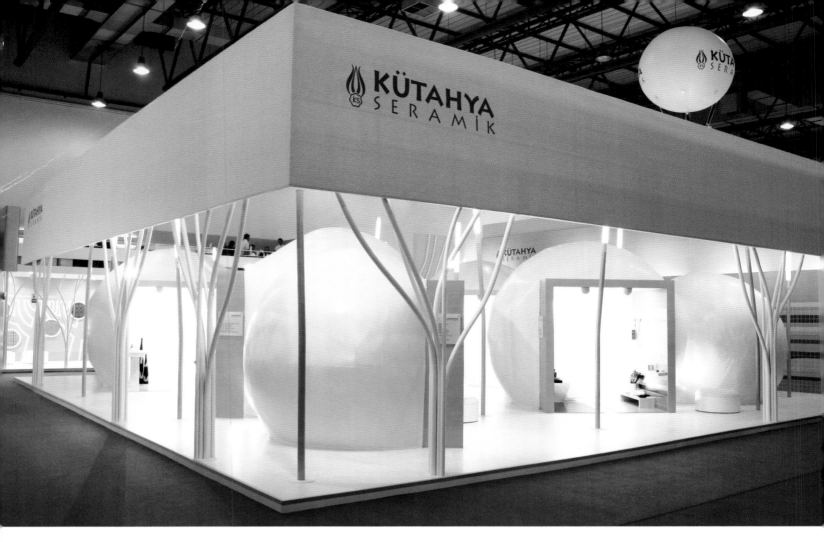

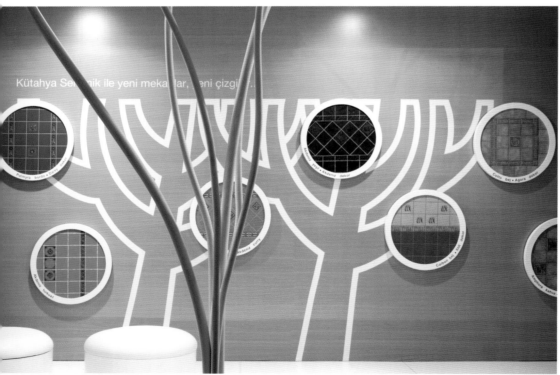

The double domes of these structures recall the traditional shape of potter's kilns, and serve as meeting and presentation areas on the stand. The back wall of the stand, again in wood, features examples of Kütahya's work.

This statement of the traditional in modern terms is persuasive and subtle, reminding the visitor of the rich and long history of ceramic ware while placing the client in a modern, efficient and contemporary context. By keeping the products largely out of view within the kiln forms, the stand also invites the visitor to come in and explore – to be part of the play.

Die kugeligen Doppelkuppeln erinnerten an die traditionelle Form türkischer Töpferöfen und dienten als Besprechungs- und Präsentationsflächen. Die Rückwand des Stands war wiederum aus Holz und zeigte Muster aus der Kütahya-Kollektion.

Die faszinierend subtile Umsetzung traditioneller Werte in moderne Ausdrucksformen erinnerte den Besucher an die uralte Geschichte der Töpferei, bot dem Aussteller jedoch zugleich einen wirkungsvoll zeitgenössischen Rahmen. Dadurch, dass die Produkte selbst im Wesentlichen in den „Brennöfen" verborgen blieben, ermunterte der Stand die Besucher zum aktiven Erkunden und Mitspielen.

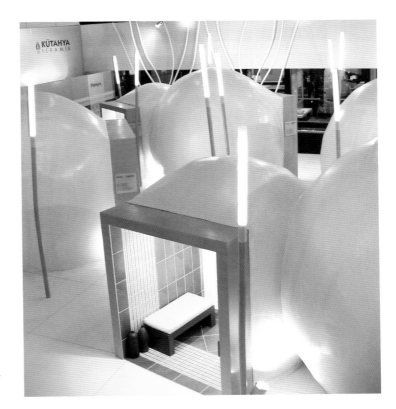

Year	**2006**
Location	**Istanbul**
Trade Fair	**Unicera**
Exhibitor	**Kütahya Seramik A.Ş., Kütahya**
Architect	**demirdendesign, Istanbul**
Size	**240 m²**
Realisation	**Çizgi Tasarim**
Lighting	**demirdendesign, Istanbul**
Graphics/Communication	**demirdendesign, Istanbul**
Photos	**demirdendesign, Istanbul**

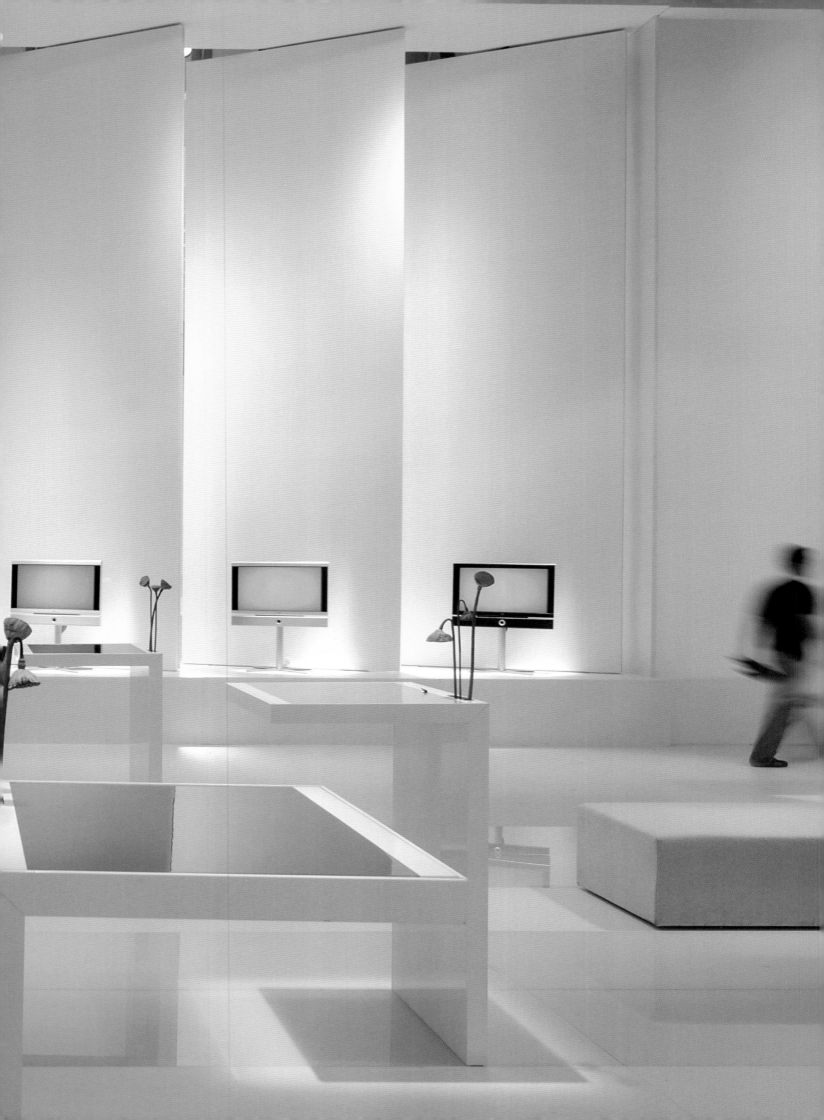

White Space, with Colours

Farbtupfer auf Weiß

Braun Wagner
for Loewe Opta

Braun Wagner
für Loewe Opta

A two thousand square metre white box, divided down the middle by a central catwalk wonderwall, displaying a range of current and recent projects, was Braun Wagner's third successive design for Loewe at the 2005 IFA, in conjunction with identity specialists Interbrand Zintzmeyer & Lux. It sounds a simple solution: the wonderwall puts dealers on one side, general public on the other, solving one of the classic dichotomies of such events. And white, well, isn't it the new black?

Not quite. Conventional large flat screen televisions had often been black, but Loewe were here offering a new white range. But the stand solution used white with colour: occasional, carefully and formally placed squares of orange and green broke the monotony.

Ein 2.000 Quadratmeter großer weißer Kubus, der durch eine zentrale „Wonderwall" längs zweigeteilt ist und die aktuellen Projekte zeigt – das war das dritte erfolgreiche Design von Braun Wagner in Zusammenarbeit mit dem Identity-Spezialisten Interbrand Zintzmeyer & Lux für Loewe, diesmal bei der IFA 2005. Die Lösung klingt einfach: Die „Zauberwand" zwischen den unterschiedlich gestalteten Bereichen für Wiederverkäufer und Laienpublikum löst ein klassisches Dilemma solcher Events. Und ist Weiß nicht ohnehin das neue Schwarz?

Nicht unbedingt. Während große Flachbildschirme bislang meist schwarz waren, bot Loewe bei der IFA eine neue Serie in Weiß an. Der Stand kombinierte Weiß jedoch mit Farbe: In gewählten Abständen brachen Quadrate in Grün und Orange die Monotonie auf.

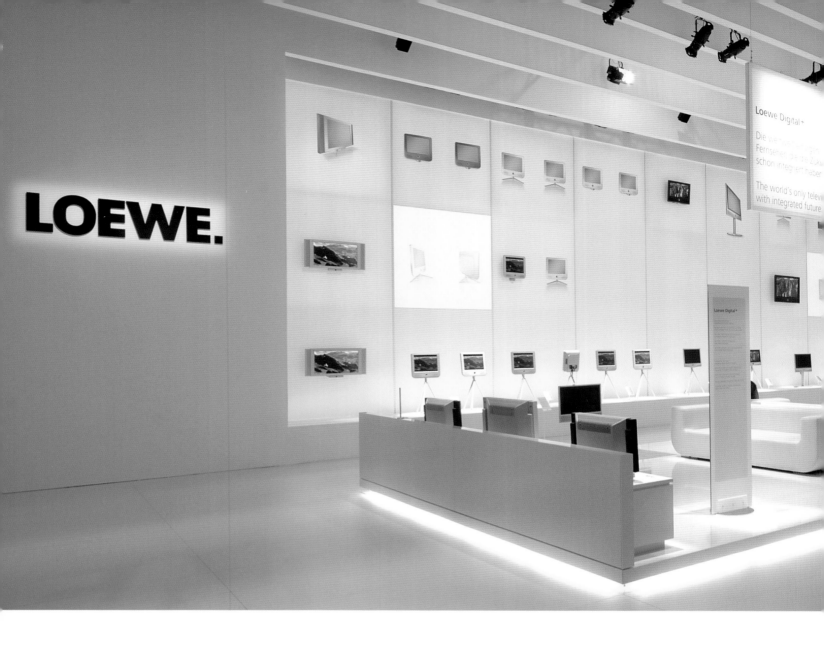

Year	**2005**
Location	**Berlin**
Trade Fair	**IFA**
Exhibitor	**Loewe Opta GmbH, Kronach**
Architect	**Braun Wagner, Aachen**
Size	**2,000 m²**
Realisation/Stand Building	**mac, Langenlonsheim**
Technical Realisation	**Showtec, Cologne; mu:d, Cologne**
Lighting	**Burkhard Jüterbock; Lichtkunstkonzepte, Cologne**
Graphics/Communication	**Interbrand Zintzmeyer & Lux, Munich**
Photos	**Knut Koops, Berlin**

And by subtly enriching the colour diversity of the space the design suggested to the visitor to consider even more carefully the colour quality of the monitors on display. These hyper-colour intrusions ramped up their appreciation of the fidelity of the images.

The other advantage of the white envelope was that it empowered transitions between different spaces: a formal promenade transmogrifies into a monochrome living area with a large sofa, token fireplace and wide format wall-mounted screen. And the wonderwall itself contained moveable panels that could open up the two spaces to each other. A simple suggestion of the transparency, formal rigour and accuracy that is at the heart of the Loewe offer.

Die subtile Erweiterung der Farbpalette signalisierte den Besuchern, dass die Qualität der ausgestellten Fernsehschirme auf der gleichen Sorgfalt beruht. Gerade die bunten Tupfer stärkten das Vertrauen in die Farbtreue der Fernsehbilder.

Die weiße Hülle hatte zudem den Vorteil, dass sie Übergänge zwischen den verschiedenen Räumen ermöglichte. Das sachliche Defilee ging über in einen monochromen Wohnbereich mit großem Sofa, Elektrokamin und wandmontiertem Breitbildschirm. Die „Wonderwall" selbst bestand aus beweglichen Tafeln, mit denen man die beiden Räume zueinander öffnen konnte. Eine Anspielung auf die Transparenz, Formstrenge und Präzision, die den Kern des Loewe-Produktkonzepts bilden.

Pinball Wizard

Pinball Wizard

Mauk Design
for Sony PlayStation

Mauk Design
für Sony PlayStation

Unlike the Sony stand at IFA (see page 98 et seq.), where the whole product range was there to be discovered by the visitor on an individual journey, the E³ stand was aimed more centrally at the computer gaming market and specifically designed to cope with a high visitor throughput. Both designer and client also fully realised that each of the 60,000 plus visitors was an individual. The solution was described by one of the judges for the Exhibitor Awards (in which this stand won gold) as being "trapped inside a pinball machine – a perfect experience for a gamer." Just as a pinball machine has a fixed initial trajectory and then a random one, the flow plan for the stand ensured visitors had a planned passage past the display of new products, especially the PlayStation Portable, next to a theatre area, and then could move more freely through the general area displaying the whole range of games available on PlayStation machines.

Anders als beim Sony-Stand auf der IFA (siehe Seite 98 ff.), wo die gesamte Palette dem Besucher zur zwanglosen Erkundungsreise offenstand, zielte Sony bei der E³ weit stärker auf den Computerspielemarkt und massive Besucherzahlen. Dass jeder der über 60.000 Besucher ein Individuum ist, darüber waren sich Designer und Kunde jedoch völlig im Klaren. Was dabei herauskam, schilderte einer der Juroren bei der Preisvergabe (der Stand erhielt „Gold" bei den Exhibitor Awards) als Gefühl, „in einem Flipper gefangen zu sein – für einen Computergamer genau das Richtige." So, wie die Flipperkugel zunächst einer vorgegebenen Bahn folgen muss, danach aber in alle Richtungen rollen kann, lenkte das Flussdiagramm die Besucher gezielt so, dass sie an einem Theater und den neuen Produkten, vor allem dem neuen PlayStation Portable, vorbeikamen, bevor sie sich im offenen Ausstellungsbereich mit sämtlichen Spielen für PlayStation-Geräte frei bewegen konnten.

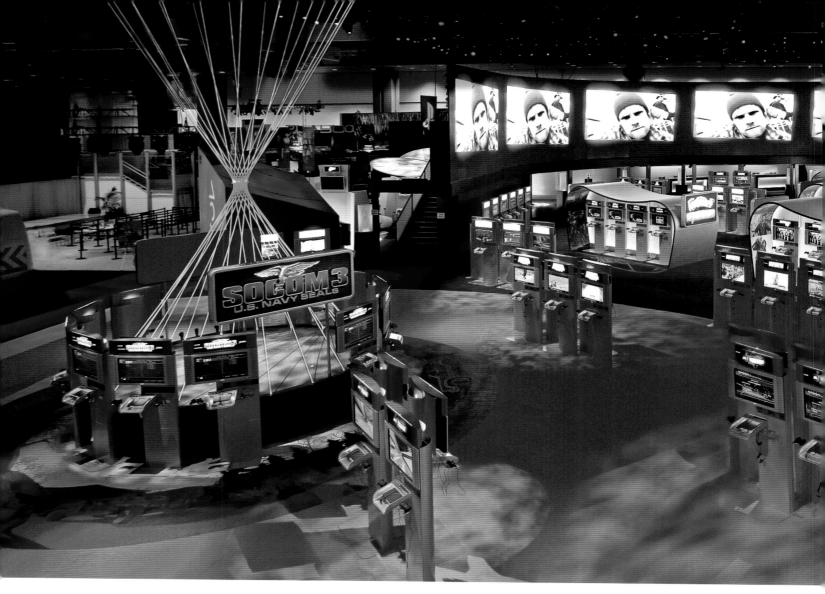

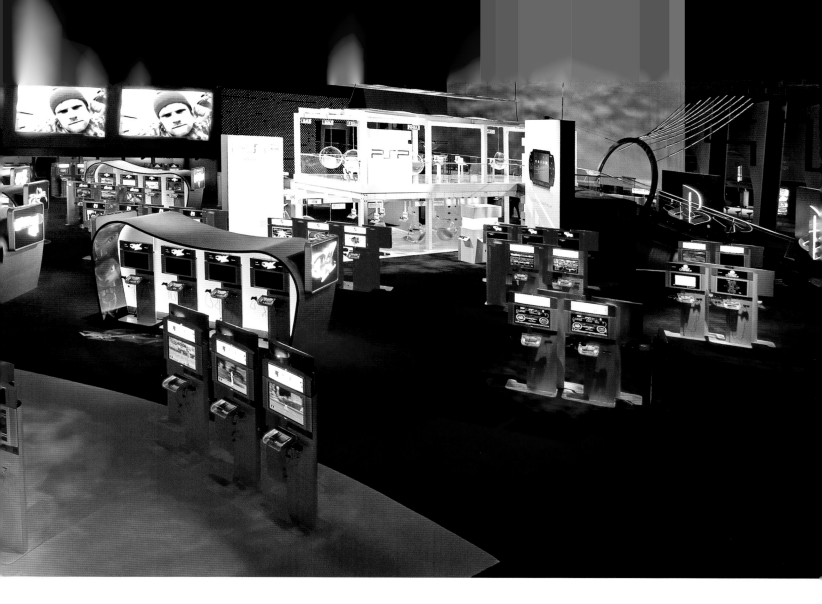

Previous PlayStation stands by Mauk had used a hub system, and while this stand used a central fibre optic totem to mark the stand's position in the hall, it also distinguished between the two main phases of the visitor's journey by making the heroic new product area into a white and translucent two storey structure, and letting colour into the rest of the stand. By making the new products area a special and visually distinct part of the whole, the design accentuated the opportunity to see the new kit, rather than making it an obligatory route to the main area.

The quality and success of this stand shows how a well-embedded working relationship between designer and client can create wizard results.

Bei früheren Messen für PlayStation hatte Mauk den Stand um eine Mittelachse herum angeordnet. Diesmal gab es zwar einen „Totempfahl" aus Glasfasersträngen als optische Landmarke, doch unterteilte Mauk den Rundgang in zwei Phasen: Die Neuheiten waren in einem zweistöckigen weißen Pavillon mit viel Glas untergebracht, alles Übrige ringsum satt farbig gestaltet. Dadurch, dass sich die neuen Produkte visuell abhoben und für sich blieben, war die Begegnung mit dem neuen Zubehör keine Pflichtübung auf dem Weg zum Hauptbereich des Stands, sondern ganz klar als attraktive Chance ausgewiesen.

Qualität und Erfolg dieses Stands sind ein Beispiel dafür, dass eine fundierte, gut funktionierende Beziehung zwischen Designer und Kunde eine gute Voraussetzung für geniale Ergebnisse ist.

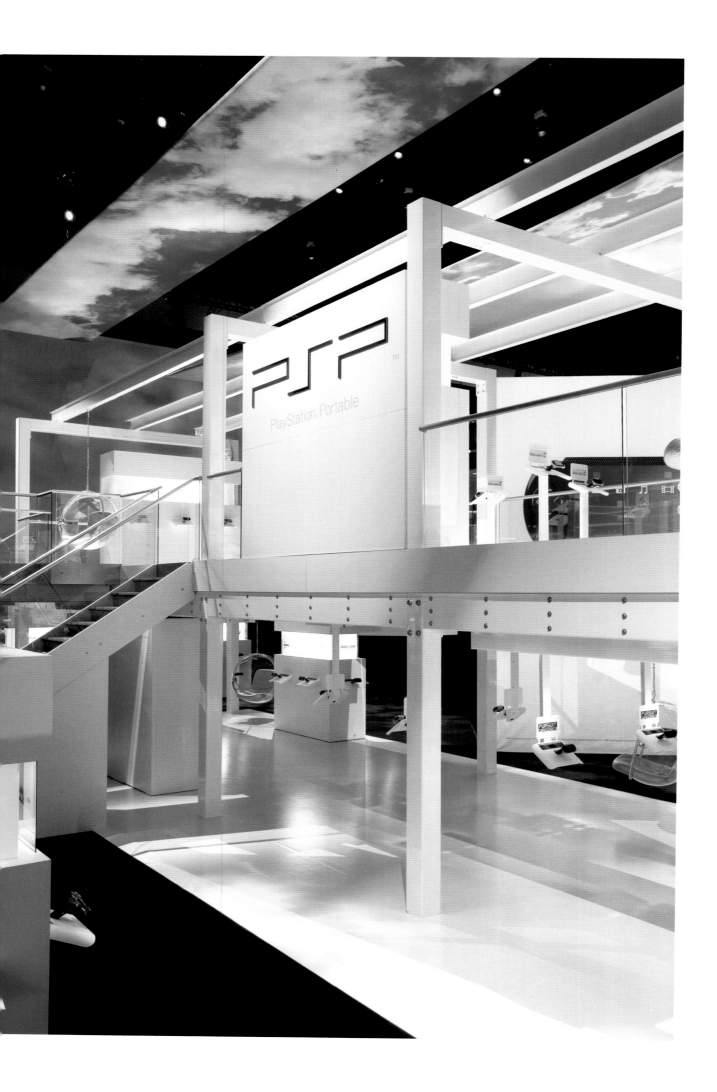

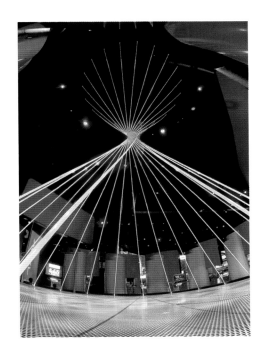

Year	**2005**
Location	**Los Angeles**
Trade Fair	**E³**
Exhibitor	**Sony Computer Entertainment, Foster City**
Architect	**Mauk Design, San Francisco**
Size	**3,354 m²**
Realisation	**Pinnacle Exhibits**
Lighting	**John Osborne**
Graphics/Communication	**Sony Computer Entertainment, Foster City, Design Department**
Photos	**Andy Caulfield**

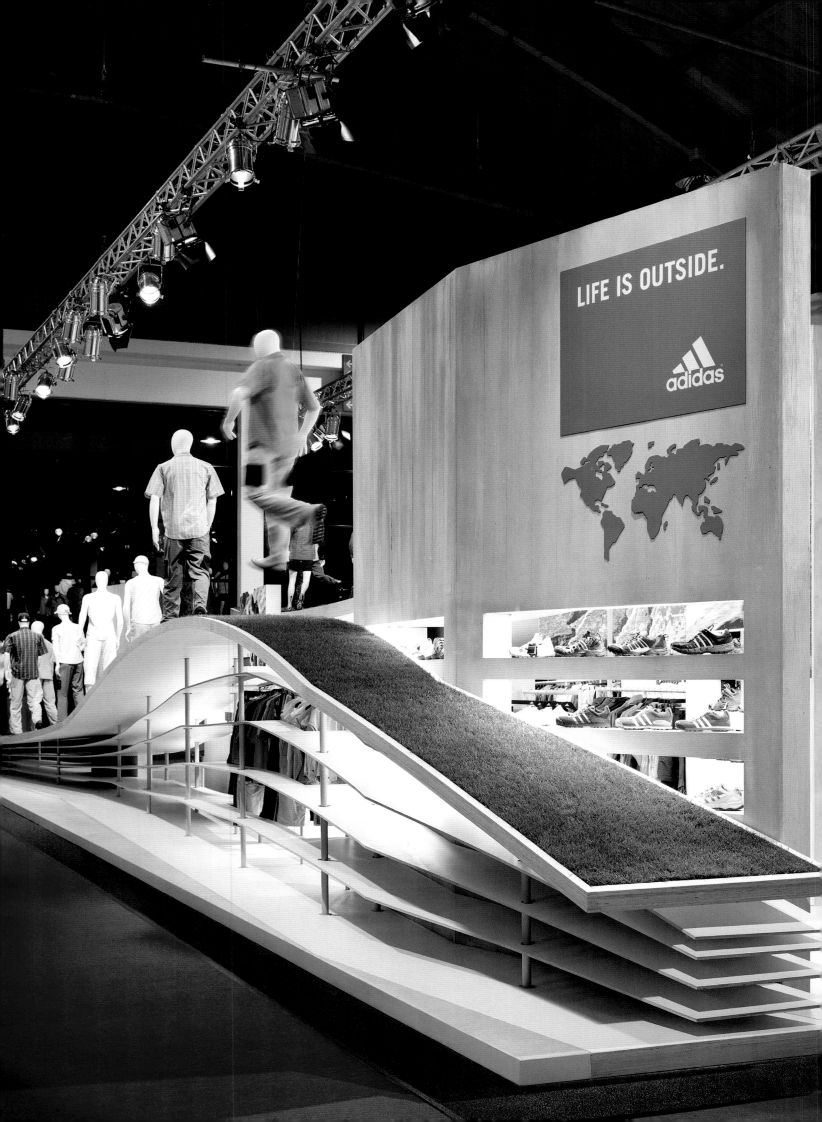

LIFE IS OUTSIDE.

adidas

Boots made for Walking

Sportliche Aktivitäten

Schusterjungen und Hurenkinder
for Adidas

Schusterjungen und Hurenkinder
für Adidas

"Shoes are a fashion statement, no?"
"Yes, and?"
"Sneakers are for clubbing in, no?"
"Yes, and?"
"You wear them because Zidane wears, them, no?"
Yes, and also shoes were made for walking and running in, for playing sport and living outdoors. That is the central message of this stand by Schusterjungen und Hurenkinder for Adidas. It is made central by the inclusion in the stand of three long strips of turf, sitting above floor level and supporting a series of running, jumping and walking figures wearing Adidas outdoor shoes and sportswear.

„Schuhe sind ein modisches Accessoire, stimmt's?"
„Ja, und?"
„Mit Turnschuhen kann man in die Disco gehen, stimmt's?"
„Ja, und?"
„Sie tragen welche, weil Zidane das auch tut, stimmt's?"
Genau. Schuhe sind obendrein dazu da, um damit zu gehen und zu laufen, Sport zu treiben und sich im Freien zu bewegen. Das ist die zentrale Botschaft dieses Stands, den Schusterjungen und Hurenkinder für Adidas entwickelte. Zur Kernaussage wird sie durch die drei langen Grasstreifen, die erhöht am Stand entlanglaufen und als Spielwiese für rennende, springende und gehende Figuren in Outdoor-Schuhen und -Kleidung von Adidas dienen.

While these three strips break up the footprint of the longitudinal stand, the loss of space is well worth the message about the brand's firm location in sports practice, and in encouraging life outdoors. The surprising and vigorous figures give a strong note of originality to the overall design, literally positioning the company as in contact with its market. The other interior spaces of the stand have a compressed feel to them, similar to being in a busy sportswear shop or even a changing room, not at all an inappropriate consequence given the scale of the products on show. Above all the wit and humour of the figures, some not even touching the ground, emphasise the ideals of sportsmanship as well as the simple pleasures of exercise.

Die drei Streifen beschneiden die langgestreckte Standfläche, doch wird der Platzverlust mehr als aufgewogen durch die Botschaft, dass Adidas in der Sportpraxis zu Hause ist und zu Outdoor-Aktivitäten ermuntert. Die originellen, kraftvollen Figuren geben dem Design insgesamt eine individuelle Note und machen deutlich, dass die Kommunikation zwischen Unternehmen und Markt funktioniert. Die Innenflächen des Stands wirken ein wenig beengt, wie ein überfüllter Sportartikelladen oder eine Umkleidekabine, doch das ist eine durchaus erwünschte Folge der ausgestellten Produktmassen. Wichtig ist vor allem die pfiffige Gestaltung der Figuren, von denen manche nicht einmal den Boden berühren. Sie verkörpern sportliche Ideale ebenso wie einfach nur Spaß an der Bewegung.

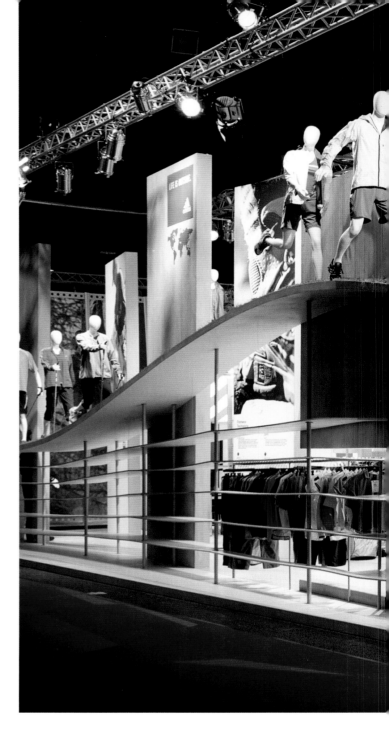

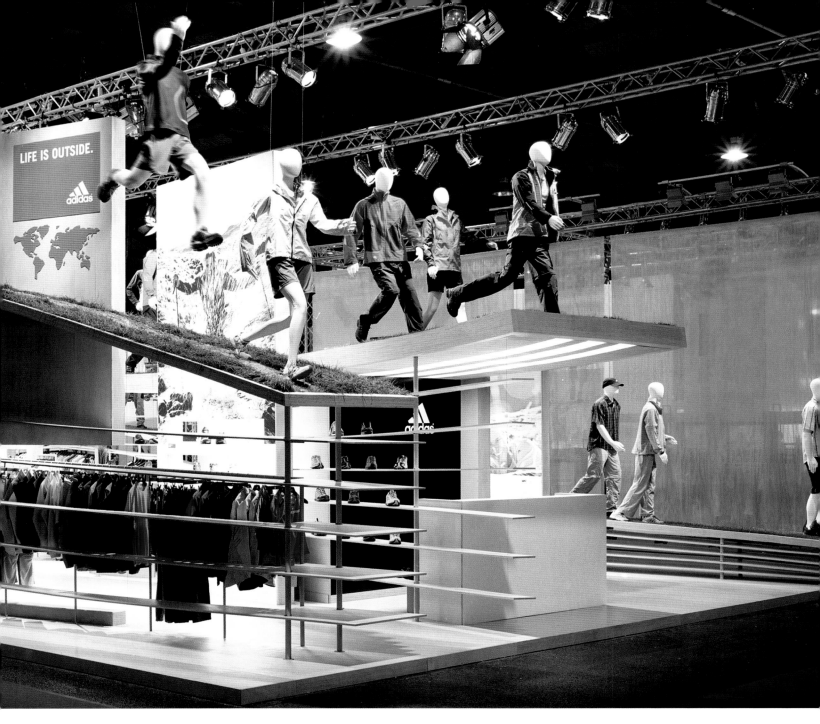

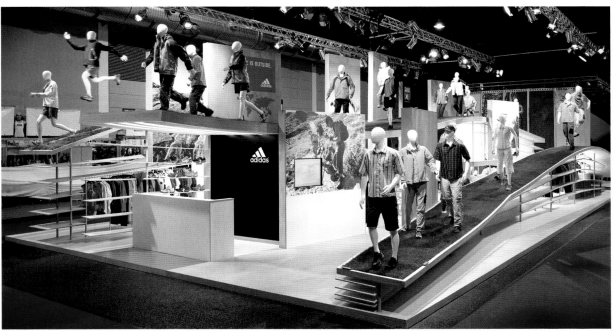

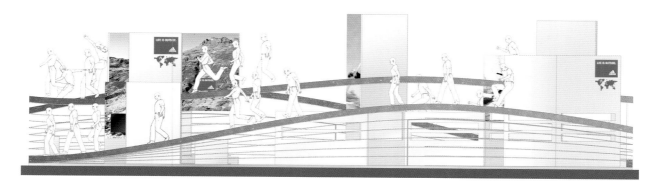

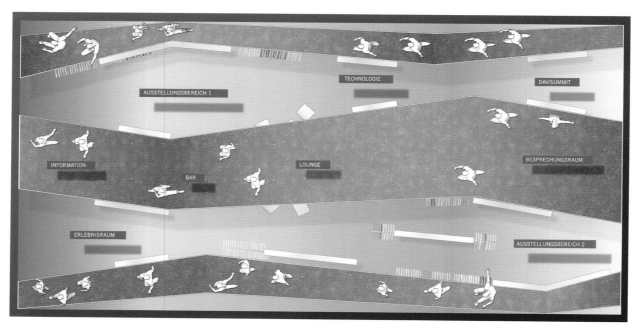

Year	**2005**
Location	**Friedrichshafen**
Trade Fair	**Outdoor**
Exhibitor	**adidas-Salomon AG, Herzogenaurach**
Architect	**Schusterjungen und Hurenkinder GmbH, Munich**
Size	**200 m²**
Stand Construction and Technical Services	**stagegroup GmbH**
Photos	**Oliver Jung, Munich**

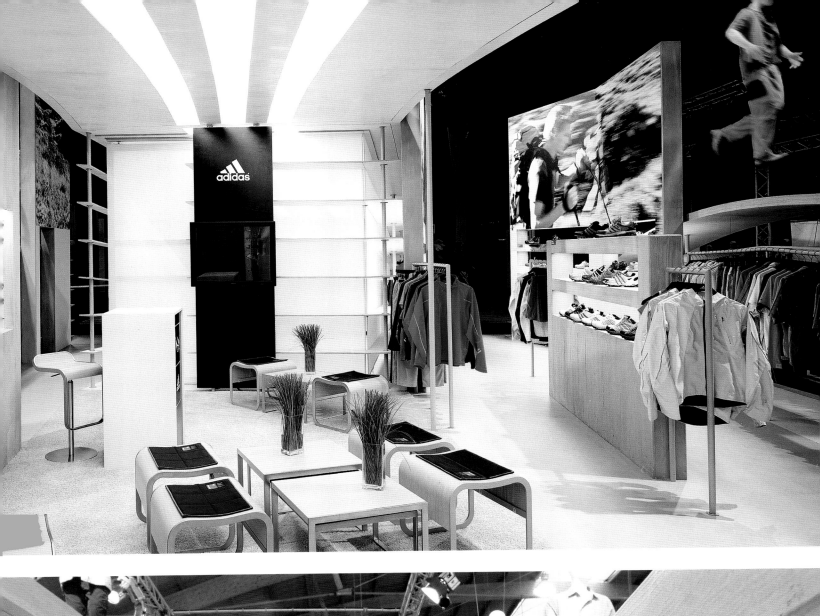
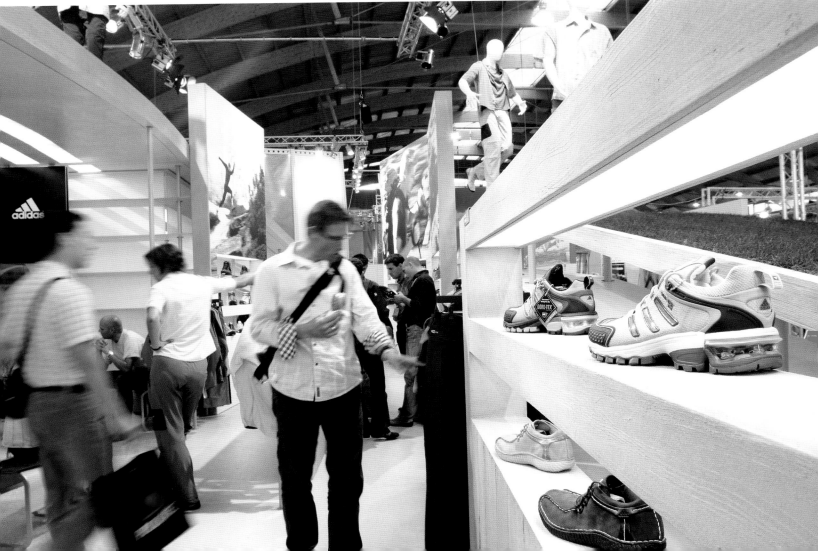

alist
world of SEREL

Form is the alphabet of

Point of Gravity

Schwerpunkt

Remar Architecture & Decoration
for ECA ELEKS

Remar Architecture & Decoration
für ECA ELEKS

Think of moons circling a planet. Their orbits are dominated by the gravitational pull of the planet, but also affected by their initial direction and velocity, the gravity of other moons and of other bodies and stars in the planetary system, and, ultimately by every other body in the universe. In the same way, a hub may be a visible centre, but the route towards or around it is not defined or easily predictable. This was the thinking that lay behind Remar's stand for sanitaryware maker ECA ELEKS: a central unit which can be seen and approached from a number of angles on the stand's perimeter.

Stellen Sie sich Monde vor, die einen Planeten umkreisen. Ihre Umlaufbahn wird bestimmt durch die Anziehungskraft des Planeten, aber auch ihre ursprüngliche Richtung und Geschwindigkeit, die Schwerkraft anderer Monde und Sterne im Planetensystem und letztlich durch jeden anderen Körper im Universum. Auf die gleiche Weise markiert ein zentraler Angelpunkt hier die Standmitte, doch ist der Weg dorthin und darum herum weder vorgegeben noch ohne weiteres vorhersagbar. Das war der Grundgedanke des Remar-Stands für den Sanitärausstatter ECA ELEKS: ein Mittelpunkt, der aus mehreren Blickwinkeln vom Rand des Stands aus sichtbar und erreichbar ist.

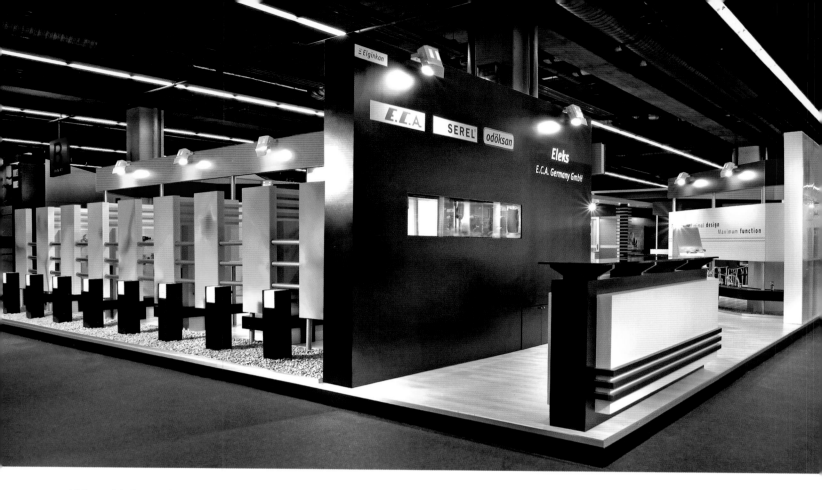

When this is combined with unusual and irregular structures and openings, and bold and varied colours, the effect is to invite the visitor not only to investigate what is going on more closely, but also to form their own opinion about the central hub, and about the ideas conveyed by the abstract forms. In other words, the design seeks to make the visitor a participator in the stand, not just an onlooker.

Kombiniert mit ausgefallenen asymmetrischen Strukturen, Öffnungen und kräftig bunten Farben wirkt das Ganze auf den Besucher wie eine Einladung zu einer Entdeckungstour, um sich selbst ein Bild vom zentralen Punkt und den Konzepten machen zu können, die hinter den abstrakten Formen stecken. Mit anderen Worten: Durch das Design ist der Besucher kein bloßer Zuschauer, sondern aktiver Teilnehmer.

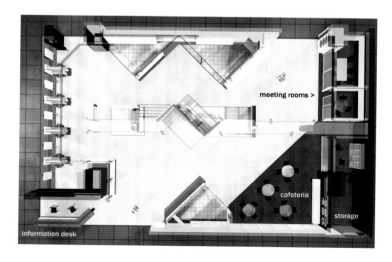

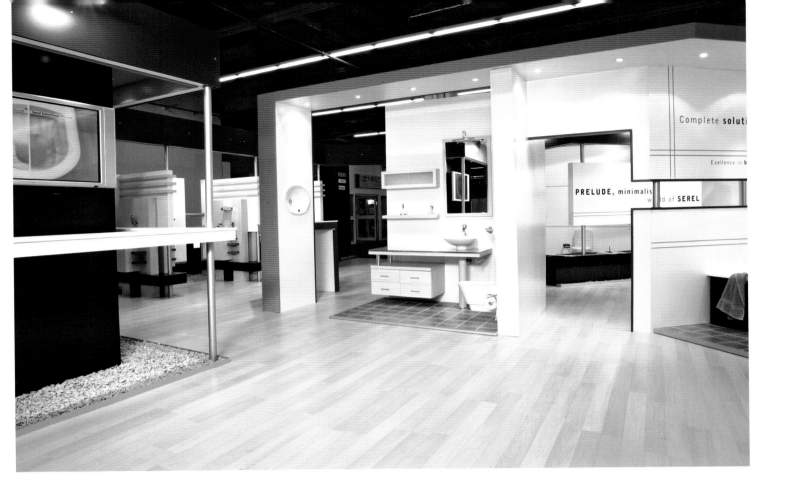

Year	**2005**
Location	**Frankfurt**
Trade Fair	**ISH**
Exhibitor	**ECA ELEKS, Istanbul**
Architect	**Remar Architecture & Decoration Ltd., Istanbul: Ahmet Nazif Sati**
Size	**273 m²**
Realisation	**Remar Architecture & Decoration Ltd., Istanbul**
Lighting	**Remar Architecture & Decoration Ltd., Istanbul**
Graphics/Communication	**MARKA**
Photos	**Remar Architecture & Decoration Ltd., Istanbul**

No Home like Place

Minimum an Aufwand

Dante Bonuccelli
for Schönbuch

Dante Bonuccelli
für Schönbuch

African tribal masks can be classified in two ways: "spirit-regarding," where the design points skywards, so that the mask is seen from the heavens, and "earth-regarding" where the design can be seen by the participants and spectators. The same kind of classification could, by extension, be applied to trade fair stands, distinguishing between those that make an open offer or invitation to the visitor, and those where the visitor has to be on the inside to find out what is happening. Both strategies contain an element of risk: the hurried visitor – and who has seen a leisurely visitor at a trade fair? – may ignore the open stand, thinking they know what it is all about, or ignore the closed one, not being interested to discover what it is about. (A third category of stands sits in the middle, of course, those with some display on the exterior but with an inner area to which the visitor is invited.)

Es gibt zwei Arten afrikanischer Masken: Die einen blicken „geistwärts", das heißt nach oben, so dass sie vom Himmel aus zu sehen sind, die anderen „erdwärts", so dass sie für Mitwirkende und Zuschauer sichtbar sind. Diese Unterscheidung lässt sich auch auf Messestände übertragen. Es gibt offene, die ein Angebot oder eine Einladung an die Adresse des Besuchers senden, und geschlossene, in die der Besucher erst eintreten muss, bevor er in Erfahrung bringt, was sich darin abspielt. Beide Strategien beinhalten ein Risiko: Der eilige Messebesucher (diese Spezies scheint die bei weitem häufigere zu sein) lässt den offenen Stand vielleicht links liegen, weil er meint, er wisse ja schon Bescheid, während er den geschlossenen ignoriert, weil er ihn nicht erst mühsam erkunden mag. (Dazwischen gibt es natürlich eine dritte Standkategorie mit ein paar externen Ausstellungsflächen und einladendem Innenbereich.)

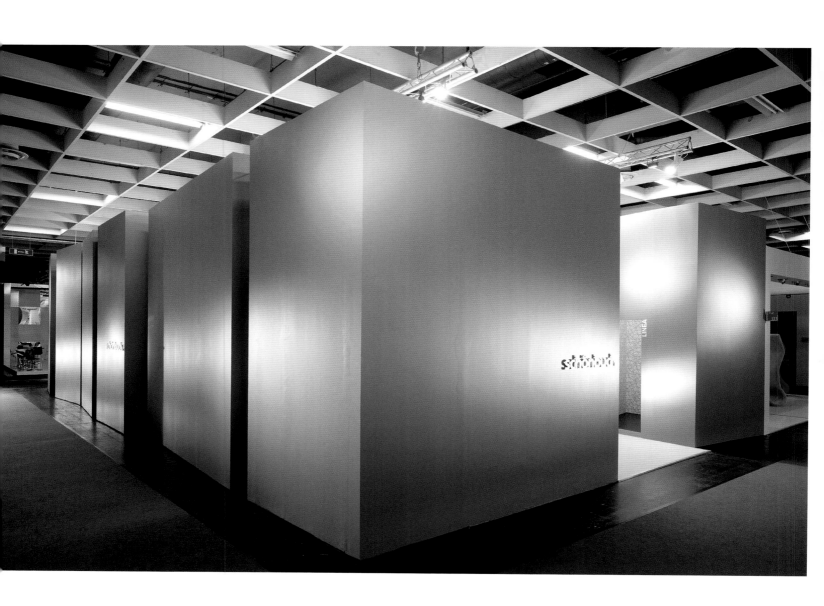

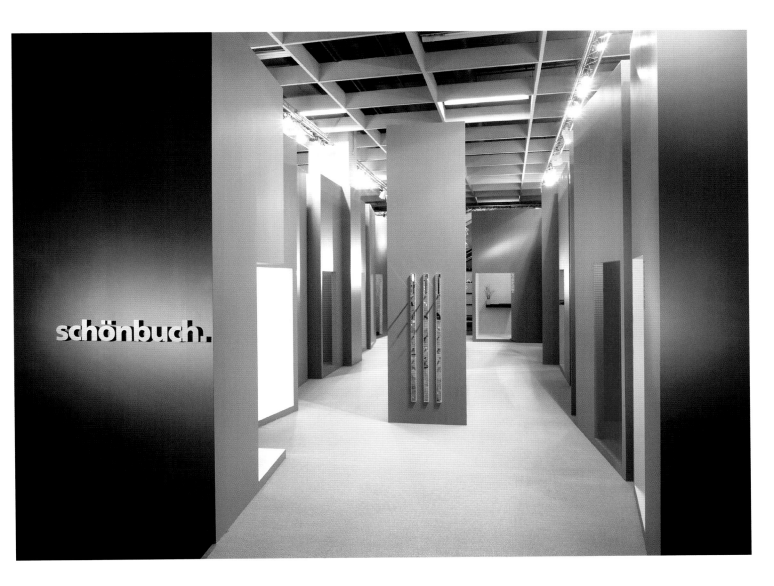

The success of a closed stand thus depends, contrary as it might seem, as much on the handling of the exterior as on the contents of the interior. The choice of colour, surfaces, wall heights, the size and placing of entrances, need to be designed with care to ensure that the visitor is intrigued into entering and not put off. The architect of the Schönbuch stand, Dante Bonuccelli, took a bold approach, using a neutral light grey, high walls and narrow entrances.

But this paid off: with the stand the visitor found a series of individual room areas each displaying one of the ten new ranges of wardrobes, chests and other storage sytems launched at the fair. Each area, designed by Carolin Sangha, had its own personality, with dramatic colours, wallcoverings and detailing: a forest of coloured lights, lime-green cutouts on a magenta wall, or monochrome Morris-inspired wallpaper, each gave an individual and immediate setting to the furniture presented.

Der Erfolg eines geschlossenen Stands hängt insofern paradoxerweise sowohl von der Gestaltung der Außenflächen ab als auch von dem, was sich im Innern verbirgt. Die Wahl der Farben, Oberflächen, Wandhöhe, die Größe und Platzierung der Eingänge müssen mit Umsicht geplant werden, damit der Besucher neugierig wird, ohne sich unwillkommen zu fühlen. Der Architekt des Schönbuch-Stands, Dante Bonuccelli, entschied sich für eine drastische Lösung mit hohen Wänden in neutralem Hellgrau und schmalen Eingängen.

Aber sie funktionierte. Im Innern des Stands entdeckte der Besucher eine Reihe individuell ausgestatteter Räume jeweils mit einem der zehn neuen Kleiderschränke, Kommoden und anderen Aufbewahrungssystemen, die bei der Messe Premiere feierten. Jeder der von Carolin Sangha gestalteten Räume besaß einen eigenen Charakter mit dramatischen Farbstellungen, Tapeten und Details: ein Strauß bunter Lichter, limonengrüne Stanzmotive auf Magenta, monochrome, Morris nachempfundene Tapetenmuster – jeder Raum bildete einen einzigartigen, unmittelbaren Rahmen für das vorgestellte Möbelstück.

CIRCUIT

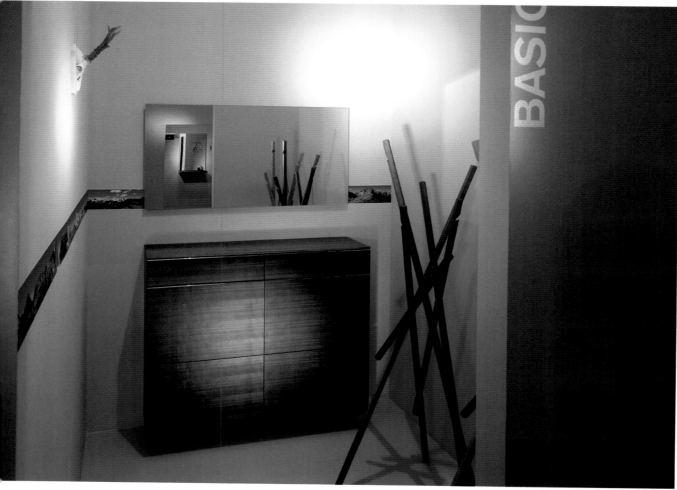

BASIC

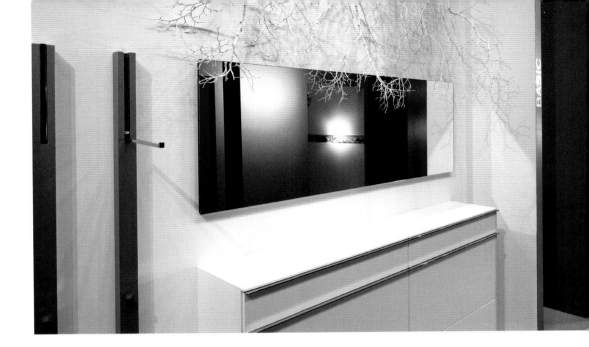

Year	**2006**
Location	**Cologne**
Trade Fair	**imm cologne**
Exhibitor	**Schönbuch, Bad Königshofen**
Architect	**Dante Bonuccelli, Milan**
Interior Design	**Carolin Sangha, Munich**
Size	**144 m²**
Realisation	**Pinguin Display, Cologne**
Graphics/Communication	**Carolin Sangha, Munich**
Photos	**Hans-Georg Esch, Hennef/Sieg**

Reflections on Style
Stilistische Erwägungen

Arno Design
for Bäumler

Arno Design
für Bäumler

The conventions of the fashion show are well established: the catwalk, the models (celebrity included), the gilt chairs, the photographers. But how to translate this buzz and excitement into the static state of a trade fair? For their clients Bäumler at the Pitto Uomo fair in 2005 Arno design in Munich used a baroque white-out approach, drenching the all white stand with light. In 2006 they went to the other extreme.

Realising that the key to the fashion show is the concentration of the audience on the display running down the catwalk, Arno turned the five by ten metre stand into an inverse catwalk, with the displays along the walls and the client as catwalker down the middle.

Die konventionellen Attribute einer Modenschau sind allseits bekannt: Laufsteg, Models (inklusive Prominenz), Ehrenplätze, Blitzlichtgewitter. Wie setzt man all die Aufgeregtheit im statischen Rahmen einer Messe um? Für die Pitti Uomo 2005 kreierte die Münchner Designfirma Arno für Bäumler eine Art barocken Schneesturm an einem rein weißen, lichtdurchfluteten Stand. 2006 verlegte man sich auf das andere Extrem.

Schlüsselfaktor der Modenschau ist der Laufsteg. Das Publikum konzentriert sich völlig auf die dort vorgeführten Modelle. Diese Erkenntnis bewog Arno dazu, den 5 x 10 Meter großen Stand in einen umgekehrten Laufsteg zu verwandeln, bei dem die Ausstellungsstücke an den Wänden hängen und der Besucher dazwischen herdefiliert.

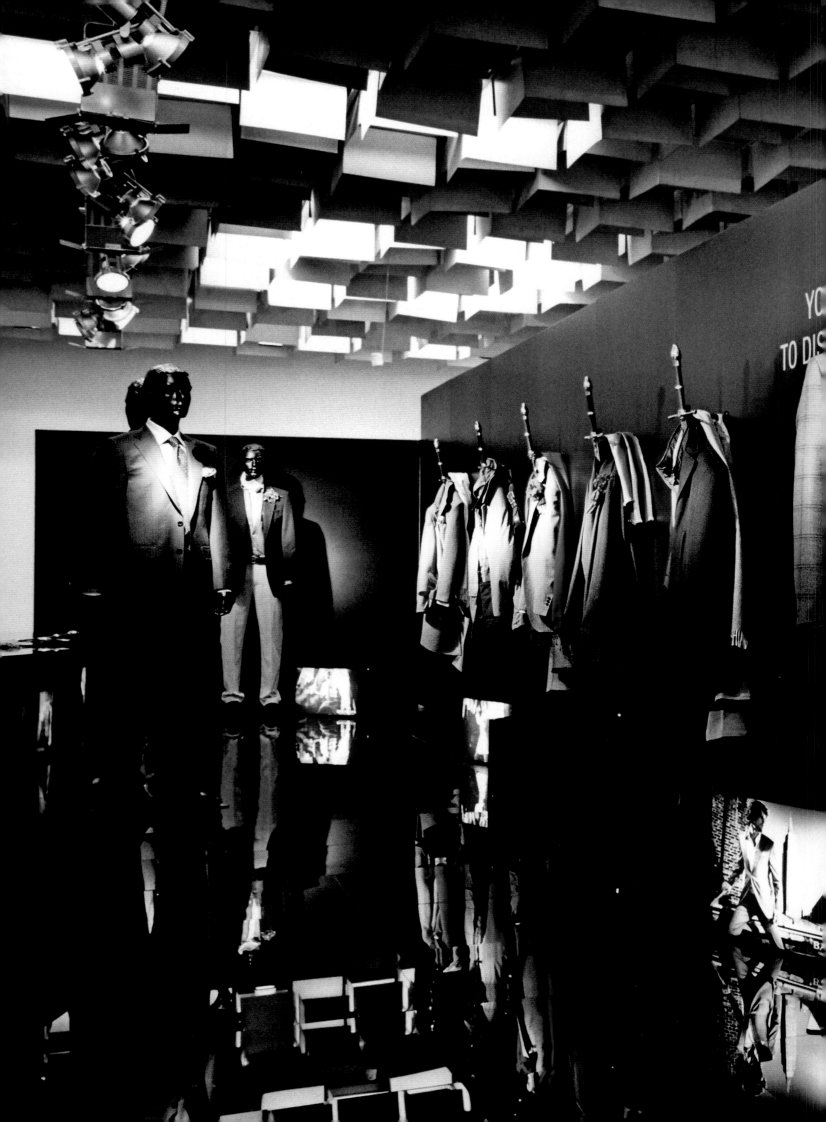

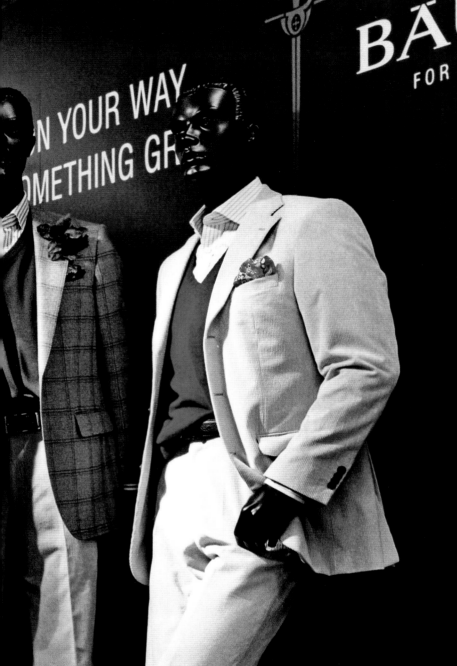

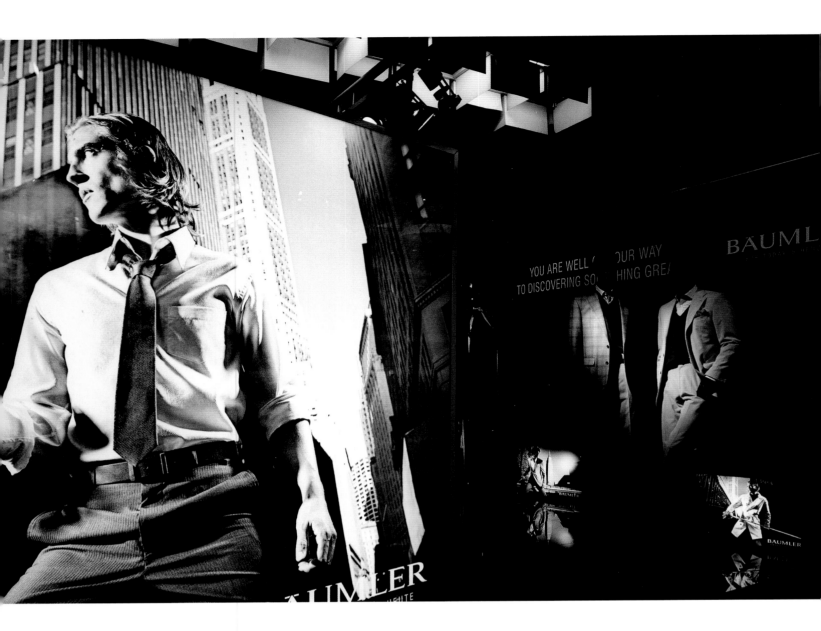

A black, spotlit stand with a reflective mirrored floor heightened and intensified the sense of involvement, and by repeating the designs showcased either on full size black mannequins or as sets of clothes hung on ornamental frames they created the sense of repetition and change of viewpoint that is another important element. Floor level television screens also added to the emotional and visual charge of the overall design.

Creating a small stand can be more of a challenge to a designer than filling a large one, since on a small stand every part of the space has a lot of work to do. (The problem with a large stand is often that of managing the transfers between the different sub-spaces within the stand and so avoiding monotony.) By reversing the conventions here, by making the smallness of the stand's footprint part of the experience of the stand, Arno created a stand with its own very individual and expressive dynamic.

Der von Spotlights beleuchtete tiefschwarze Stand mit spiegelndem Bodenbelag verstärkte bei den Besuchern das Gefühl, eine aktive Rolle zu spielen. Die Präsentation der Modelle einmal auf lebensgroßen schwarzen Schaufensterpuppen und noch einmal an dekorativen Garderoben hängend weckte den Eindruck einer Wiederholung von wechselnden Standpunkten aus, die ein weiteres wichtiges Element bildet. Die in Bodenhöhe angebrachten Bildschirme steigerten die emotionale und visuelle Atmosphäre des Gesamtbildes.

Ein kleiner Stand stellt Designer oft vor schwierigere Probleme als ein großer, denn jeder Raumteil muss eine Menge leisten. (Die Schwierigkeit bei großen Ständen ist eher, die Übergänge zwischen den einzelnen Teilbereichen so zu gestalten, dass keine Langeweile aufkommt.) Durch die Umkehrung der Konventionen und die Nutzung der kleinen Fläche als Teil der Erfahrung beim Standbesuch gelang Arno ein Stand mit ganz individueller, sehr ausdrucksvoller Dynamik.

Year	**2006**
Location	**Florence**
Trade Fair	**Pitti Uomo**
Exhibitor	**Hans Bäumler AG**
Architect	**Arno Design GmbH, Munich: Claus Neuleib**
Size	**50 m²**
Realisation	**Arno Design GmbH, Munich**
Lighting	**Arno Design GmbH, Munich**
Graphics/ Communication	**Arno Design GmbH, Munich**
Styling	**H. E. Schlender, Dusseldorf**
Photos	**ARNO ©/ Frank Kotzerke**

VITSŒ

In the Pink

Perfektion in Pink

Thomas Manss & Company
for Vitsœ

Thomas Manss & Company
für Vitsœ

When the English gentleman took horse to pursue the fox, he would do so in a "pink coat". The coat was in fact scarlet in colour, and the story went that it was called pink after the tailor who made the best ones. Alas, there seems to be no record of such a tailor, but the word pink was used in the seventeenth century to describe something perfect or exquisite, in the eighteenth for the elegance of a dandy, and then enters the hunting-field in the nineteenth, where it acquires a new etymology. Proof of the endless shifting patterns and peculiarities of the English language.

Wenn ein englischer Gentleman sich auf die Fuchsjagd begab, schlüpfte er dazu traditionsbewusst in den „pink coat", den Jagdrock, der natürlich nicht rosa war, sondern scharlachrot. „Pink" hieß das edle Stück der Überlieferung nach deshalb, weil ein Schneider dieses Namens die besten Röcke herstellte – historisch fehlt von diesem Mann allerdings jede Spur. Stattdessen bezeichnete „pink" ab dem 17. Jahrhundert in England etwas Exquisites, und im 18. Jahrhundert das elegante Outfit eines Dandys. Im 19. Jahrhundert schließlich hielt der Begriff Einzug ins Jagdrevier und bekam dort eine neue Bedeutung – ein typisches Beispiel für die Wunderlichkeiten der englischen Sprache.

This seemingly simple stand for Vitsœ at London's 100% Design show has a similar layering of meanings. The stand celebrates the opening of Vitsœ's new retail premises in London's Wigmore Street. Vitsœ has been producing Dieter Rams' 606 shelving system since 1960, believing that a good thing only needs improving, a stance at odds with a design culture of ever-changing fashion. The slightly whimsical drawing of Wigmore Street's Victorian Renaissance-revival architecture makes a subtle point about real originality and fitness for purpose. And Thomas Manss' witty take on this also goes back to the original meaning: pink as perfection.

Der Vitsœ-Stand auf der Londoner 100% Design wirkt auf den ersten Blick einfach, besitzt aber ähnlich viele Bedeutungsebenen. Aufhänger ist die Eröffnung des neuen Vitsœ-Ladens in der Londoner Wigmore Street. Seit 1960 produziert Vitsœ Dieter Rams' Regalsystem 606 in der festen Überzeugung, dass man eine gute Sache nur immer weiter verbessern muss – eine Haltung, die sich von der schnelllebigen Design-Kultur mit ihren ständig wechselnden Moden wohltuend abhebt. Die etwas eigenwillige Zeichnung der viktorianischen Neorenaissance-Fassade aus der Wigmore Street steht für echte Originalität und zeigt, dass die Umsetzung der Aufgabe angemessen ist. Damit verweist Thomas Manss zugleich geschickt auf die erste Bedeutung von pink gleich Perfektion.

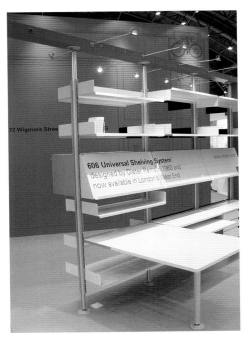

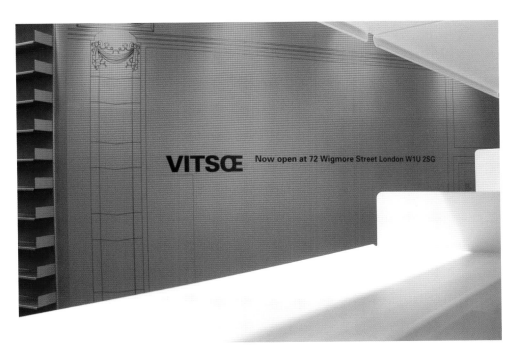

Year	**2004**
Location	**London**
Trade Fair	**100% Design**
Exhibitor	**Vitsœ, London**
Architect	**Thomas Manss & Company, London**
Size	**42 m²**
Realisation	**Thomas Manss & Company, London and Vitsœ, London**
Lighting	**Basis Lighting**
Graphics/Communication	**Thomas Manss & Company, London**
Photos	**Vitsœ, London**

Bright White

Ganz in Weiß

EOOS
for Walter Knoll

EOOS
für Walter Knoll

The choice of furniture for a home or an office, a restaurant or a hotel, becomes a very direct statement about the mood of the space, its ambience. The challenge for the design of a stand in a furniture fair becomes what ambience to convey. In some cases this will be dictated by the nature of the products – a maker of traditional furniture will look for a traditional setting. Modern and contemporary furniture is a more complex matter – even if the forms are seemingly abstract, the long tradition of modernism in fact imbues the forms with layers of meaning, some of which will appeal to some visitors, some to others. A simply neutral solution will deaden everything.

Die Möblierung einer Wohnung oder eines Büros, Restaurants oder Hotels wirkt sich unmittelbar auf die Atmosphäre des Raums aus. Bei einem Stand für eine Möbelmesse besteht die Herausforderung für den Designer darin, welche Stimmung er vermitteln soll. In manchen Fällen nimmt ihm der Charakter der Produkte selbst die Entscheidung ab: ein Stilmöbelhersteller wünscht sich natürlich ein traditionelles Setting. Moderne und postmoderne Möbel bereiten dagegen mehr Kopfzerbrechen, denn selbst wenn ihre Formen scheinbar abstrakt sind, sind sie durch die lange Tradition des Modernismus mit diversen Bedeutungsschichten befrachtet, von denen einige diese, andere jene Besucher ansprechen. Eine neutrale Lösung würde jedoch alles einebnen.

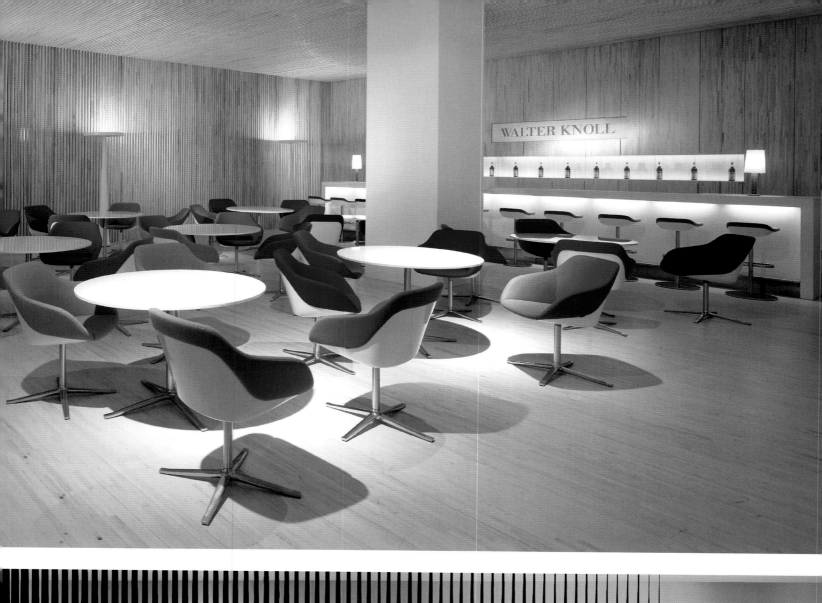

The approach developed by EOOS (who had also designed five of the nine new pieces of furniture presented at the fair) was to be positively abstract. The main area of the longitudinal stand has a white floor and white walls, while a softer, natural wood solution is adopted for the café area. White or black vertical blinds divide off or background individual exhibits, and most of the pieces on display were finished in white or black, with occasional colour details through cushions and throws. The result is that the formal value of each item is exposed to the maximum, without the surface texture or pattern interfering with the visitor's appreciation. This bold solution is modified by the planters of white flowers and the occasional pieces in cream or brown leather. As a consequence, the overall effect is exacting but not harsh.

The use of a radical design, no doubt informed by the designers' own work on the company's products, also positions the client as outgoing, contemporary and engaged with the potential of the future.

Der Ansatz, für den sich EOOS entschied (die Firma entwarf auch fünf der neun hier präsentierten neuen Möbelstücke), war kompromisslos abstrakt. Bei der Hauptfläche des längsrechteckigen Stands waren Fußboden und Wände weiß, die Cafeteria dagegen in sanfteren Holztönen gehalten. Weiße oder schwarze vertikale Trennwände standen zwischen den einzelnen Ausstellungsbereichen oder bildeten deren Hintergrund. Die meisten der ausgestellten Möbelstücke waren ebenfalls in Schwarz oder Weiß ausgeführt. Nur hier und da kam etwas Farbe ins Spiel, meist in Form von Kissen und Überwürfen, die die Form jedes Objekts optimal zur Geltung brachten, ohne dass Oberflächentextur oder Musterung das Urteil des Betrachters beeinflussten. Abgemildert wurde diese rigorose Lösung durch Pflanzgefäße mit weißen Blüten und dem einen oder anderen Stück aus cremefarbenem oder braunem Leder. Die Gesamtwirkung war anspruchsvoll, aber keineswegs brutal.

Das radikale Konzept war zweifellos inspiriert durch die Produktentwicklungen der Designer für diesen Kunden. Es positioniert ihn als zeitgemäßes, für Neues offenes Unternehmen mit Blick für zukünftige Potentiale.

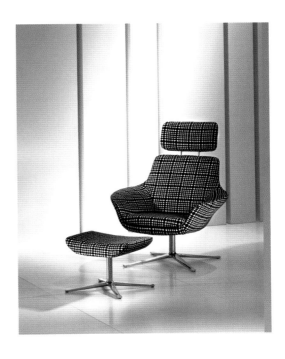

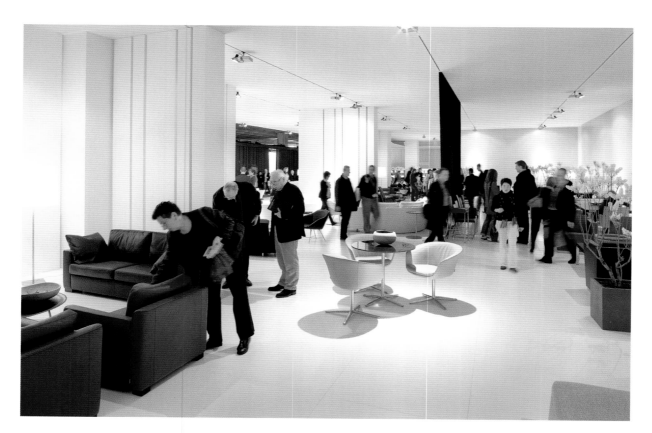
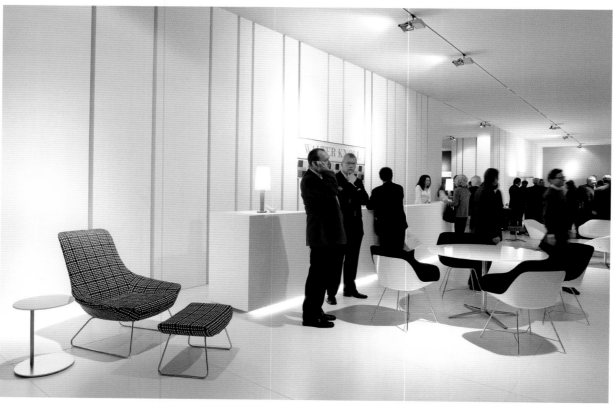

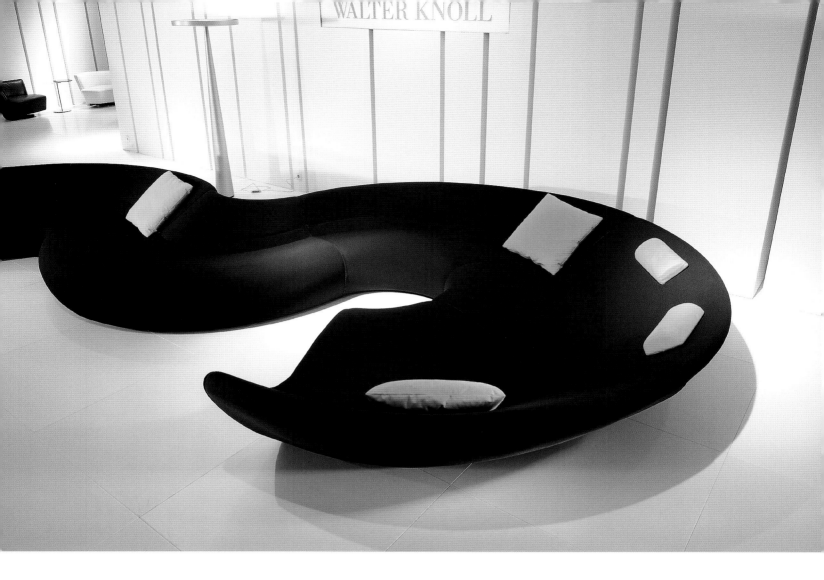

Year	**2006**
Location	**Cologne**
Trade Fair	**imm cologne**
Exhibitor	**Walter Knoll AG & Co. KG, Herrenberg**
Architect	**EOOS, Vienna**
Size	**600 m²**
Realisation	**Messebau Rittmeier und Partner, Cologne**
Graphics/Communication	**Redlin Büro für Gestaltung, Ludwigsburg**
Styling	**Sabine Heck, Stuttgart**
Photos	**Hans-Georg Esch, Hennef/Sieg**

Iron Age Bandwidth
Eiserne Bandbreite

demirdendesign
for Nokia

demirdendesign
für Nokia

This open and clear stand uses a number of visual metaphors to convey the client's telecommunications offer. An exterior framework of white horizontal bars expresses the concept of clear channels, while within the stand the use of white units to provide display areas for information and for seating underpins the progressive approach of the client and allows for different contexts and markets for portable telecoms to be explored for both business and personal users.

An overall simple though vibrant palette of colours, with the overall tonality of white, emphasises Nokia's commitment to delivering versatile contemporary design.

Der offene, übersichtliche Stand setzt gleich mehrere visuelle Metaphern ein, um das Telekommunikationsangebot des Kunden zu präsentieren. Der äußere Rahmen aus weißen Horizontalen steht für offene Kommunikationskanäle. Im Standinnern dienen kubische weiße Konstruktionen als Displays für Informationen und als Sitzmöglichkeiten. Sie unterstreichen den progressiven Anspruch des Ausstellers und bieten Geschäfts- und Privatkunden Gelegenheit, verschiedene Kontexte und Märkte für tragbare Telekommunikationsgeräte auszuloten.

Die bei aller Einfachheit pulsierende Farbgebung mit viel Weiß unterstreicht Nokias Anspruch, vielseitiges, zeitgemäßes Design zu bieten.

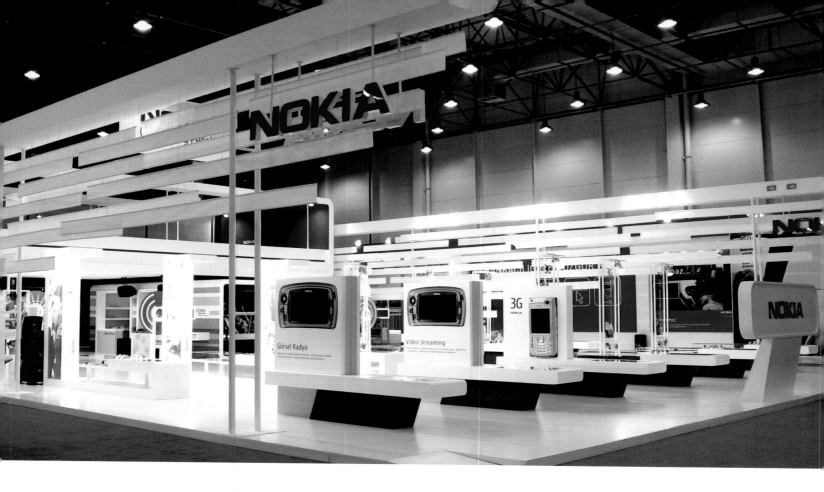

The name Demirden means "of iron" and is a reflection of the fact that the grandfather of the founding partners in the company, two sisters and their brother, was an ironmaster, and that the agency began designing in metal when it was founded in 1994, before moving into trade stand design and product design. With their stand for the same client at the same show in 2004 they – modern alchemists, perhaps – turned iron into gold, as the stand won a gold award in the 2005 Exhibitor magazine design awards. Proof that quality can travel.

Der Name Demirden bedeutet „eisern" – ein Verweis darauf, dass der Großvater der Firmeninhaber Eisenfabrikant war und die Agentur sich nach ihrer Gründung 1994 zunächst mit Metallgestaltung beschäftigte. Erst später verlegten die beiden Schwestern und ihr Bruder sich auch auf Messebau und Produktdesign. Modernen Alchemisten gleich, gelang es ihnen bei diesem Stand, Eisen in Gold zu verwandeln, denn er bescherte ihnen 2005 den Designpreis in Gold der Zeitschrift Exhibitor. Qualität setzt sich eben durch.

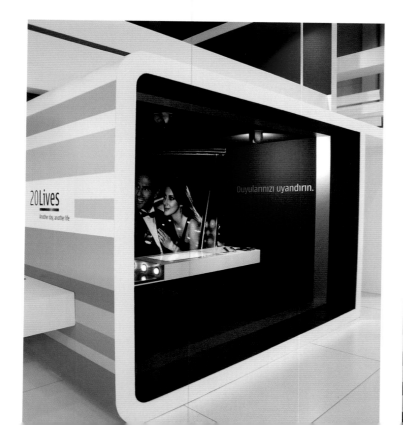

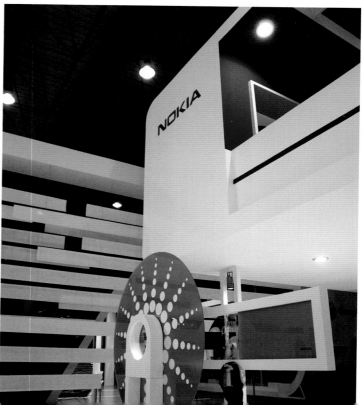

Year	**2005**
Location	**Istanbul**
Trade Fair	**CeBIT Eurasia**
Exhibitor	**Nokia CMO, Istanbul**
Architect	**demirdendesign, Istanbul**
Size	**450 m²**
Realisation	**OR-ÇE**
Lighting	**demirdendesign, Istanbul**
Graphics/Communication	**demirdendesign, Istanbul**
Photos	**demirdendesign, Istanbul**

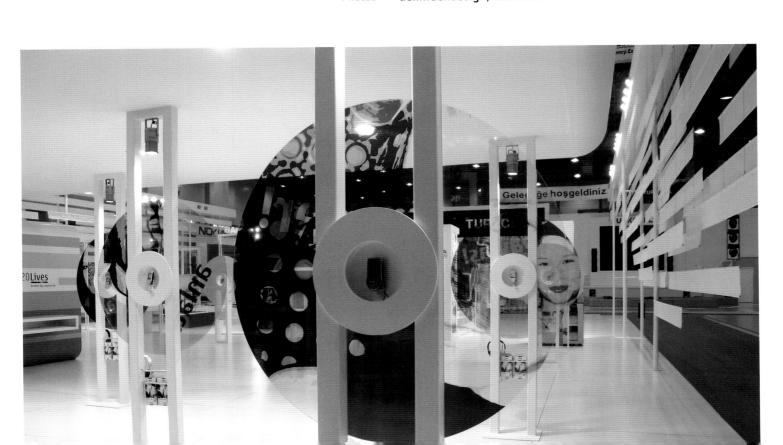

Virtual Architecture

Virtuelle Architektur

Atelier Brückner
for Panasonic

Atelier Brückner
für Panasonic

Virtuality is a central concept in contemporary life, often associated with our parallel existence on-line, and with computer gaming. Even though the hopes of virtual reality of a decade or more ago have now dissipated, the notion of virtuality remains central to a digital world. And its use extends beyond the screen: look at projects for buildings such as the DuMont centre or the Luxembourg Concert Hall by Jean Nouvel and one can see the disappearance of boundary, the transference between surface and content and the mobility of the fixed that are key aspects of the concept.

In this, their third stand for Panasonic at IFA, Atelier Brückner have put the concept of virtuality to work in a trade fair setting. The internal walls of the stand act as projection screen for a continuously looping film, in which the action moves across and around the entire interior space.

Virtualität gehört zu den Kernkonzepten der Gegenwart und hat viel mit unserer Parallelwelt im Internet und Computerspielen zu tun. Auch wenn die Hoffnungen, die man noch vor rund zehn Jahren in die virtuelle Realität setzte, längst verpufft sind, bleibt die Virtualität ein zentraler Bereich unserer digitalisierten Lebenswelt. Ihre Einsatzmöglichkeiten gehen weit über den Bildschirm hinaus: Schaut man sich Bauprojekte wie das DuMont-Center oder Jean Nouvels Konzerthalle in Luxemburg an, erkennt man auch hier die Schlüsselaspekte des Konzepts wie das Verwischen von Grenzen, die Rückkoppelung zwischen Oberfläche und Gehalt und die Mobilität des eigentlich Unbeweglichen.

In seinem dritten Stand für Panasonic, diesmal bei der IFA 2005, setzte Atelier Brückner Virtualität im Kontext einer Messe um. Die Innenwände des Stands bilden die Projektionsflächen für einen Endlosfilm, der den gesamten Innenraum bespielt.

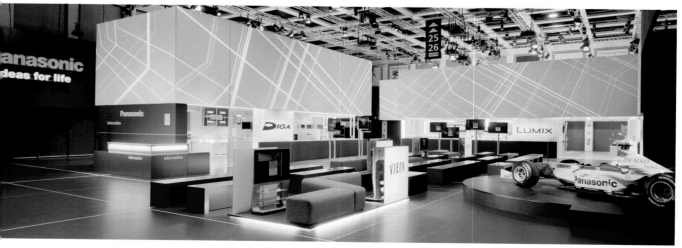

In previous stands, video walls had acted as pathways through the stand, here the effect is total immersion. What begins as a pattern of white lines on blue (matching the patterns of the floor and walls of the stand) morphs into a surface peopled by abstracted figures and a racing car in motion, then to a pattern of swirls, straight and curved lines, then into a whirlpool of digital cameras, and so on. At key moments the same images are relayed onto the "dropscreens", HD flat screens mounted on vertical poles around the stand area: after a few moments of synchronisation, the dropscreens continue with their own images. The words Lumix, Viera and Diga come into and out of view. These three terms refer to Panasonic's digital cameras, HD screens and DVD recorders respectively, and each of these brands has a presentation area under the main screen/walls. The projection uses metaphors of image capture, editing, networking and display to reinforce the links between the three sectors of the company's business highlighted at the fair. This stand seems extremely straightforward, once executed. In fact, it is a radical solution, requiring confidence on the part of the client and sensibility on the part of the designer.

Bei früheren Ständen dienten Videowände als Wegweiser, doch hier taucht der Besucher in sie ein. Ein zunächst lockeres Gefüge weißer Linien auf Blau (passend zu Boden und Wänden des Stands) wird allmählich von abstrakten Figuren und einem fahrenden Rennwagen bevölkert, verwandelt sich in ein Muster aus Wirbeln, Geraden und Bögen und schließlich in einen Strudel digitaler Kameras und dergleichen. An bestimmten Schlüsselpunkten wird dasselbe Bild auf die „Dropscreens" projiziert (rings um die Standfläche verteilte HD-Flachbildschirme auf vertikalen Ständern): Die Bilder bleiben ein paar Sekunden lang synchron, danach zeigen die Plasmabildschirme wieder eigene Bilder. Die Begriffe Lumix, Viera und Diga werden ein- und ausgeblendet. Sie stehen für die Digitalkameras, Plasmabildschirme und DVD-Recorder von Panasonic. Jede dieser Marken wird in einer eigenen Präsentationsfläche unter der umlaufenden Projektionswand vorgestellt. Mit Metaphern für Bilderfassung und -bearbeitung, für Netzwerken und Wiedergabe unterstreicht die Projektion die Verflechtungen zwischen den drei hier präsentierten Standbeinen des Unternehmens. Der Stand wirkt konsequent schnörkellos – eine geradezu radikale Lösung, die dem Kunden Vertrauen und dem Designer Sensibilität abverlangt.

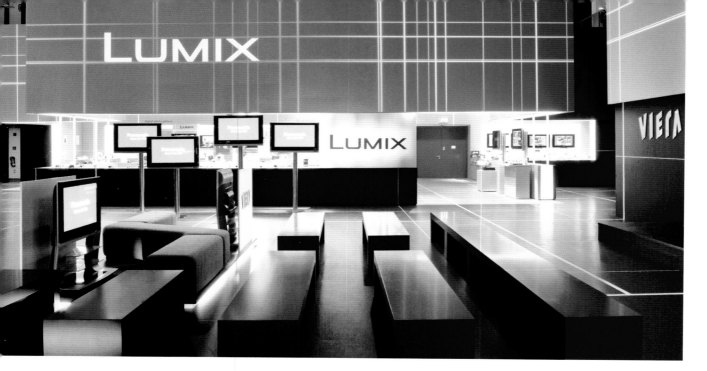

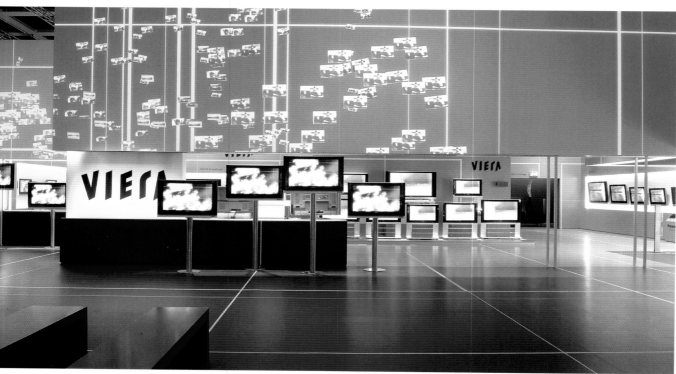

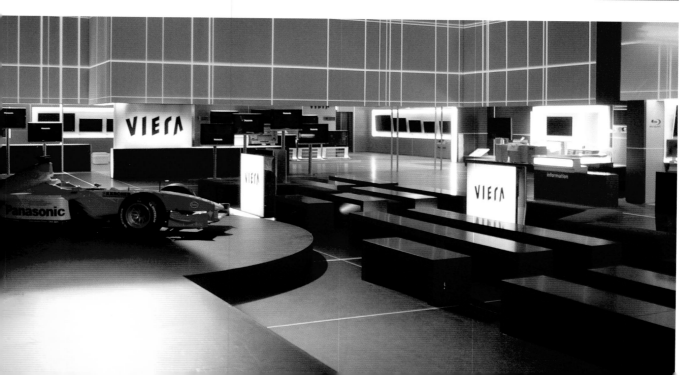

Year	**2005**
Location	**Berlin**
Trade Fair	**IFA**
Exhibitor	**Panasonic Marketing Europe GmbH, Hamburg**
Architect	**Atelier Brückner GmbH, Stuttgart:** **Creative Direction: Prof. Uwe R. Brückner;** **Project Coordination: Shirin Brückner;** **Project Management: Bernd Möller;** **Team: Dirk Schubert, Sven Unger, Uli Matheus,** **Lars Jürgens**
Size	**2,800 m²**
Realisation	**Display International Schwendinger GmbH &** **Co. KG, Würselen**
Light Planning	**Burkhard Jüterbock, Cologne**
Lighting	**Roadshow Veranstaltungstechnik, Walluf**
Graphics/Communication	**Atelier Brückner GmbH, Stuttgart:** **Ulrike Mumm**
Graphics Production	**DZ-Werbung GmbH, Hanover**
Wall Animation/Film Concept	**Atelier Brückner GmbH, Stuttgart**
Film Design and Production	**Marc Tamschick, Berlin; m-box, Göllner &** **Retschitzegger GbR, Berlin**
Media Hardware	**Lang Audiovision AG, Lindlar**
Photos	**Markus Mahle**

PART OF YOUR TRAINING. PART OF

Champion

AUTHENTIC ATHLETIC APPAREL

Going Walkabout

Auf Wanderschaft

Dieter Thiel
for Adidas

Dieter Thiel
für Adidas

A company that produces several thousand new products each year cannot rely on a few fairs, even ones as important as ISPO in Munich, to show the totality of its offer to the whole of its clientele. So Adidas have developed, as well as in-house events at other locations around the world, a "permanent fair" at its headquarters in Herzogenaurach, a dedicated brand centre where clients are invited to see and order new products and future lines, technological innovations and new promotions.

The stand at ISPO is therefore now a meeting centre, a brandscape, where, according to Albrecht Bangert, who worked on the communications and graphics content along-side Dieter Thiel, the stand's architect, "brand awareness through quality instead of quantity is the strategy."

Ein Unternehmen, das Jahr für Jahr Tausende neuer Produkte herstellt, kommt mit ein paar Messen, selbst so bedeutenden Events wie der Münchner ISPO, nicht aus, um die ganze Bandbreite seines Angebots sämtlichen Käuferschichten vorzuführen. Adidas entwickelte deshalb neben hausinternen Events an Standorten weltweit in der Firmenzentrale in Herzogenaurach eine „Dauerausstellung". Adidas-Kunden können im Brand Center neue Produkte, künftige Produktlinien, technische Innovationen und neues Promotionmaterial begutachten und bestellen.

Der Stand bei der ISPO dient deshalb eher als Treffpunkt und Markenlandschaft. Nach den Worten Albrecht Bangerts, der zusammen mit dem Standarchitekten Dieter Thiel die Kommunikation und die grafischen Konzepte des Standes erarbeitete, lautet die Strategie „Markenwahrnehmung durch Qualität statt Quantität."

A few highlight products are shown: for this fair the key themes were "running" and "outdoor." Under a formal yellow grid the two themes were expressed individually, running by a rhythm of curved smooth lines, outdoor by more ordered "alpine" forms and shapes. The result was a dense and visually exciting area, full of surprises, an appropriate location for chance and interesting encounters. There was also a third business area with rooms for private meetings.

The development of this broad front strategy by Adidas shows how the ethos of the temporary stand can be transmuted and extended into a set of different dialogues and contexts as part of a broad branding and marketing strategy.

Vorgeführt werden jeweils nur einige wenige herausragende Produkte. Die Schlüsselthemen der ISPO waren „Laufen" und „Outdoor". Unter einem eckigen gelben Gitter wurden diese zwei Themen separat behandelt: das Laufen mit einer rhythmischen Abfolge weich geschwungener Linien, Outdoor durch geordnetere „alpine" Formen. Das Ergebnis war eine dichte, visuell spannende Fläche voller Überraschungen – genau das richtige Umfeld für interessante, anregende Zufallsbegegnungen. Ein dritter Bereich bot Räume für vertrauliche Besprechungen.

Die Entwicklung dieser breit angelegten Strategie bei Adidas beweist, dass sich das Ethos des zeitgenössischen Messestands in unterschiedliche Dialoge und Kontexte im Rahmen einer übergeordneten Marken- und Marketingstrategie überführen und ausweiten lässt.

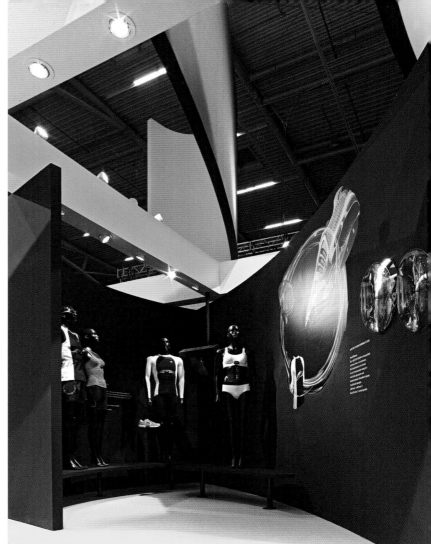
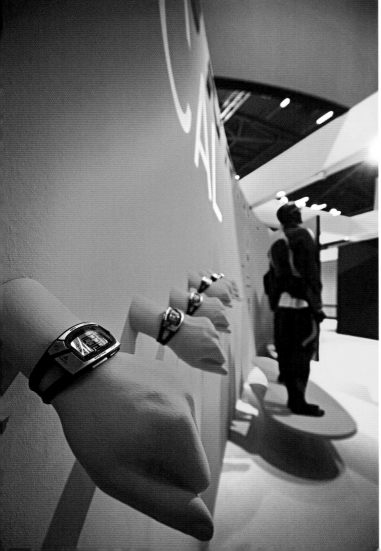
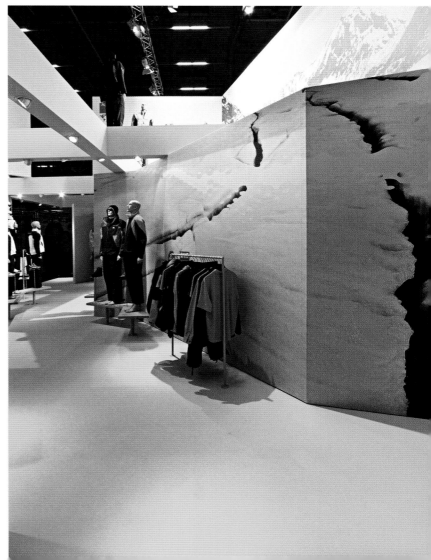

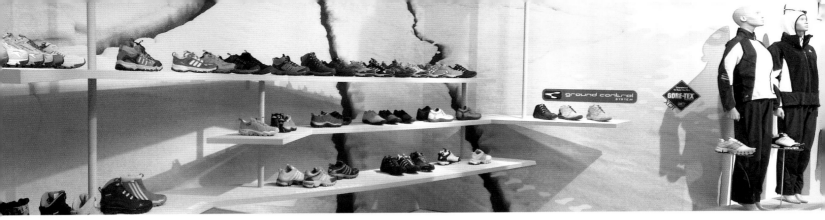

2006

Munich

ispo

adidas AG, Herzogenaurach

Dieter Thiel, Basle

600 m²

Kunzweiler Group, Weil am Rhein

Bangert International, Schopfheim

Rainer Viertlböck, Gauting

"innovation is the compass by which this company sets its direction."
— W.C. Ford, Jr.

Transport

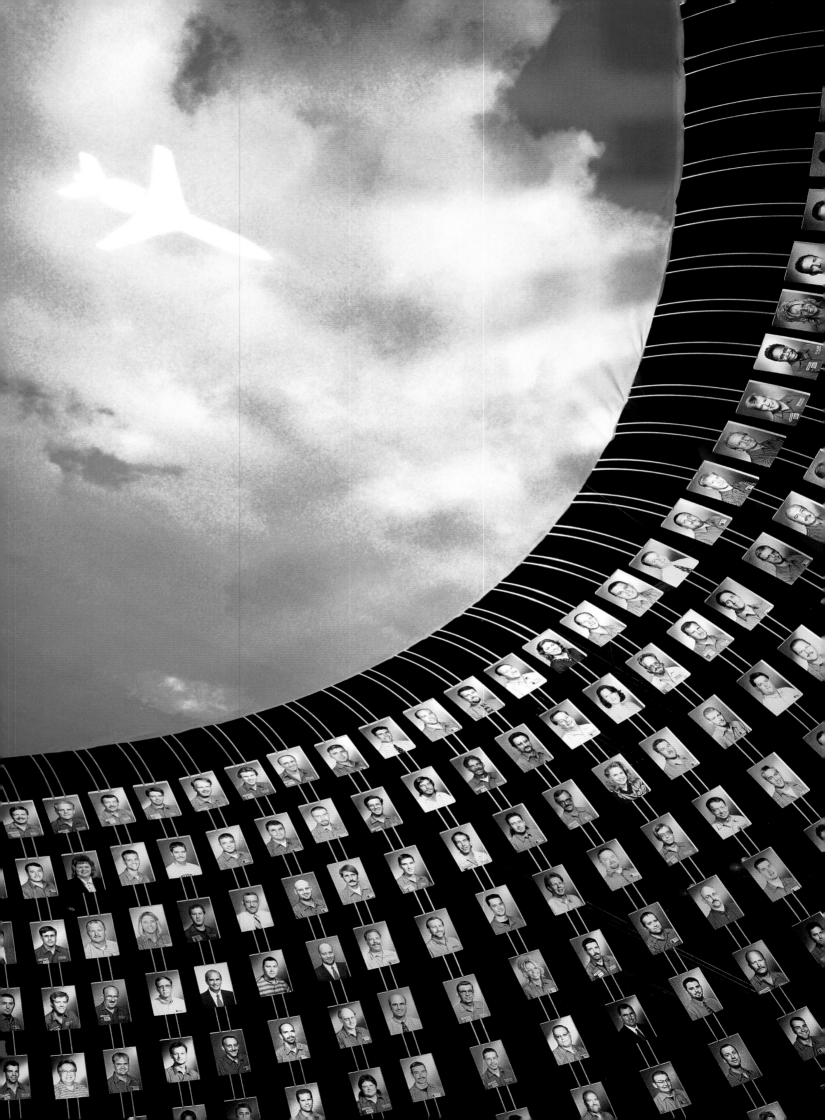

Skywriting

Himmelsschrift

Mauk Design
for Duncan Aviation

Mauk Design
für Duncan Aviation

This 30 x 40 foot stand is the third design by Mauk for Duncan Aviation since the company started its business of maintaining and servicing corporate aircraft in 1984. From the beginning, designer and client realised that the value of a business that is looking after such expensive and important equipment lay in the workforce, and their expertise and dedication. Corporate aircraft are expensive to own and run, so any down-time for servicing must be kept to a minimum, but equally they transport the most important people in the corporation, so their safety and efficiency is also paramount. Meeting those two objectives is in the end in the hands of the company's employees.

Der 9 x 12 Meter große Stand ist der dritte von Mauk für Duncan Aviation, seit das Unternehmen sich 1984 in der Wartung und Betreuung von Firmenflugzeugen etablierte. Von Anfang an waren Designer und Kunde sich einig, dass ein Betrieb, der so wertvolle Maschinen instandhält, sich vor allem durch Erfahrung und Engagement seiner Mitarbeiter auszeichnet. Firmenflugzeuge sind in Anschaffung und Betrieb eine kostspielige Sache. Die Ausfallzeiten wegen Wartungsarbeiten müssen deshalb möglichst knapp gehalten werden, doch zugleich transportieren sie die wichtigsten Leute eines Unternehmens, so dass Sicherheit und Funktionsfähigkeit gegeben sein müssen. Beiden Forderungen gleichermaßen gerecht zu werden, ist letztlich Sache der Belegschaft.

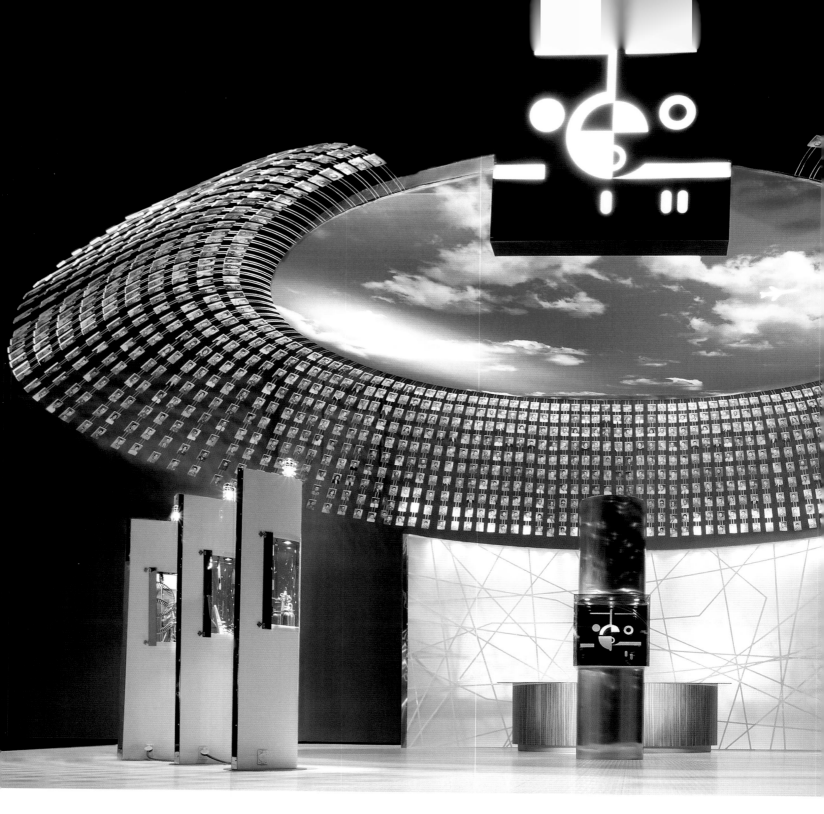

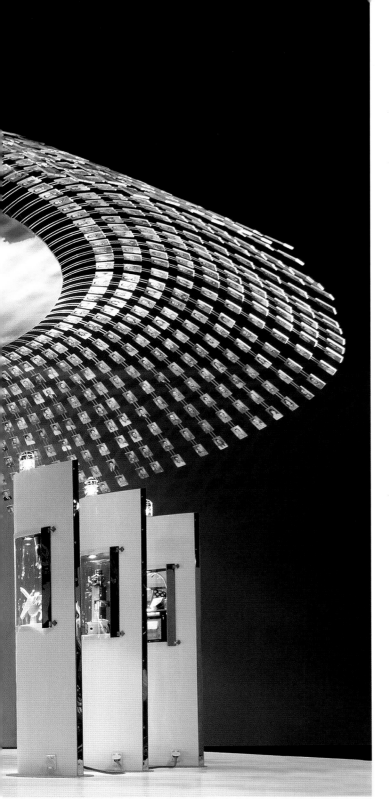

So the first stand, like the present one, featured the names and images of the workforce – not the managers and directors only, but the shop-floor team as well. As the team has grown from just under eighty to over two thousand two hundred, a larger stand was needed, and a different approach to putting the names on the outer wall of the previous drum stand. Mauk's solution was a ceiling of images, a sky filled with pictures of those who, literally in this case, watch over their customers.

To the human element Mauk added the other necessary elements of precision and efficiency: the detailing of the support elements on the stand show this in their material quality and elegant execution. And fronting the stand was a glass and steel sculpture of the Duncan Aviation logo, originally designed by Mauk – and still unchanged.

Beim ersten Stand wurden deshalb ebenso wie nun beim dritten die Namen und Fotos der Mitarbeiter präsentiert – nicht nur von Managern und Vorstand, sondern auch der Werkstattcrew. Da die Mannschaft von knapp 80 auf über 2.200 angewachsen ist, musste der Stand etwas größer sein, doch auch so konnte man nicht mehr alle Namen an der Fassade anzeigen wie beim zylindrischen ersten Stand. Mauk hängte deshalb die Decke des Standes – den Himmel sozusagen – voll mit den Fotos der Leute, die für ihre Kunden als eine Art Schutzengel fungieren.

Neben dem menschlichen Faktor kamen bei Mauk andere wesentliche Elemente wie Präzision und Effizienz nicht zu kurz. Die strukturellen Teile des Standes bekräftigen diese Werte durch Materialqualität und elegante Ausführung. Vor dem Stand befand sich eine Plastik des Duncan-Firmenlogos aus Stahl und Glas, ein bis heute unverändertes Mauk-Werk der ersten Stunde.

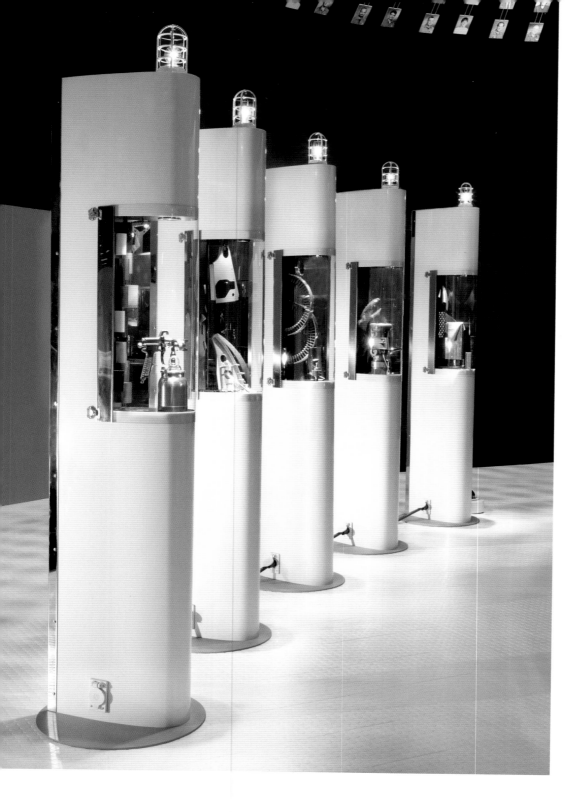

Customer Recommendation Letters

Aircraft Corridor Map Wall

Reception Desk

Divisional
Display Fins

Divisional
Display Fins

Logo Sculpture

Seating/Conversation

Seating/Conversation

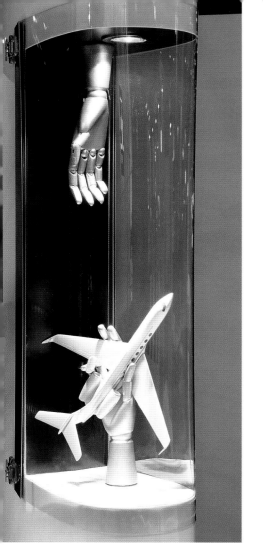

Year	**2005**
Location	**Orlando**
Trade Fair	**NBAA**
Exhibitor	**Duncan Aviation, Lincoln**
Architect	**Mauk Design, San Francisco**
Size	**186 m²**
Realisation	**Czarnowski Exhibits**
Lighting	**Czarnowski**
Graphics/Communication	**Mauk Design, San Francisco**
Photos	**Andy Caulfield**

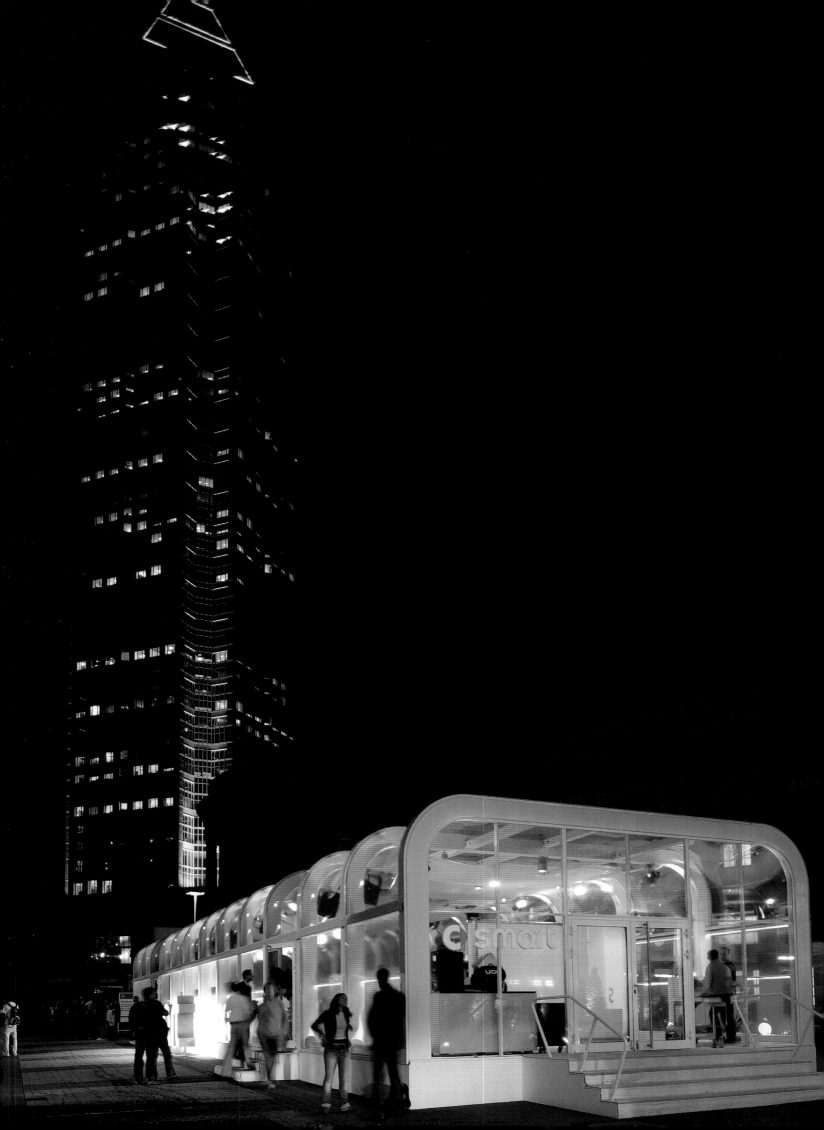

Driving on the Inside Track
Auf der Überholspur

Braun Wagner
for smart

Braun Wagner
für smart

Someone once described the smart as a toy car, not in the sense that it needed a key to wind it up, but in the old sense of a toy – miniature, specialised, exquisite. The development of the range of vehicles has maintained this chic quality, and the same brand values can be seen in this stand design by Braun Wagner.

It is almost as if the car is put in an interior setting, portrayed as a lifestyle accessory rather than a mode of transport. In the main display area the teardrop modern lights, the soft furnishings, though in cool and contemporary colours, contribute to this subtle effect. The translucent hospitality tube has a club-type lightshow and is more catwalk than forecourt.

Wer den smart ein Spielzeugauto nennt, meint nicht, dass man ihn mit einem Schlüssel aufziehen müsste, sondern dass er wie eine vorzüglich gemachte Miniaturausgabe wirkt. Die Modelle haben sich trotz zunehmender Vielfalt ihren schicken Anspruch bewahrt, und genau diese Markenwerte finden sich auch beim Standdesign von Braun Wagner wieder.

Man könnte fast glauben, der Wagen stünde in einem Innenraum, eher wie eine Art Lifestyle-Accessoire denn ein Transportmittel. Die angesagten Tropfenleuchten und die kühlen, aktuellen Farben der bequemen Sitze auf der Hauptausstellungsfläche tragen zu diesem subtilen Effekt bei. Der gläserne Hospitality-Pavillon ist mit einer Lightshow ausgestattet, die an einen Club erinnert und eher Laufsteg als Atrium ist.

That this is only part of the intended effect can be seen in the use of materials, which emphasise the technical virtuosity of the product with high plasma screens, high-tech fabrics for backlighting, self-supporting frame construction, and so forth.

The accessory performs, and performs flawlessly. And the smartware collection launched at the show makes it clear that this accessory can accessorise.

Dass dieser Effekt beabsichtigt ist, beweisen die eingesetzten Materialien. Sie unterstreichen die technische Brillanz des Produkts etwa mit hoch angebrachten Plasmabildschirmen, den Hightech-Geweben der Backlights und freitragenden Rahmenkonstruktionen.

Dieses Accessoire schmückt nicht nur – es bringt tadellose Leistung. Die auf der IAA vorgestellte „smartware"-Kollektion zeigt, dass sich auch ein schickes Accessoire mit weiteren Zutaten noch attraktiver machen lässt.

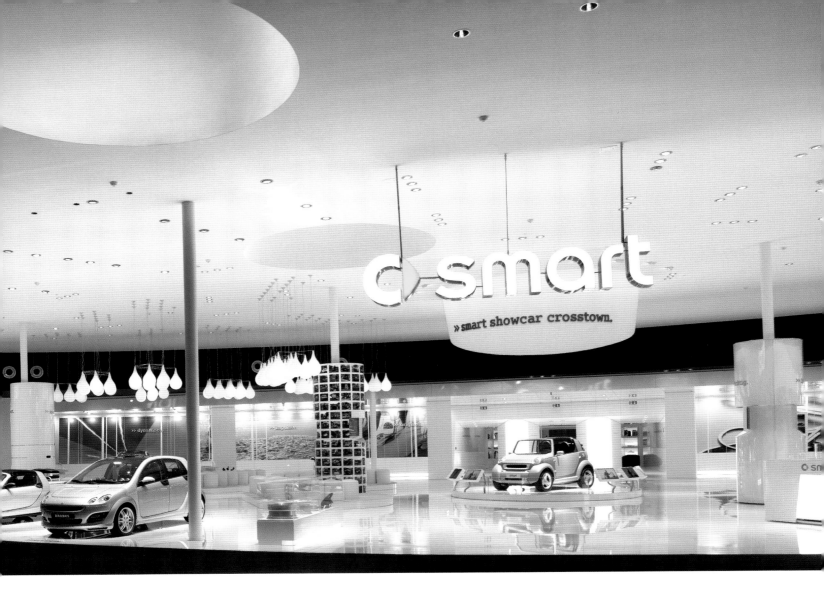

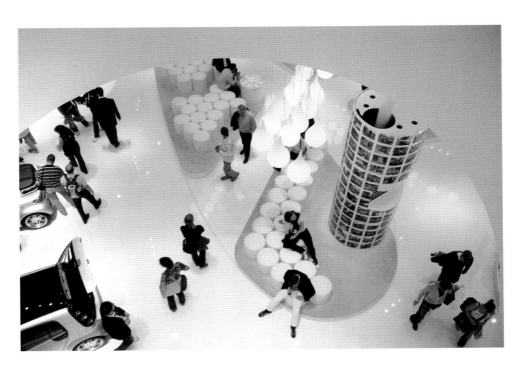

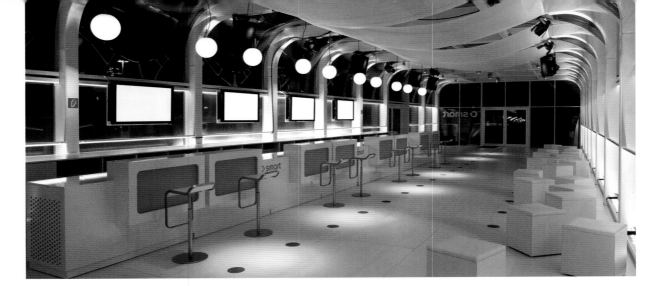

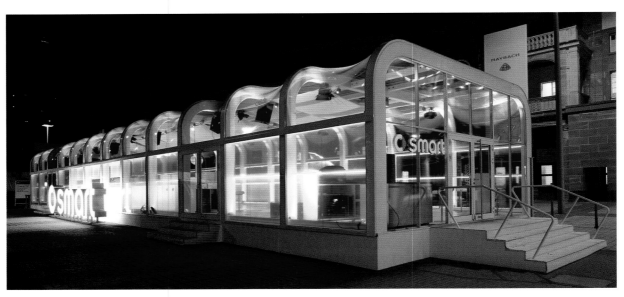

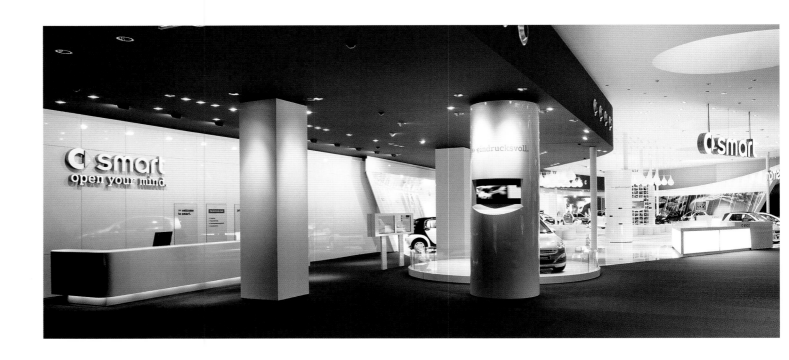

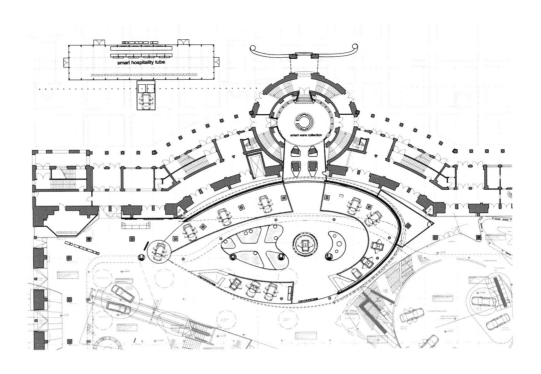

Year	**2005**
Location	**Frankfurt**
Trade Fair	**IAA**
Exhibitor	**smart gmbh**
Architect	**Braun Wagner, Aachen**
Size	**2,000 m²**
Realisation	**Klartext, Willich**
Lighting	**Burkhard Jüterbock, Lichtkunstkonzepte, Cologne; Jörg Verbeck, Tom Langridge, Trussco, Neuss**
Technical Realisation	**Light Company, Neuss; mu:d, Cologne; Klartext, Willich**
Graphics/Communication	**Braun Wagner, Aachen**
Film Production	**Gunnar Ohlenschläger, Media, Sound & Pictures, Offenbach; Markus Frey, Neonred, Hürth**
Photos	**Andreas Keller, Altdorf**

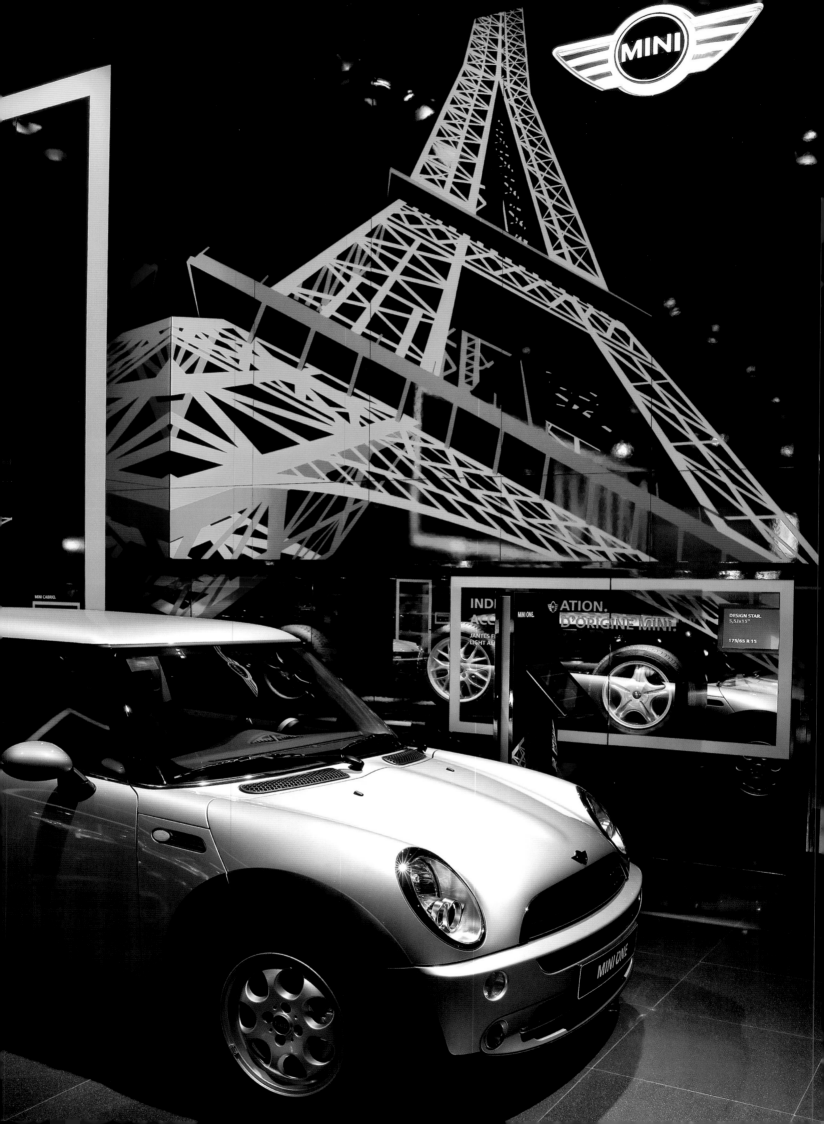

Up Close and Personal
Ein persönliches Accessoire

:: dan pearlman markenarchitektur
for Mini

:: dan pearlman markenarchitektur
für Mini

The Mini is not just a car or a brand but a lifestyle, and an international one as well, from Brooklyn to Beijing to Barcelona. That is the central message of this stand at the Paris motor show, under the strapline "Let's Mini." The stand takes its styling and imagery from the club rather than the car park, with bold iconic images in black and gold frames and dark reflective surfaces. The theme is that the Mini is part of youth culture, urban and cool: in the designer's words, the stand is packed with "abstract urban impressions, full of life in which the car acts as an icon of mobility, agility and joie de vivre".

Der Mini ist weder Auto noch Marke, sondern ein Lebensstil, obendrein einer, der von Brooklyn über Bombay bis Barcelona global Anklang findet. Bei der Pariser Automobilausstellung war dies die zentrale Botschaft des Mini-Auftritts unter dem Motto „Let's Mini". Styling und Bildmetaphorik des Stands mit plakativen Bildern in schwarz-goldenen Rahmen und spiegelnden dunklen Oberflächen entstammen eher der Disco als dem Autohaus. Der Tenor lautet: Der Mini ist Teil der coolen städtischen Jugendkultur. Mit den Worten des Designers: Der Stand ist dicht bestückt mit „abstrakten urbanen Impressionen und voller Leben, in dem der Wagen als Ikone der Mobilität, Agilität und Lebensfreude fungiert."

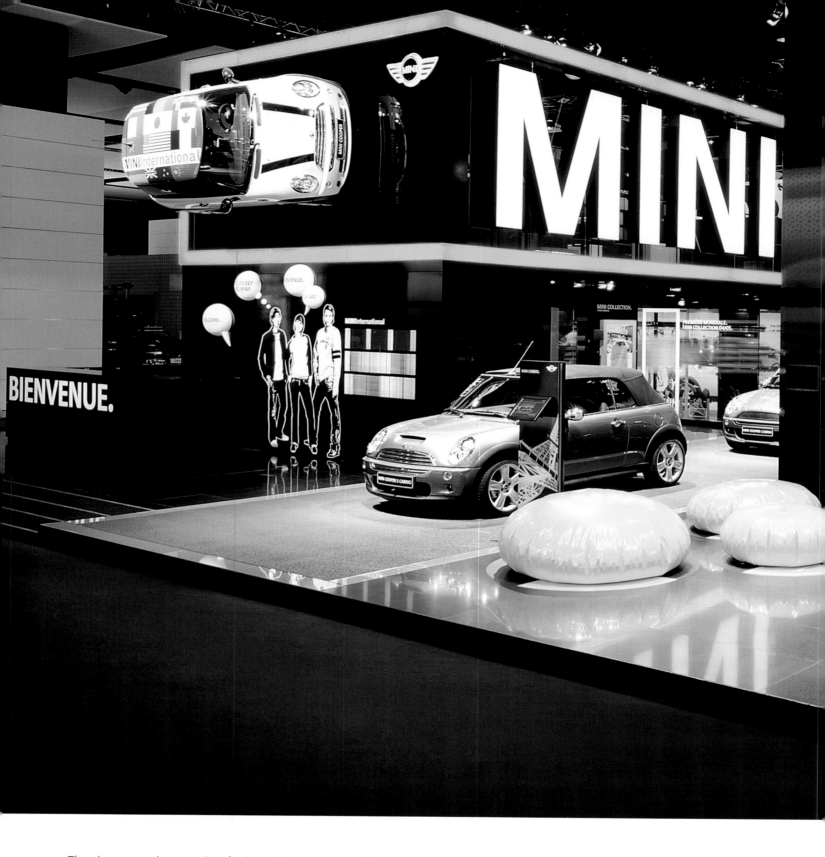

The show was the occasion for launching a range of lifestyle accessories and clothing, the Mini Collection Premiere, as well as the John Cooper Works Tuning Kit: both intended to enhance performance. The continuing success of the Mini has relied on the brand being able to modulate and equate itself with trends in fashion, design and culture (something that the original Mini also achieved.) The bold use of graphics and the contemporary hi-tech tone of the architecture show how this stand develops and improves that process, by insisting on the special personality of the car and its relevance to the target market.

Anlässlich dieser Messe lancierte Mini Lifestyle-Accessoires und Bekleidung als „Mini Collection Premiere" sowie das John Cooper Works Tuning Kit. Beides zielt auf Leistungsverbesserung. Der andauernde Erfolg des Mini hat viel damit zu tun, dass die Marke sich Mode-, Design- und Kulturtrends anzupassen weiß (das konnte schon der allererste Mini). Die plakativen grafischen Elemente und der zeitgenössische Hitech-Touch der Standarchitektur beweisen, dass der Auftritt genau diesen Prozess weiterentwickelt und bereichert, indem er die individuelle Persönlichkeit des Wagens und seine Bedeutung für die Zielgruppe unterstreicht.

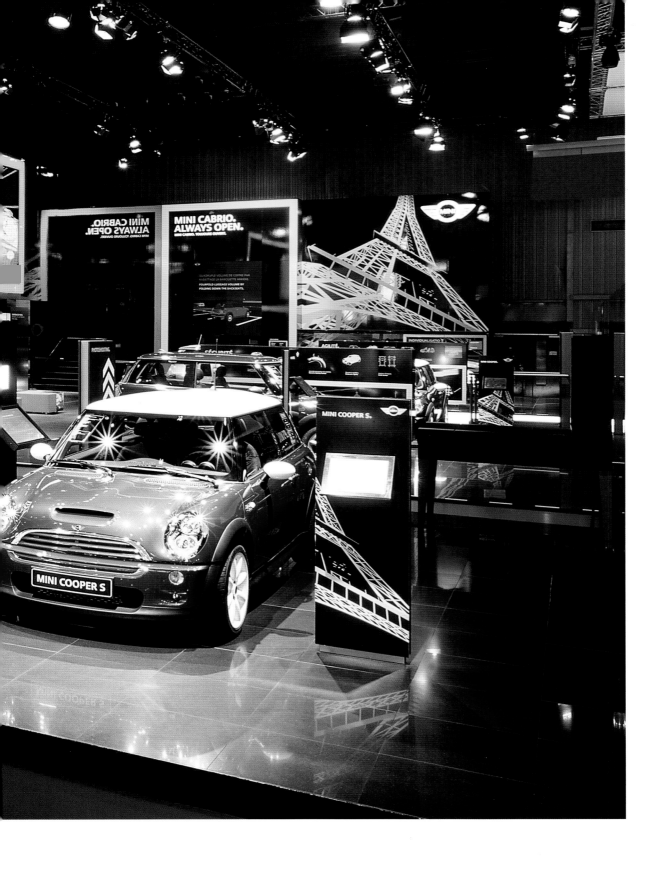

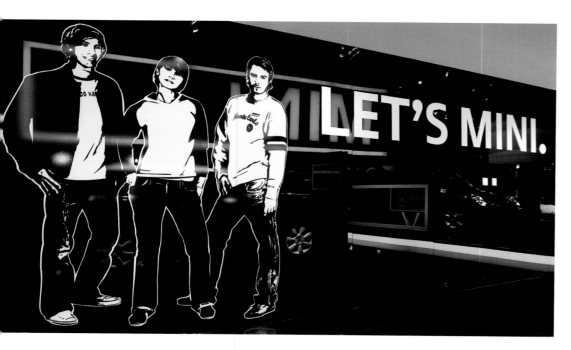

Year	**2004**
Location	**Paris**
Trade Fair	**Mondial de l'Automobile**
Exhibitor	**BMW Group AG, Munich**
Architect	**:: dan pearlman markenarchitektur, Berlin**
Size	**567 m²**
Realisation	**Kothig Messebau GmbH**
Statics	**Posselt Consult GmbH**
Lighting	**Service für Showtechnik**
Graphics/Communication	**:: dan pearlman markenarchitektur, Berlin; Graphics Steering: Atelier B.; Graphics Implementation: Weila Bildtechnik GmbH; Oberndörfer Grafik GmbH**
Lifestyle Decoration	**Studio 38 pure communication GmbH**
Film	**gate.11 audio-visuelle kommunikation GmbH**
Sound, Technics, Exhibits	**MKT AG, ict (Innovative Communication Technologies AG); gosub communications gmbh**
Implementation Planning and Steering	**Puchner + Schum**
Photos	**diephotodesigner.de**

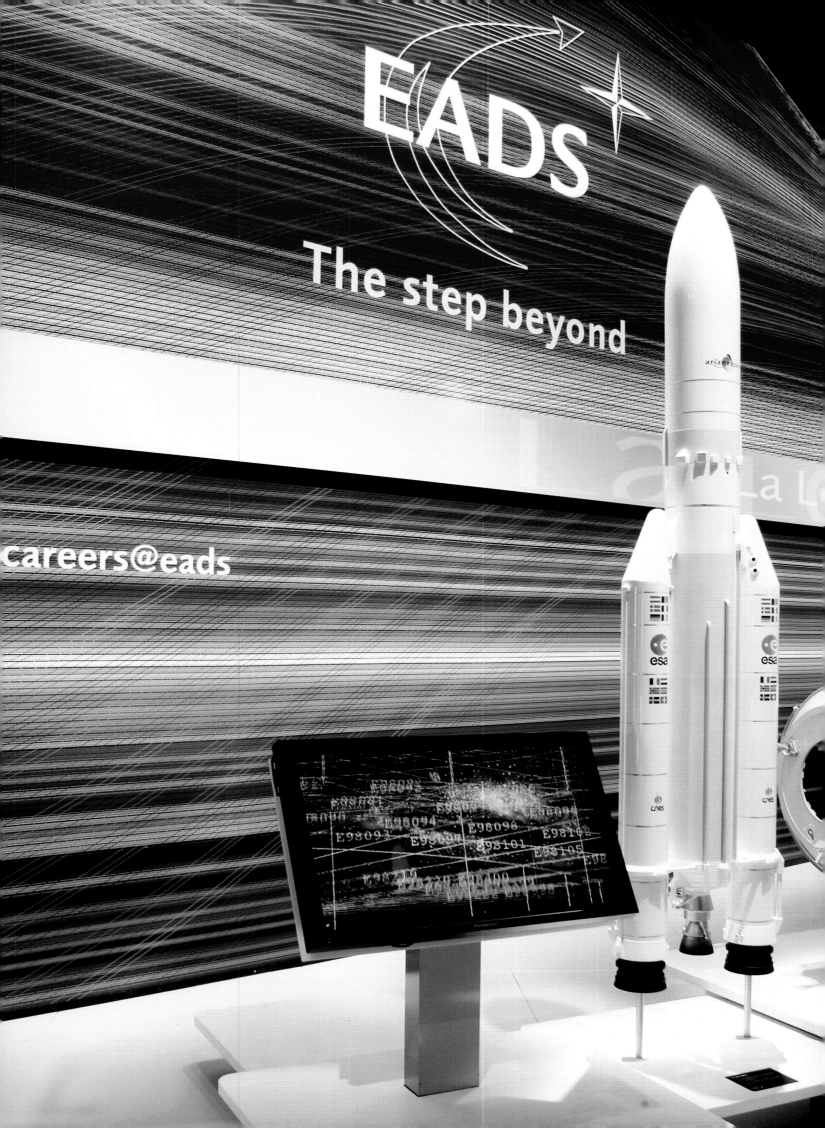

Core Values

Kernwerte

VRPE Team
for EADS Deutschland

VRPE Team
für EADS Deutschland

Building an airliner whose two passenger decks are each longer than the distance covered by the Wright brothers' first flight would seem to be a big enough story, but the challenge facing VRPE for EADS at the Paris Air show was more subtle. Airbus is part only of one third of EADS business, the others being space and defence. Each had its own clientele at the show, so required their own areas, while the corporation needs to stress its unified nature.

The solution was The Core, a two storey white inverted and truncated cone that formed the visual centerpiece of the stand, flanked on one side by a two storey meeting and hospitality pavilion and on the other by a mockup of the passenger cabins on the A380, also – appropriately – on two levels.

Ein Flugzeug zu konstruieren, dessen beide Passagierdecks länger sind als die Strecke, die die Brüder Wright bei ihrem ersten Flug zurücklegten, ist buchstäblich eine ganz große Sache. Die Herausforderung für VRPE bei der Gestaltung des EADS-Stands für die Pariser Luftfahrtmesse war weitaus subtiler. Airbus bildet neben Raumfahrt und Verteidigung eines der drei Standbeine der EADS-Gruppe. Obwohl jede Sparte bei der Airshow ihre eigene Kundengruppe betreute und deshalb einen separaten Bereich benötigte, war dem Konzern an einem einheitlichen Auftritt gelegen.

Die Lösung war ein zweistöckiger, umgekehrter weißer Stumpfkegel als visueller Ankerpunkt des Stands, flankiert von einem zweigeschossigen Pavillon als Treffpunkt und Gästelounge auf der einen und von einem Modell der bezeichnenderweise ebenfalls zweistöckigen Passagierkabinen des A380 auf der anderen Seite.

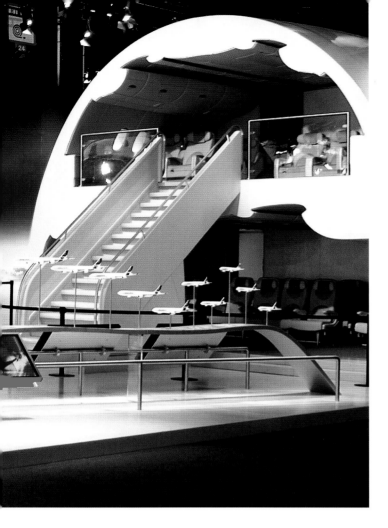

Keeping the core white (though with coloured lights under-
scoring the segments of the structure), allowed the individual
sectors to use their brand colours to identify their locations.
The form of the Core, with its bands of white stepping out-
wards as it rose, formed a metaphor for progress and achieve-
ment, using the visual vocabulary of the venturi of a rocket or
the inlet of a jet engine. The Core positions the company as a
leader in the field, by using imagery, in a formal way, directly
related to the field concerned.

Während der Kegel absichtlich weiß blieb, auch wenn er zur
Betonung der einzelnen Segmente farbig beleuchtet wurde,
waren die Unternehmensbereiche jeweils anhand ihrer Mar-
kenfarben klar unterschieden. Die nach oben ausladender
werdende Kegelform diente als Sinnbild für Fortschritt und
Leistung, zumal die vorkragenden Reifen das visuelle Vokabu-
lar von Raketen- und Düsenjetturbinen konnotieren. Den
Führungsanspruch des Unternehmens drückt der Kegel – „the
Core" – insofern mit einer Bildsprache aus, die direkt der be-
treffenden Branche entlehnt ist.

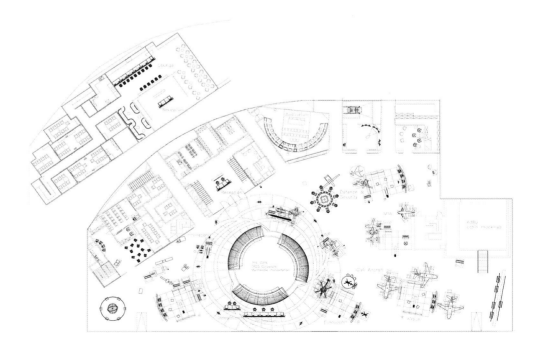

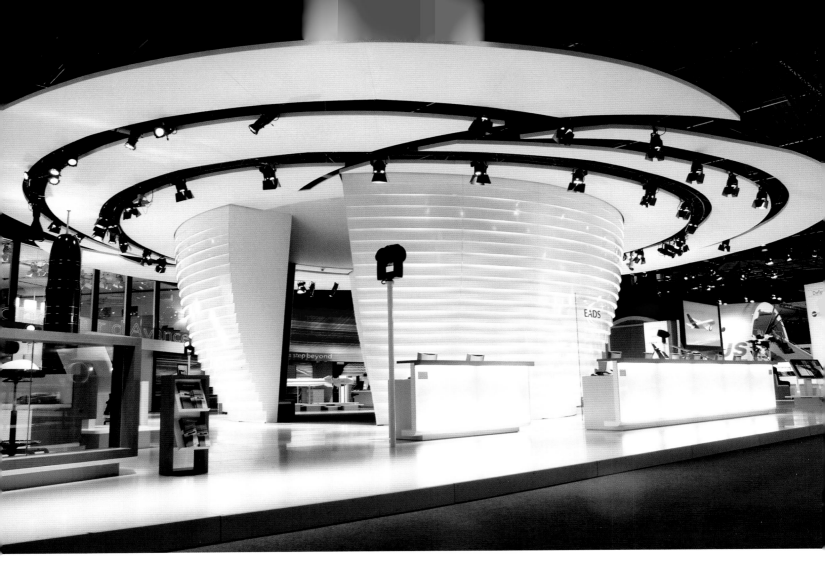

Year	**2005**
Location	**Le Bourget**
Trade Fair	**Paris Airshow Le Bourget**
Exhibitor	**EADS Deutschland GmbH, Ottobrunn**
Architect	**VRPE Team GmbH, Hohenbrunn: A. Rieder**
Size	**2,300 m²**
Realisation	**VRPE Team GmbH, VRPE Media GmbH, Hohenbrunn**
Lighting	**Showtec Beleuchtungs und Beschallungs GmbH**
Graphics/Communication	**VRPE Media GmbH, Hohenbrunn: M. Schlechter**
Multimedia	**VRPE Media GmbH, Hohenbrunn: A. Wahlers, R. William**
Photos	**Bernhard Rohnke, Arne Wahlers**

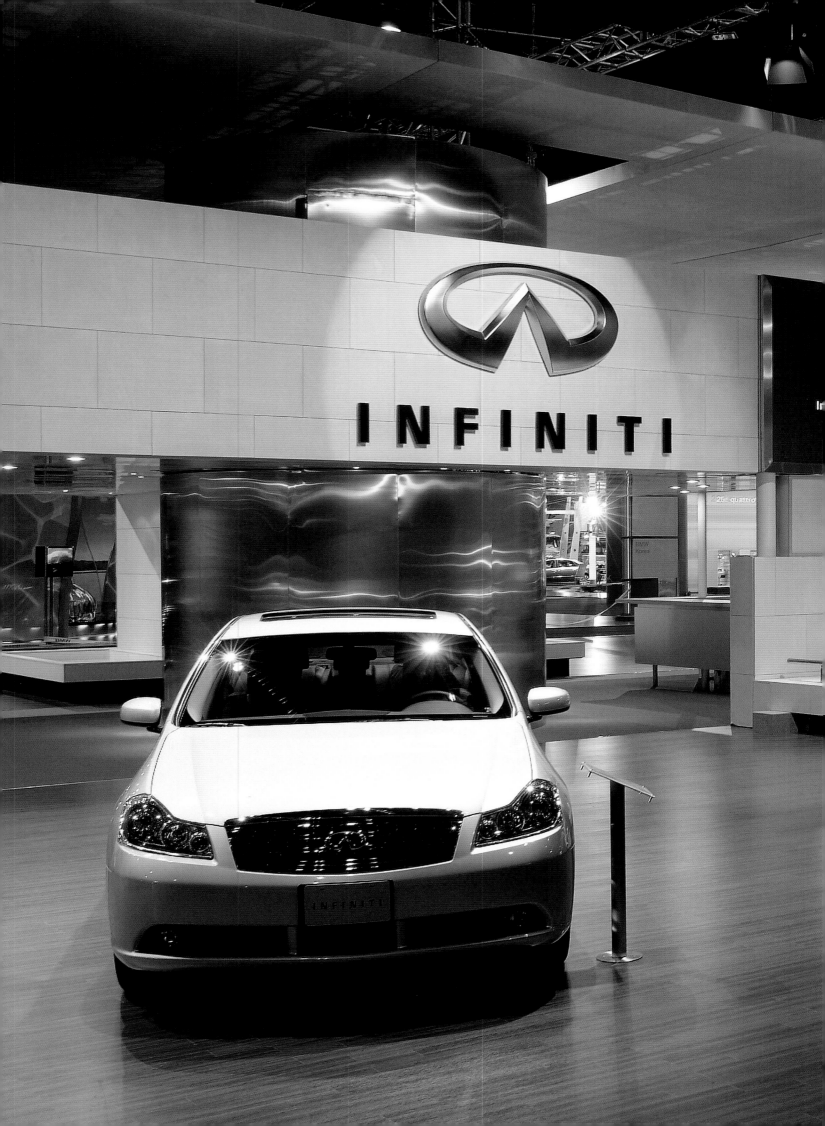

Stating it Simply

Der Einfachheit halber

The George P. Johnson Company
for Infiniti Korea

The George P. Johnson Company
für Infiniti Korea

What are the components of luxury? Material finish? Comfort? Performance? Appearance? All of these, at least, and probably some undefinable extra quality that lifts the conglomeration of these qualities into a perfect whole. And if finding the definition is difficult enough, then finding an appropriate three-dimensional metaphor to convey the concept is a real challenge.

For the Nissan Infiniti range of sedans and SUVs, the design team at George P. Johnson relied, in the end, on simplicity. The vehicles are set out around the perimeter of the stand, and in the centre is a two level white box, with an overhanging white roof, carefully proportioned and fitted out in the interior with glazed meeting spaces furnished with white contemporary furniture.

Was macht Luxus aus? Materialverarbeitung? Komfort? Leistung? Aussehen? All das natürlich und vermutlich obendrein eine undefinierbare Besonderheit, die aus den diversen Eigenschaften ein perfektes Gesamtbild macht. Dieses Element zu identifizieren ist schon schwierig genug, doch die wahre Kunst besteht darin, es in eine passende dreidimensionale Metapher umzusetzen.

Für die Limousinen und Geländewagen der Marke Infiniti setzte das Designteam von George P. Johnson letztlich auf Schlichtheit. Die Fahrzeuge standen rings um einen sorgfältig proportionierten zweistöckigen weißen Kasten mit überstehendem weißem Dach. Im Innern befanden sich gläserne Besprechungsräume, ausgestattet mit modernen weißen Möbeln.

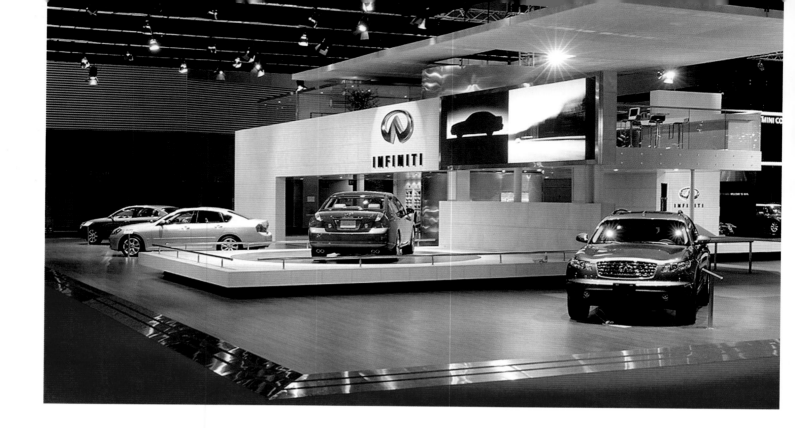

The overall result is elegant without being austere, an architectural statement in the Modernist, almost Miesian idiom, executed with care and feeling, that provides exactly the right backdrop – and at the same time the right centrepiece – to the products on display. Because the architecture is so seemingly understated, its design qualities, the balance of the structural elements and the play of volume and space, can be all the more appreciated, and make a clear statement about the aims and values of the brand. Rather than trying to be insistent and shout about the brand, the stand succeeds through its detatchment, elegance and finish. Not surprisingly, the design won a Gold ED Award.

Der Gesamteindruck ist elegant, ohne karg zu wirken: ein liebevoll und mit Bedacht ausgeführtes architektonisches Statement in einem modernistischen, an Mies van der Rohe erinnernden Idiom, das genau den richtigen Hintergrund für die ausgestellten Produkte und zugleich den Dreh- und Angelpunkt des Ganzen bildet. Gerade weil die Architektur in den Hintergrund tritt, sind ihre Designqualitäten, das Gleichgewicht ihrer strukturellen Elemente und das Wechselspiel von umbautem und offenem Raum umso besser erlebbar und machen eine unmissverständliche Aussage über die Ziele und Werte der Marke. Anstatt mit viel Getöse die Werbetrommel zu rühren, gelingt dies dem Stand gerade durch seine Distanziertheit, Eleganz und sein Finish. Es überrascht daher nicht, dass er den Event Design Award in Gold gewann.

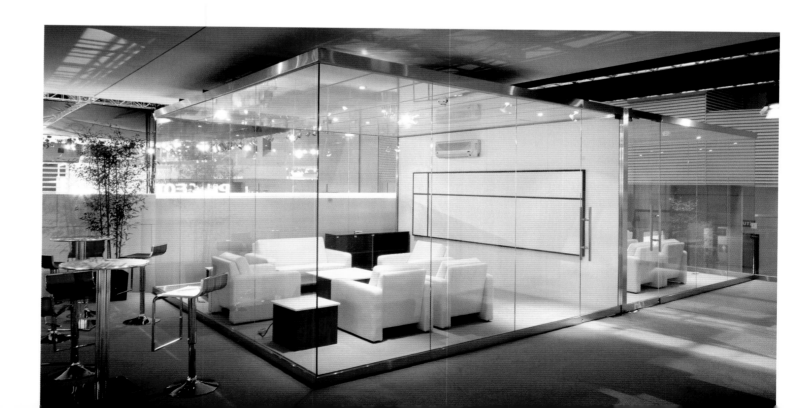

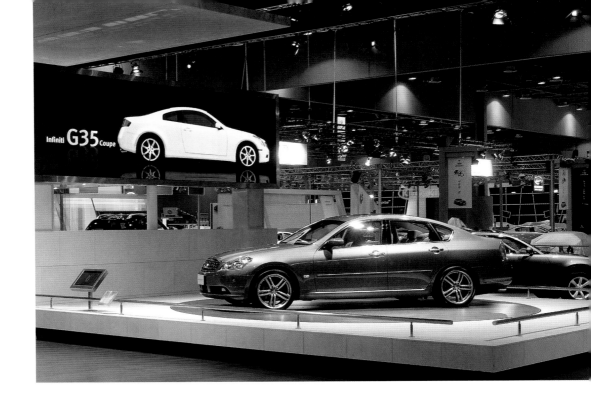

Year	**2005**
Location	**Seoul**
Trade Fair	**Seoul Motor Show**
Exhibitor	**Infinity Korea, Seoul**
Architect	**The George P. Johnson Company,** **Auburn Hills: Joel McCall**
Size	**1,000 m²**
Realisation	**The George P. Johnson Company Korea,** **Japan, Sydney, US**
Stand Construction and Technical Services	**The George P. Johnson Company Korea;** **Kingsmen Korea**
Graphics/Communication	**The George P. Johnson Company, Sydney:** **Julien La Bas**
Photos	**Noon Pictures**

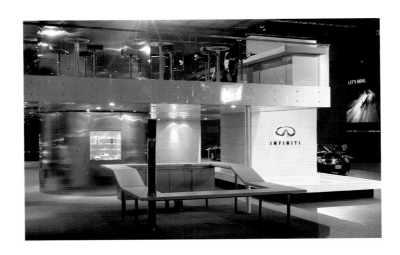

Rectolinear Curves

Geraden und Rundungen

Schmidhuber + Partner
and Mutabor Design
for Audi

Schmidhuber + Partner
und Mutabor Design
für Audi

The passing of Modernism has freed up designers to re-interpret and re-vitalise the classic forms of the discipline. At first glance this stand seems a pure Modernist statement: a rectolinear structure, an upper deck mounted on most Corbusian pilotis, divided into three rectangular bays on the façade, pierced below with perfect and symmetrical circles, each focussing on a different Audi model displayed below. This included the Shooting Brake Concept Vehicle, premiered at Tokyo.

But a closer look at the stand suggests something more complex is going forward. The surfaces of the structure are overlaid with curving meshwork patterns, in a slightly darker grey than the base grey colour. These subtle additions give the whole a sense of movement and fluidity which undercuts the severity of the principal forms.

Das Ende des Modernismus macht Designern den Weg frei, die klassischen Formen ihrer Zunft neu zu interpretieren und zu revitalisieren. Auf den ersten Blick erscheint dieser Stand durchaus noch modernistisch: eine geradlinige Struktur mit einem Obergeschoss auf Säulen, die an Le Corbusiers Pilotis erinnern und einer in drei Rechtecke unterteilten Fassade. Symmetrisch angeordnete kreisrunde Öffnungen heben je ein Audi-Modell hervor (darunter das in Tokio erstmals vorgestellte Concept Car mit der neuen Shooting-Brake-Technologie).

Bei näherem Hinsehen zeigt sich jedoch, dass am Stand etwas ganz anderes passiert. Die Wandflächen sind mit Gitternetzen und geschwungenen Linien in einem etwas helleren als dem Hintergrundgrau überzogen. Auf subtile Weise vermitteln sie den Eindruck von Bewegung und Geschmeidigkeit und lockern so die strengen Grundformen auf.

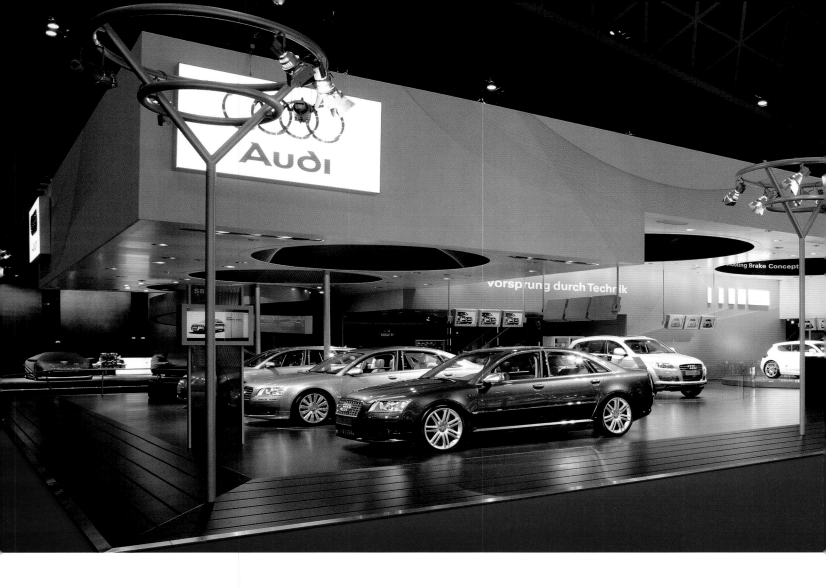

There is also a curved spiral band descending from the upper deck to hover over a circular bench: a purist might see in this an echo of the library ramp in Corb's Maison La Roche, but it is in reality a visual balance to the large rectangular window of the hospitality suite on the other end of the façade. Both use a strong orange motif, marking the design out not as a parody of Modernism but as an independent statement. This interpretation is reinforced by the handling of the hospitality area. The furniture is modern classic, but the use of colour – a palette of orange, cream and dark wood – combined with the large monochrome images show that this is a contemporary space.

In der schwungvollen Spirale, die vom Oberdeck aus zu einer runden Sitzbank verläuft, dürfte ein Purist Echos der Treppe zur Bibliothek in Le Corbusiers Villa La Roche erkennen, aber es handelt sich in Wirklichkeit um den visuellen Kontrapunkt zum großen Rechteckfenster der Gästesuite am anderen Ende der Rückwand. Dank der leuchtend orangefarbenen Akzente wirkt das Design nicht wie eine Persiflage auf den Modernismus, sondern bildet ein eigenständiges Statement. Das unterstreicht auch die Gestaltung des Gästebereichs: In Verbindung mit großen Schwarzweißbildern rückt die klassisch moderne Möblierung in den Farben Orange, Creme und in dunklem Holz den Raum ganz klar in die Gegenwart.

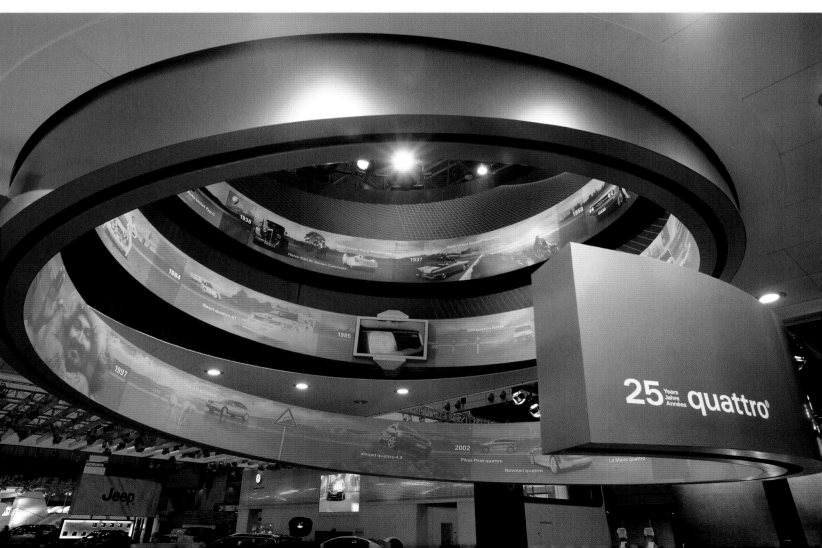

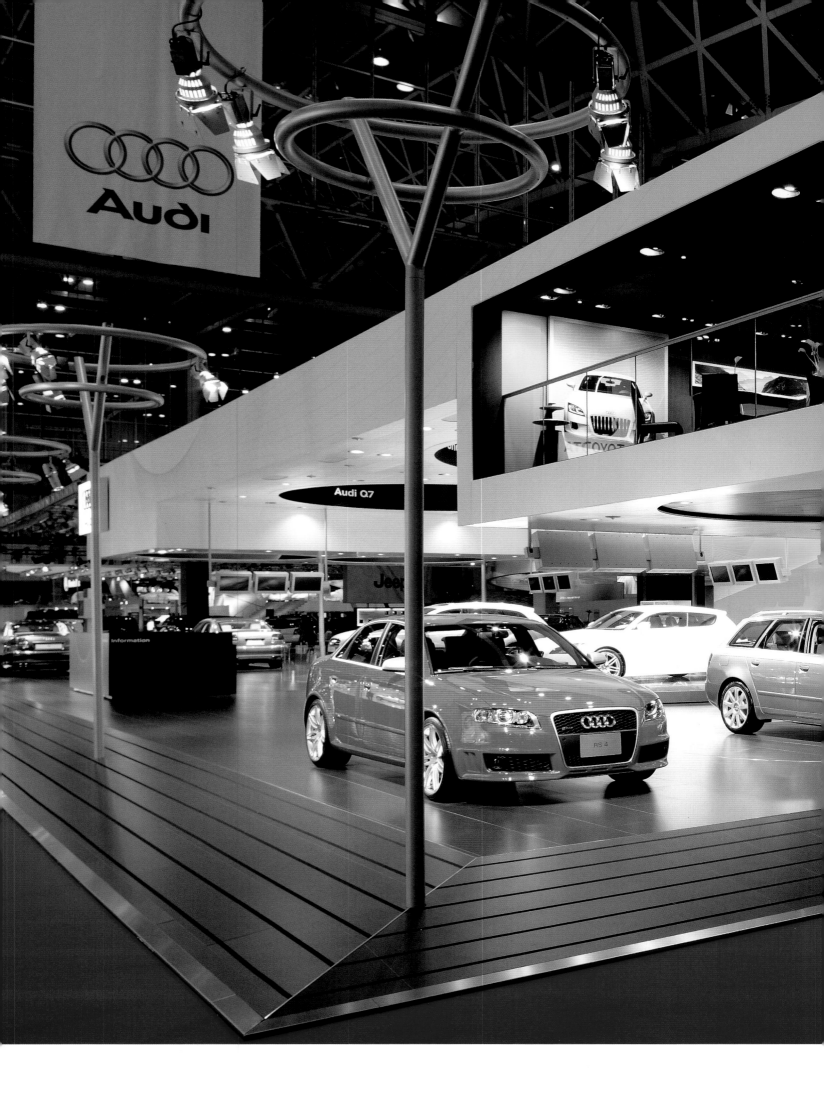

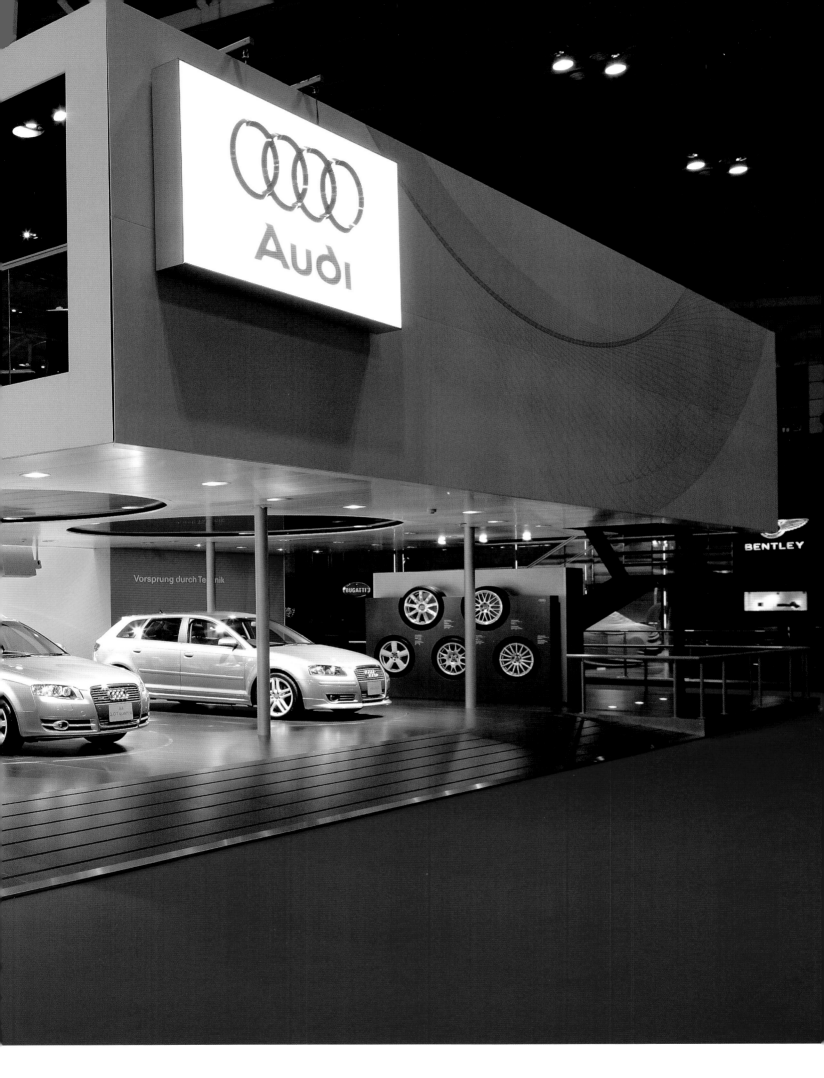

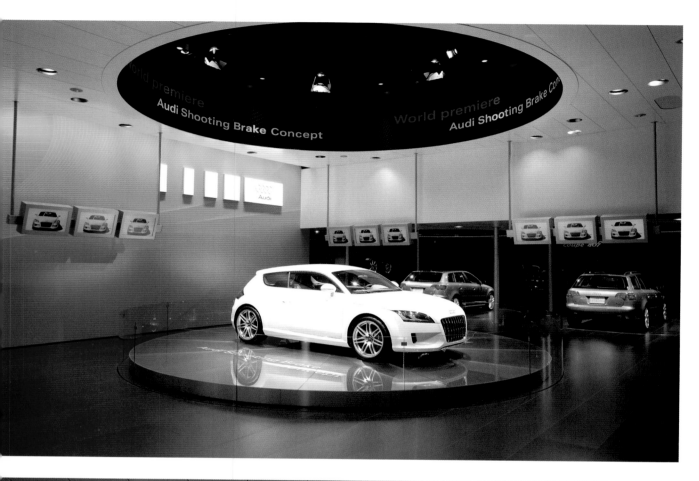

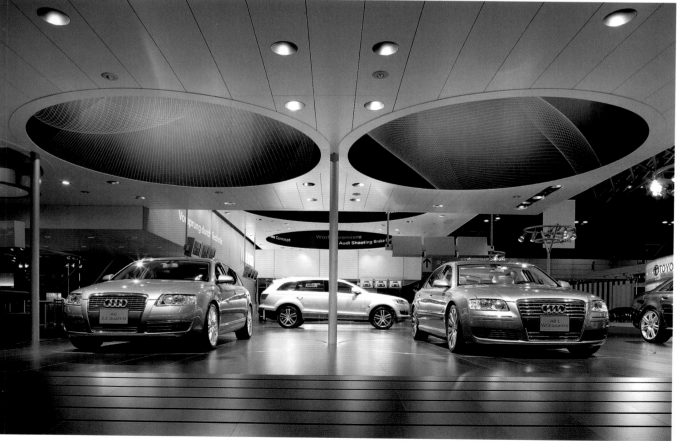

Year	**2005**
Location	**Tokyo**
Trade Fair	**Tokyo Motor Show**
Exhibitor	**Audi AG, Ingolstadt**
Concept and Architecture	**Schmidhuber + Partner, Munich**
Concept and Communication	**Mutabor Design GmbH, Hamburg**
Size	**987 m²**
Realisation	**Expo Company, Monschau**
Structural Engineering	**3e Werner Sobek exhibition & entertainment engineering, Stuttgart**
Light Planning	**Four to One scale design, Hürth**
Show Light	**Showtec, Hürth**
Media Planning	**Planet Media, Berlin**
Airconditioning	**Bloos Däumling Huber, Munich**
Membrane	**Covertex GmbH, Obing**
Media Technology	**CT Creative Technology, Nürtingen**
Highlight Unveiling	**Messebau Klostermair, Untermaxfeld**
Photos	**Andreas Keller, Altdorf**

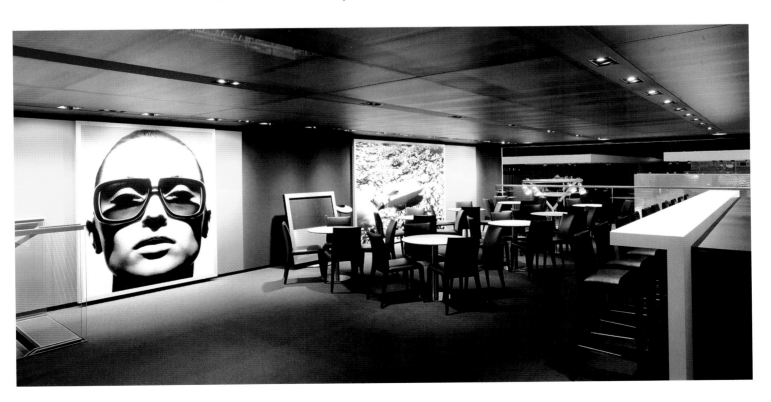

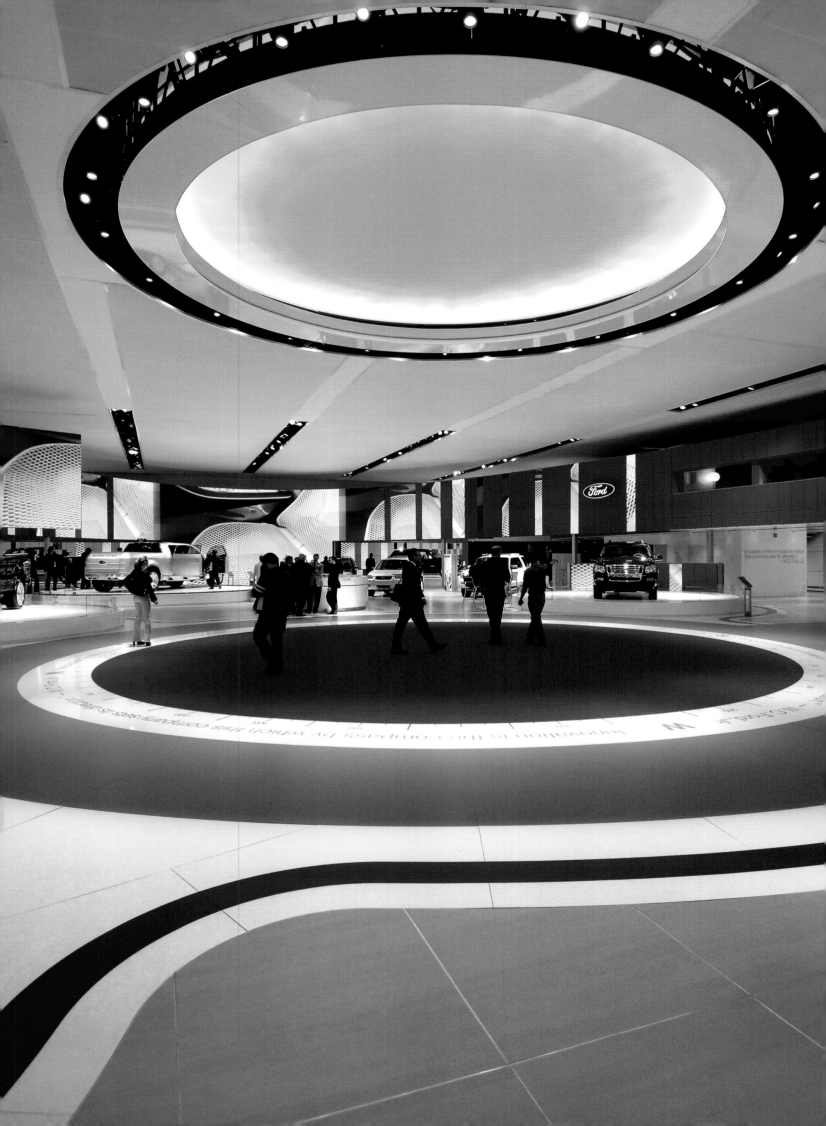

The Thin Blue Line

Blau, blau, blau

Imagination
for Ford

Imagination
für Ford

There's an old story that says that Henry Ford would say to buyers of the Model T Ford that "you can have it any colour you like as long as it's black." True or not, today one would say that Henry certainly knew something about the power of colour in defining a brand. Except now it's blue.

London-based designers Imagination put blue into the foreground for the IAAS show in Detroit. Within the island stand the central area was ringed by an open double height ellipse, blue without and blue within, and with the colour statement reinforced by end panels on the narrower edges and by blue facings (and blue interiors) for the hospitality pavilions along the reverse edge of the stand. The blue band was not just a linking loop: the role of the centrality of the brand was emphasised by the central blue "pool" – a clear space within the loop, and at the centre of the stand, from which the visitor could look over the full range of the Ford offer.

Der Legende nach erklärte Henry Ford Interessenten für das Modell T des öfteren: „Sie können den Wagen in jeder Farbe haben, solange es Schwarz ist." Ob wahr oder nicht, man würde Ford heute in jedem Fall zugutehalten, dass er über den Wert der Farbe für die Definition einer Marke genau Bescheid wusste. Heutzutage ist es Blau.

Bei der NAIAS in Detroit stellte das Londoner Designbüro Imagination Blau ganz in den Vordergrund. Die Mitte des Inselstands war von einer offenen doppelstöckigen, innen und außen blauen Ellipse eingerahmt. Die Farbwirkung wurde noch verstärkt durch Endpaneele an den Schmalseiten und die blauen Fassaden (und Interieurs) der Gästepavillons an der Rückseite des Stands. Das blaue Band bildete nicht nur das Bindeglied, sondern spielte für die Marke eine elementare Rolle, die der zentrale blaue „Pool" noch unterstrich – ein freier Raum innerhalb der Schleife mitten im Stand, von dem aus der Besucher die ganze Ford-Palette im Blick hatte.

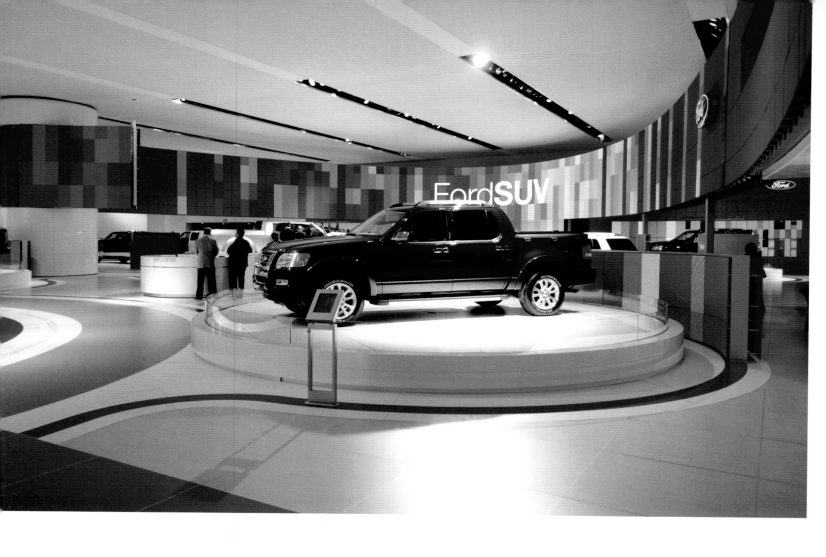

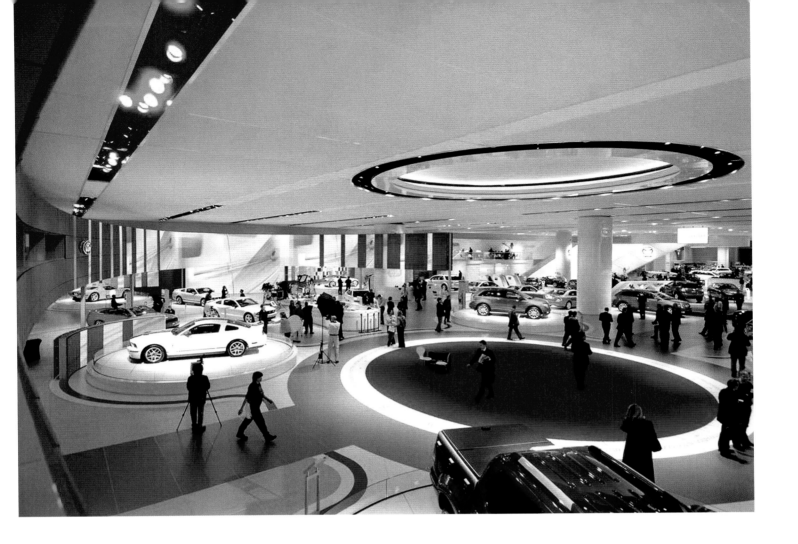

This acted as – and was marked as – a compass point to survey the whole. It was mirrored by a circular ring of lights in the ceiling of the stand. The white ceiling and the exterior walls, with generous corner and side entrances, by enclosing the whole stand gave an air of completeness to the project, a sense of wholeness and containment. Their presence meant that the visitor only discovered the blue band once within the stand. This makes the blue element into an affirmation of the brand's values rather than a proclamation: it is a gesture of confidence.

On the inside face of the blue band there were programmable areas where communication and information videos could be shown on large scale screens, but the central premise was that blue was the link and guarantee of the value of the brand. Given the diversity of the Ford programme, from urban saloons to hybrid prototypes to SUVs, the central message of reliability and continuity was an important one, deliberately moving aside from the multiple marque offer of earlier fairs and restating Ford as a major player in the American automobile market, just as Henry had known all along.

Die Fläche war als Angelpunkt des gesamten Stands ausgewiesen und hervorgehoben durch einen Lampenkreis unter der Standdecke. Die weiße Decke und die Außenwände mit großzügigen Eck- und Seitenöffnungen umschlossen den ganzen Stand und vermittelten so ein Gefühl der Vollständigkeit und Ganzheit. Wegen der Wände entdeckten die Besucher das blaue Band erst nach dem Betreten des Standes. Auf diese Weise proklamierte es die Markenwerte nicht nur, sondern verbürgte sich sozusagen für sie.

An der Innenfläche des blauen Bandes gab es programmierbare Bereiche, wo Werbe- und Dokumentarvideos auf großformatigen Bildschirmen abliefen, doch als Grundprinzip fungierte das Blau als Bindeglied und Garant des Markenwerts. Angesichts der vielseitigen Ford-Palette von Stadtautos über Prototypen mit Hybridmotor bis zu Geländewagen propagierte die zentrale Botschaft Zuverlässigkeit und Kontinuität, anders als beim früheren Messekonzept, das auf die Breite des Markenangebots setzte. Damit rückte Ford wieder in die Riege der ganz Großen im US-Kraftfahrzeugmarkt auf – ganz wie zu Henry Fords Zeiten.

Year	**2006**
Location	**Detroit**
Trade Fair	**NAIAS**
Exhibitor	**The Ford Motor Company**
Architect	**Imagination Ltd, London**
Size	**3,400 m²**
Realisation	**Imagination Ltd, London**
Lighting	**Imagination Ltd, London**
Graphics/Communication	**Imagination Ltd, London**
Photos	**Imagination Ltd, London: Jason Hobday**

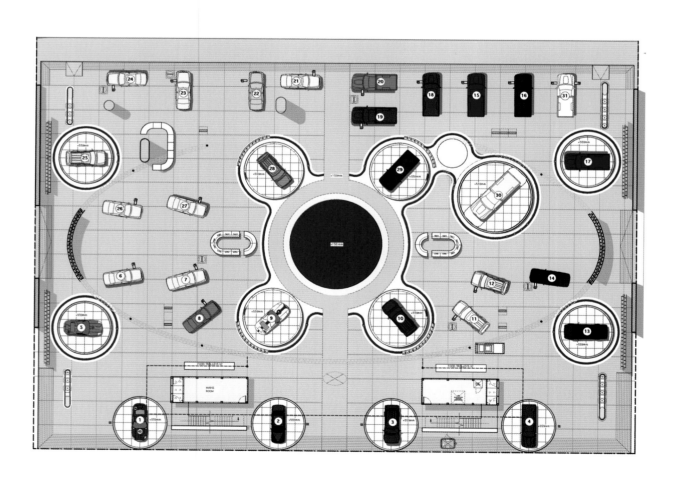

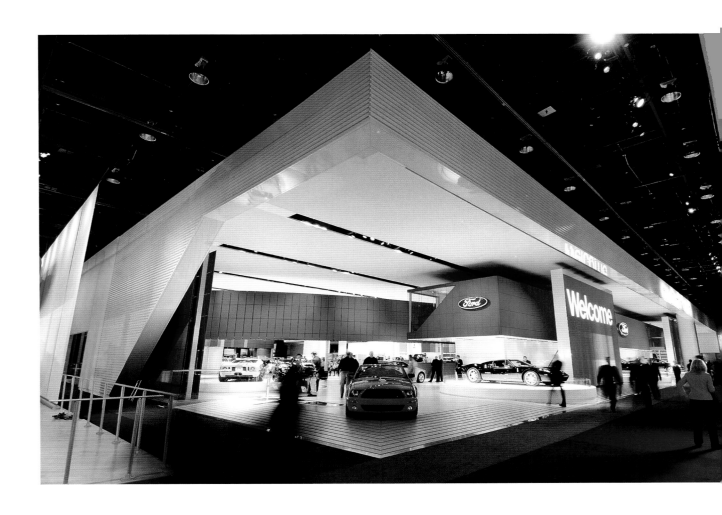

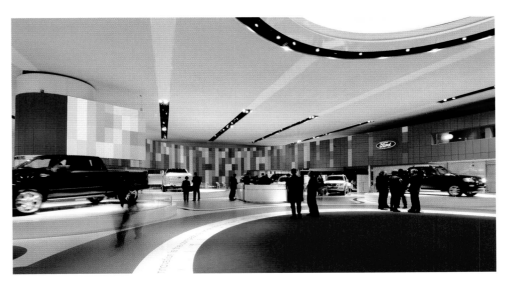

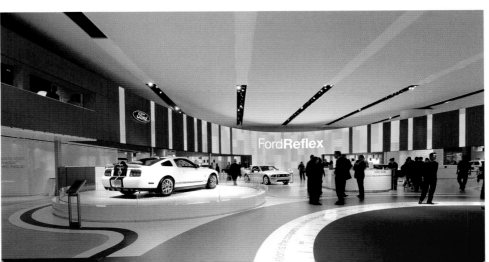

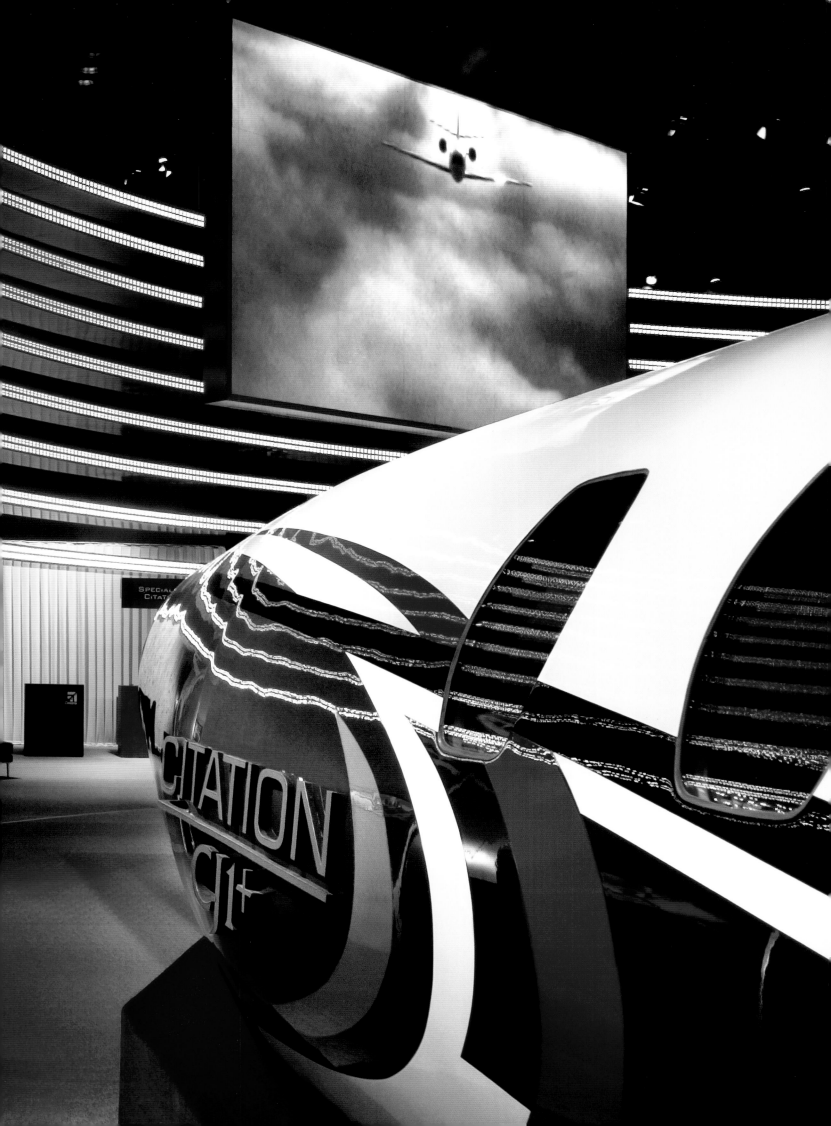

Plane Choices

In Startposition

The George P. Johnson Company
for Cessna

The George P. Johnson Company
für Cessna

Economy passengers choose price, business customers choose airline: executive travellers choose aircraft. It's about viewpoint: board a conventional airliner from a terminal and if you are lucky you see the tail. Travel on an executive jet and you get to encounter it head on, as you board. Once inside, you get the chance to check out the internal fittings, comfort and luxury. How, then, to convey these two key moments in the restricted spaced of a trade fair stand.

Part one is to forget the wings: they take up too much space. But then present the fuselages head on, with direct access to the interiors. Frame these with a curving, banked wall of LED-faced strips that can run a continuous lightshow which will link the different products on offer, and in its welcoming curved shape replicates – albeit inversely – the experience of entry.

In der Economy Class wählt man eine Preiskategorie, in der Business Class eine Fluglinie, als Manager eine bestimmte Maschine. Der Unterschied liegt in der Perspektive: Steigt man vom Terminal in ein Verkehrsflugzeug, bekommt man höchstens das Heck zu sehen. Auf einen Privatjet geht man vom Bug her zu und kann sich die Innenausstattung genau ansehen und den Luxus genießen. Wie aber lassen sich diese zwei Schlüsselelemente im beschränkten Rahmen eines Messestands verknüpfen?

Als Erstes verzichtet man auf die viel zu sperrigen Flügel. Dann zeigt man den Rumpf im Querschnitt mit direktem Zugang zur Kabine. Das Ganze rahmt man mit einer geschwungenen, überhöhten Wand aus LED-beschichteten Streifen ein, auf denen eine Endlos-Lightshow die angebotenen Produkte überblendet. Die einladend gerundete Form imitiert (wenn auch seitenverkehrt) den gebogenen Flugzeugrumpf.

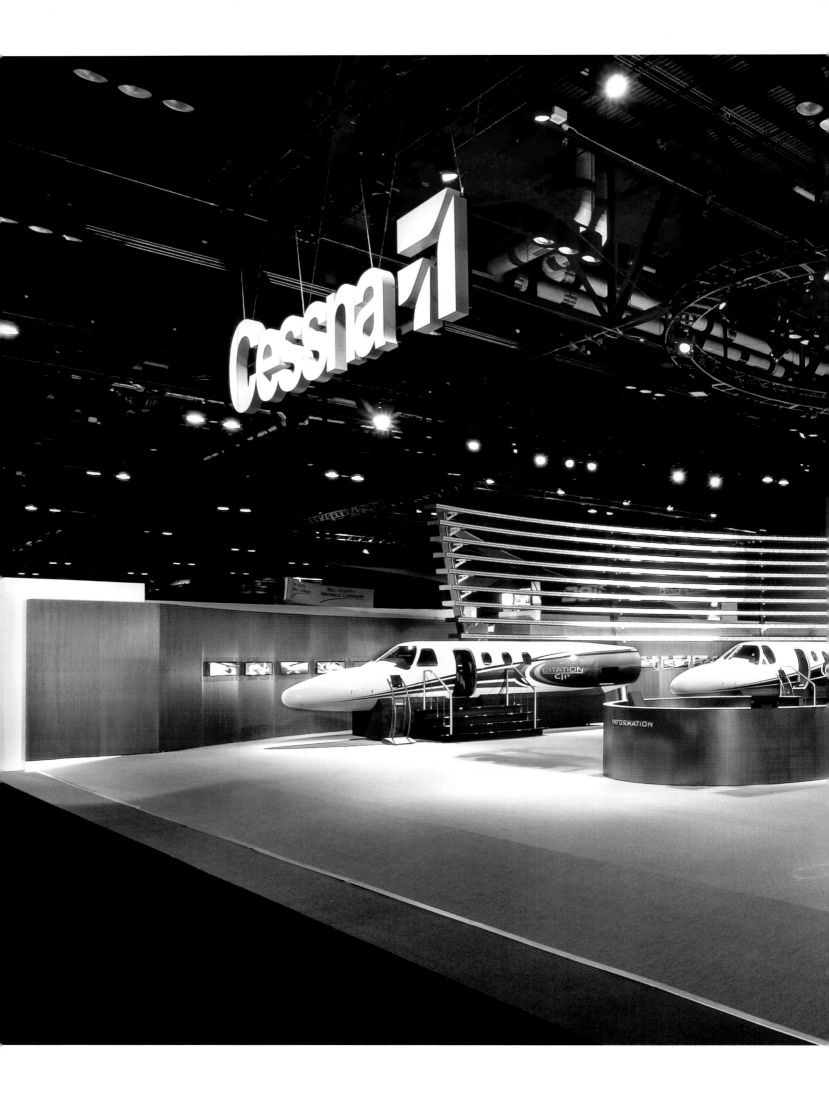

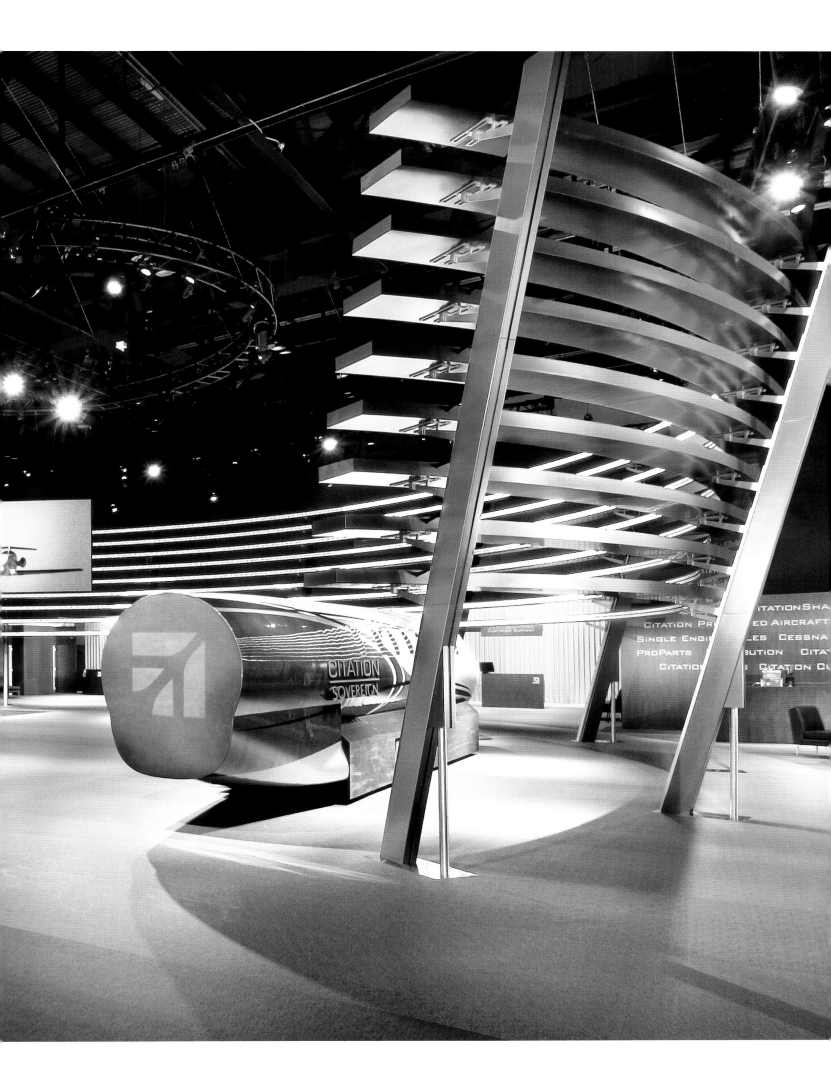

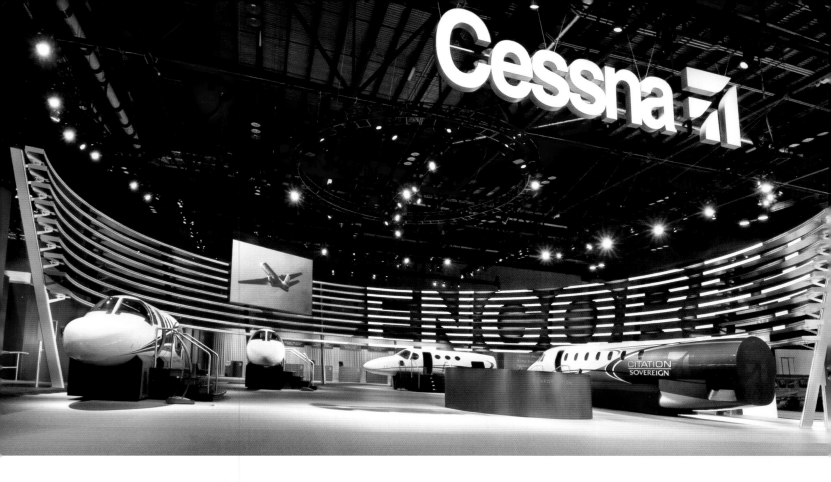

Then pass under the lightshow wall to enter the meeting and hospitality space. Conventional wisdom might have linked the aircraft interiors with the spaces for more direct contact, but this would ignore the fact that not all visitors to a stand are customers, and that not all customers need to be reminded of the product they own or lease, but would intuitively understand the symbolism of going backstage to talk.

Unter der Projektionswand betritt man die Besucherlounge. Konventionellere Lösungen hätten sie vermutlich eher an die Flugzeugkabine angebunden, um einen unmittelbaren Kontakt herzustellen, doch nicht jeder Besucher ist auch ein Kunde. Die wiederum brauchen für ein Produkt, das sie längst besitzen oder leasen, in der Regel kein Anschauungsobjekt, sondern erkennen spontan die Symbolik, wenn sie sich zur Besprechung quasi hinter die Kulissen begeben.

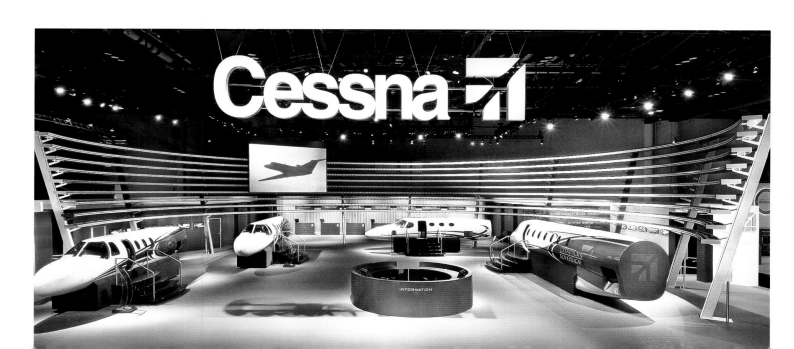

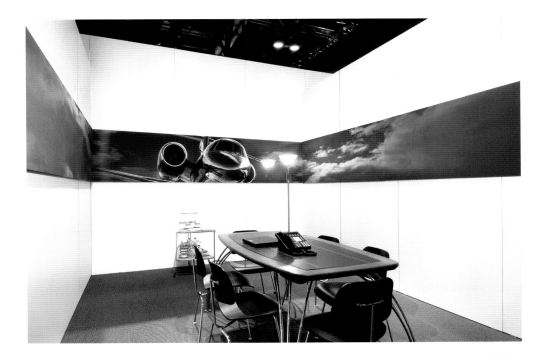

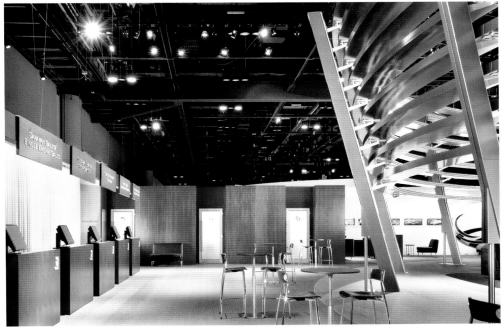

The result is a stand that is welcoming on the outside, in its open public face, but also discerning in creating a range of opportunities for involvement for visitors of different levels of engagement.

Das Ergebnis ist ein Stand, der nach außen einladend offen für jedermann ist, zugleich aber für Besucher mit unterschiedlichen Anliegen ein differenziertes Angebot an Kontaktmöglichkeiten bereithält.

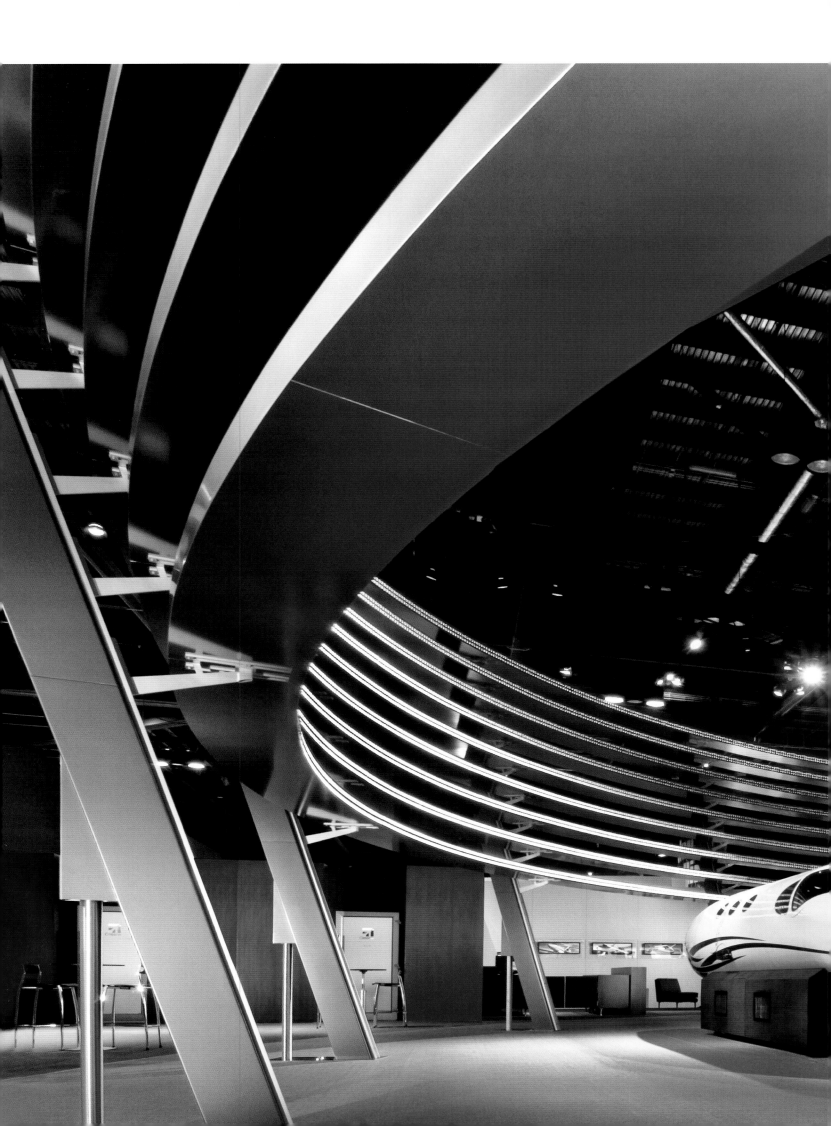

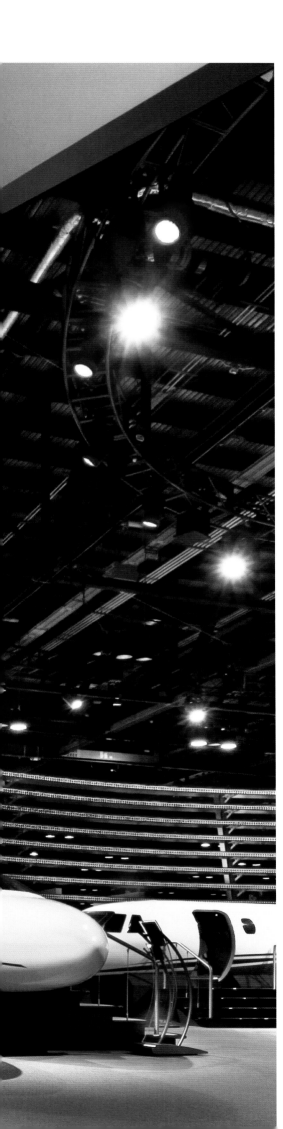

Year	**2005**
Location	**Orlando**
Trade Fair	**NBAA**
Exhibitor	**Cessna Aircraft Company, Wichita**
Architect	**The George P. Johnson Company, Auburn Hills: Chuck Bajnai, Darren Pasdernick, Paul Hemsworth**
Size	**1,337 m²**
Lighting	**PRG, Inc.**
Graphics/Communication	**The George P. Johnson Company, Auburn Hills: Mike Waraniak, Craig Lyons**
Presentation Materials	**Mindfield Pictures, Detroit; Cessna Aircraft Company, Wichita: Tom Zwemke**
Photos	**Jamie Padgett, Padgett & Co., Chicago**

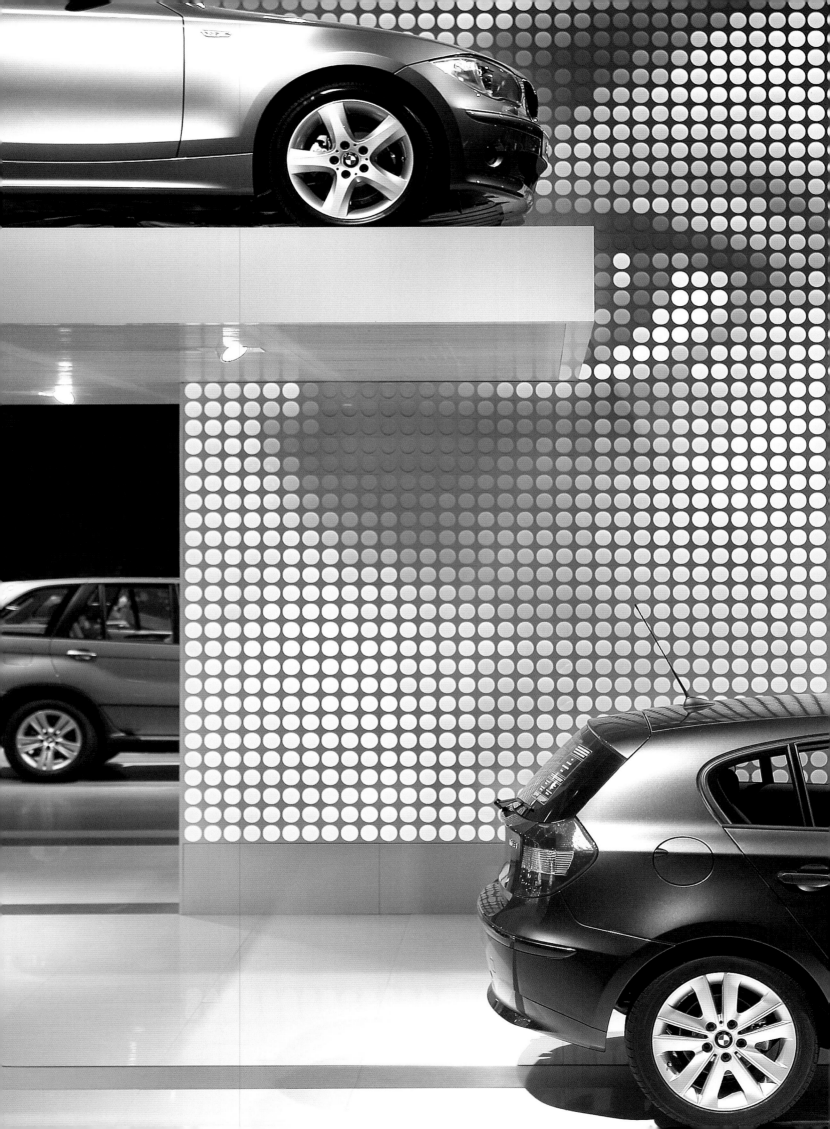

Lining up for the Curve

Geraden als Kurven

:: dan pearlman markenarchitektur
for BMW

:: dan pearlman markenarchitektur
für BMW

Right of line at the Paris motor show BMW stand was the BMW H$_2$R, a record breaking monster capable of 300 kilometers per hour that runs on hydrogen. This in itself symbolises two key aspects of the BMW brand: its commitment to the sheer joy of driving and the importance of technological innovation to support that. Just as the curving shape of the H$_2$R hinted, even at rest, in the immense power under the hood, so the rest of the stand design used similar imagery and form to express the power of the brand. A minimalist architectural approach, mainly in white and silver, is relieved by touches of soft colour and swirling patterns, without disturbing the overall order of the stand.

Den Ehrenplatz beim BMW-Stand der Pariser Automobilausstellung hatte der H$_2$R inne, das jüngste, 300 Stundenkilometer schnelle Kraftpaket von BMW mit alternativem Wasserstoffantrieb. Allein diese Tatsache macht zwei Schlüsselaspekte der Marke BMW deutlich: ihr Bekenntnis zur zweckfreien Freude am Fahren und die Bedeutung der technologischen Innovationen, die sie gewährleisten. Genau wie die schwungvolle Karosserie des H$_2$R selbst im Stand ahnen lässt, wie viel Power unter der Motorhaube steckt, setzte das Standdesign auch anderswo ähnliche Metaphern und Formen ein, um die Stärken der Marke hervorzuheben. Die vorwiegend in Weiß und Silber gehaltene minimalistische Architektur wurde aufgelockert durch ein paar sanfte Farbtupfer und wirbelnde Muster, ohne den geordneten Gesamteindruck zu beeinträchtigten.

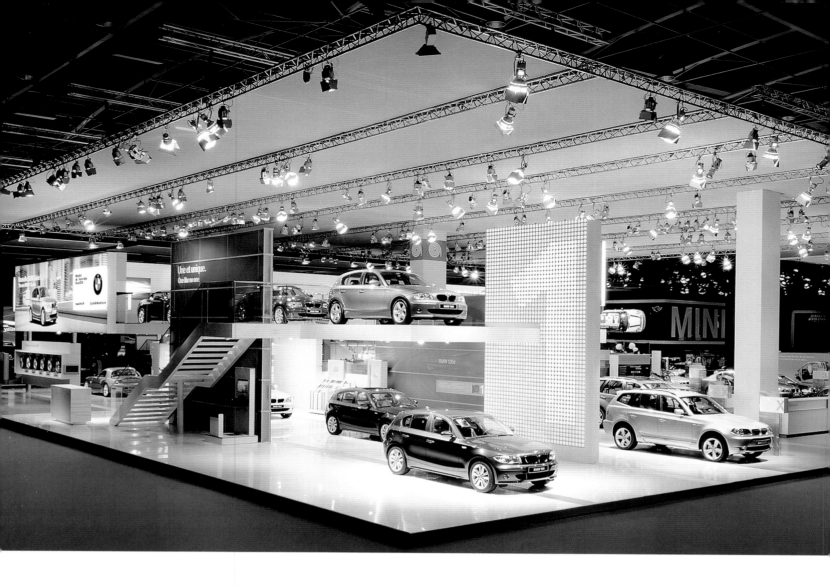

The show saw the premiere of the BMW 1 series and the launch of the new M5 series. These vehicles were often presented in individual spaces on the two-tier island stand, with accompanying graphics related to the main theme of the stand, "the aim of every straight line is to be a curve." This Zen-like notion may be unprovable, but it does convey the maturity and development of the BMW brand, its authoritative position in the industry and its determination for technical leadership.

Die Ausstellung war Premiere der BMW 1er-Serie und der neuen M5-Serie. Innerhalb des zweiteiligen Inselstands standen diese Fahrzeuge überwiegend in separaten Flächen; die grafischen Elemente lehnten sich an das Hauptthema des Standes an: „Das Ziel einer jeden Gerade ist die Kurve." Diese Behauptung (die vom Zen inspiriert scheint) mag unbeweisbar sein, sie suggeriert jedoch den ausgereiften Entwicklungsstand der Marke BMW, ihre beherrschende Stellung innerhalb der Branche und ihren Anspruch auf die technische Führungsrolle.

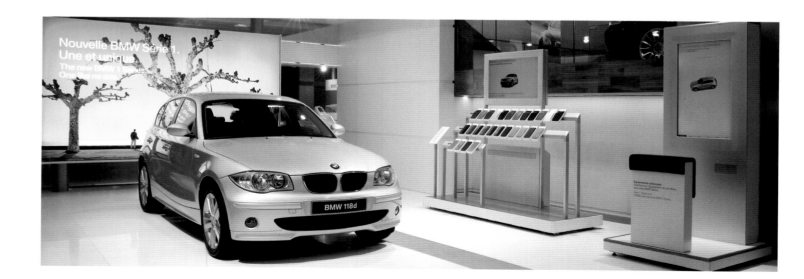

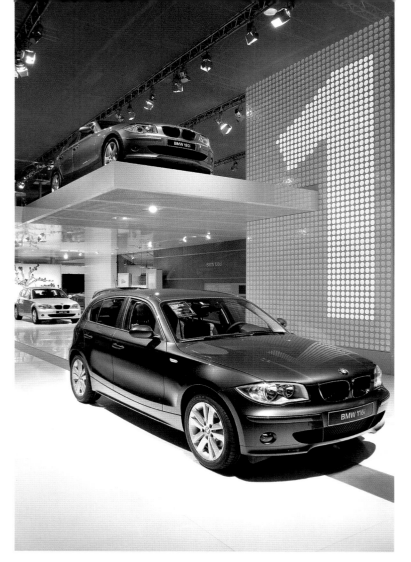

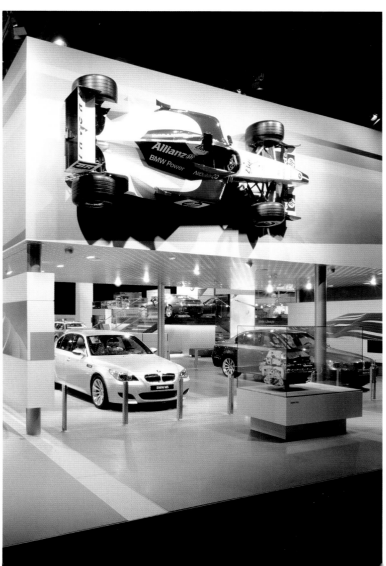

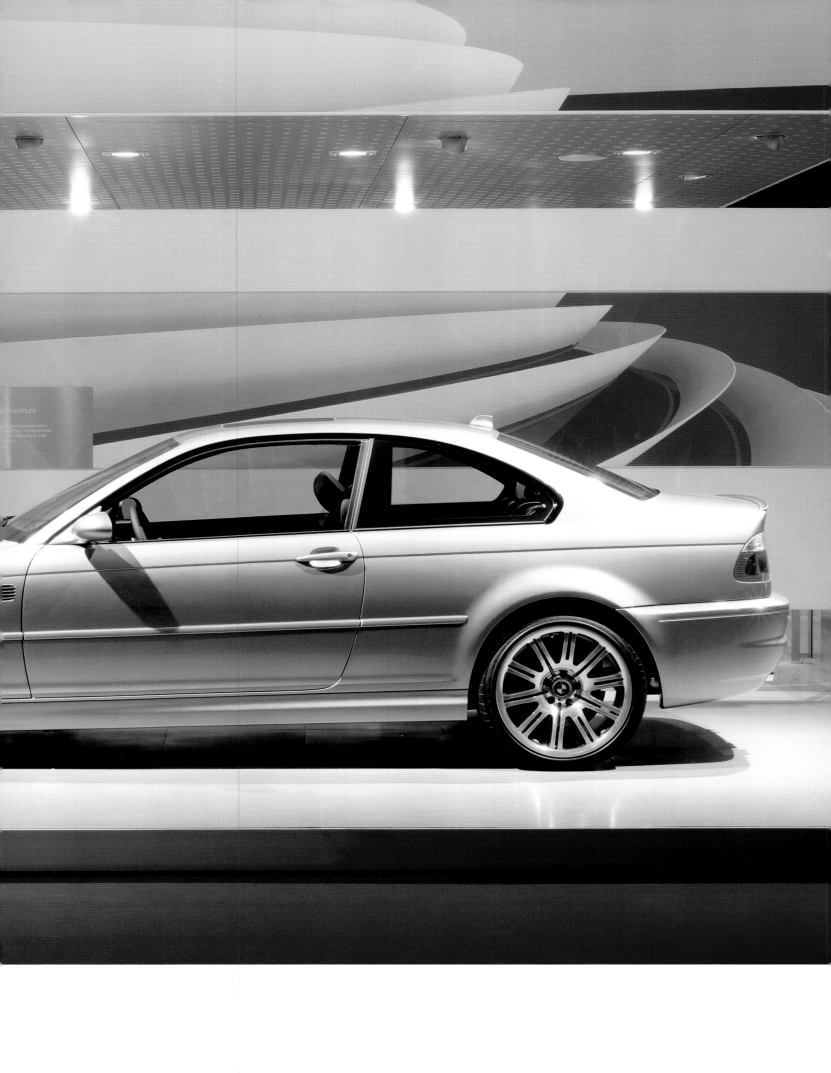

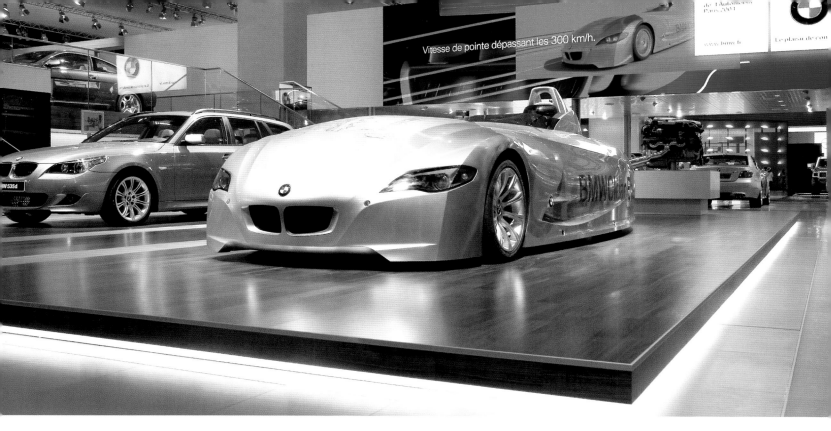

Year	**2004**
Location	**Paris**
Trade Fair	**Mondial de l'Automobile**
Exhibitor	**BMW Group AG, Munich**
Architect	**:: dan pearlman markenarchitektur, Berlin**
Size	**1,295 m²**
Realisation	**Raumtechnik Messebau & Event Services GmbH**
Statics	**Posselt Consult GmbH**
Lighting	**Service für Showtechnik**
Graphics/Communication	**:: dan pearlman markenarchitektur, Berlin; Graphics Steering: Atelier B.; Graphics Implementation: Weila Bildtechnik GmbH; Oberndörfer Grafik GmbH**
Lifestyle Decoration	**Studio 38 pure communication GmbH**
Film	**gate.11 audio-visuelle kommunikation GmbH**
Sound, Technics, Exhibits	**MKT AG, ict (Innovative Communication Technologies AG), Expolab**
Implementation Planning and Steering	**Puchner + Schum**
Photos	**diephotodesigner.de**

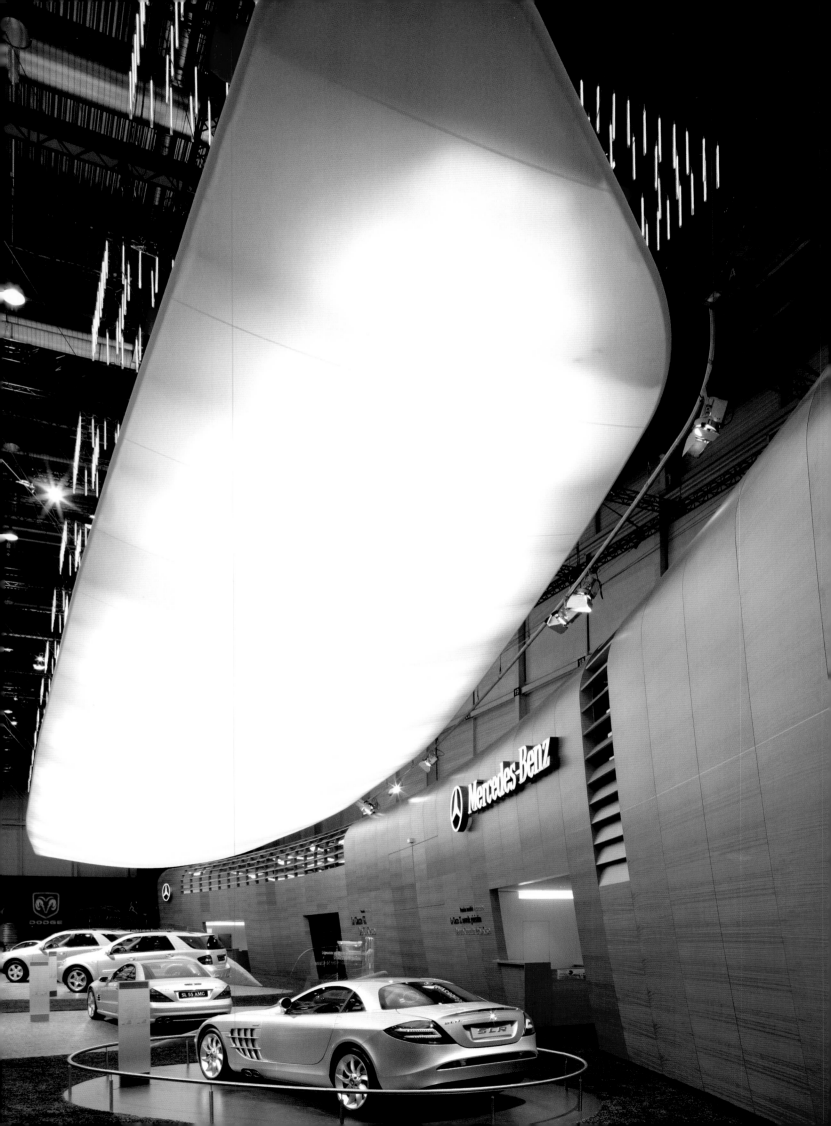

Having a Quiet Chat

Interaktion möglich

Kauffmann Theilig & Partner
and KMS Team
for Mercedes-Benz

Kauffmann Theilig & Partner
und KMS Team
für Mercedes-Benz

Some stand designs make the visitor into a participant, others into a spectator. Often the distinction is relevant and appropriate: a product launch, for example, can only have visitors as spectators, while a computer games stand that did not invite visitors to take part is unlikely to be successful. In the motor show business, impressing the visitor with the size, scale and splendour of the stand is a strategy that is often pursued, which in turn heightens the visitor's excitement.

For Mercedes-Benz in Geneva the designers KMS and the architects Kauffman Theilig & Partner adopted a somewhat different strategy. Rather than merely putting products on show, the aim was to create an inviting mood. Reflecting the motto "en dialogue", a space was provided for interaction with the brand and the products.

Auf manchen Ständen sind die Besucher eher Zuschauer, auf anderen eher Mitwirkende. Diese Unterscheidung ist meistens von Belang und dem jeweiligen Gegenstand angemessen. Die Präsentation eines neuen Produkts etwa kann wohl nur Zuschauer haben, doch ein Stand mit Computerspielen, der die Besucher nicht zum Mitmachen einlädt, würde kaum großen Erfolg haben. Auf Automobilmessen herrscht die Strategie vor, das Publikum durch Größe, Angebot und Glanz zu beeindrucken. Die spektakuläre Aufmachung soll die Begeisterung der Besucher steigern.

Für den Genfer Auftritt von Mercedes-Benz erarbeiteten das Architekturbüro Kauffmann Theilig & Partner und das Designbüro KMS eine völlig andere Strategie. Keine reine Produktschau, sondern eine einladende Atmosphäre sollte geschaffen werden, die unter dem Motto „en dialogue" Raum zur Auseinandersetzung mit der Marke und den Produkten bot.

HALLE
7
📠 ➕
6
ALLEE
6400

The main visual feature of the generously proportioned stand of estimable size was a large suspended sail-shaped light towards the back of the stand, bathing the new cars in its soft white light. Several groups of cars were positioned in front of this softly curved structure faced in brown wood on "islands" of the same material. The rest of the stand was clad in dark, thick-pile carpet on which the remaining vehicles were positioned in a grid of silver rectangles.

Das wichtigste visuelle Element des geräumigen, großzügig proportionierten Stands bildete eine große segelförmige Deckenleuchte, die im hinteren Bereich die Neuheiten in warmes weißes Licht tauchte. Diese Fahrzeuge standen in mehreren Gruppen vor einer sanft geschwungenen Wand aus mitteldunklem Holz auf „Inseln" aus demselben Material. Der Rest der Standfläche war mit dunklem, hochflorigem Teppich belegt, auf dem die übrigen Fahrzeugtypen in einem regelmäßigen Raster aus silberfarbenen Rechtecken positioniert waren.

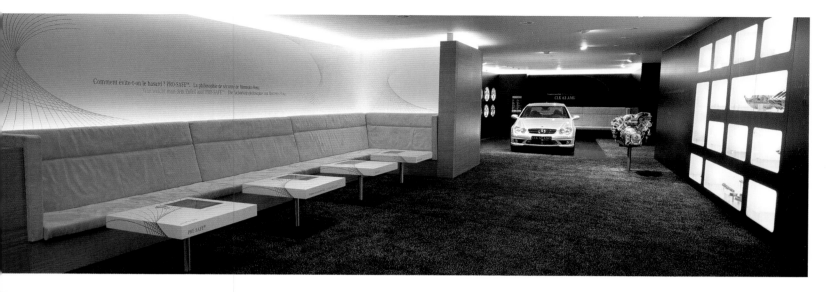

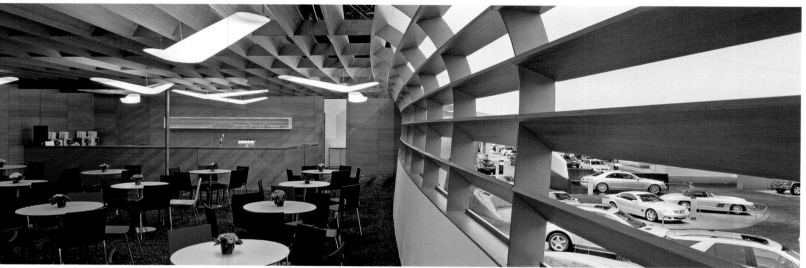

The hospitality lounges and themed detail presentation areas were behind the wall in the two-storey lounge and office area. This divided the stand into three zones, with the warmly lit exhibit zone at its heart. The lighting and natural colours were an invitation to slow down and to linger and inspect at leisure.

Having well-trained staff on hand at all times to provide information and answer questions about the vehicles on display heightened the personal and participatory experience of the visitor. One got to talk to the owner of the car, as it were, and not just to someone from Mercedes-Benz. The opportunity to create a tranquil, informal moment for the visitor was created. The use of service design in this way is innovative and has an important role in the overall concept. This goes beyond simply giving stand staff a set of rules, offering instead a framework for interactive models, participatory discourse and other more complex areas, and it is a feature of stand design that is likely to be a key one in the future.

Die Besprechungsräume und Detailpräsentationen zu bestimmten Themen waren im zweigeschossigen Lounge- und Bürobereich hinter der Wand untergebracht. Der Stand wurde somit dreigeteilt, wobei der Bereich unter dem Leuchtkörper als Herzstück fungierte. Licht und natürliche Farben luden den Besucher ein zu verweilen, sich in aller Ruhe umzuschauen und das Tempo herunterzuschalten.

Dass das gut geschulte Standpersonal stets für Informationen und Fragen zu den Ausstellungsfahrzeugen zur Verfügung stand, verstärkte die persönliche Einbindung des Besuchers in das Standgeschehen. Statt mit jemandem von Mercedes-Benz hatte man den Eindruck, quasi mit dem Besitzer selbst zu sprechen, die Interaktion spielte sich in einer ruhigen, zwanglosen Atmosphäre ab. Dieses Einbeziehen von Service in das Standdesign ist innovativ und spielt eine wichtige Rolle im Gesamtkonzept. Es geht weit über die üblichen Richtlinien für Standpersonal hinaus und erstreckt sich auf den Entwurf von Interaktionsmodellen, partizipative Gesprächsführung und noch komplexere Gebiete – ein Element, das in zukünftigen Standkonzeptionen von wesentlicher Bedeutung sein wird.

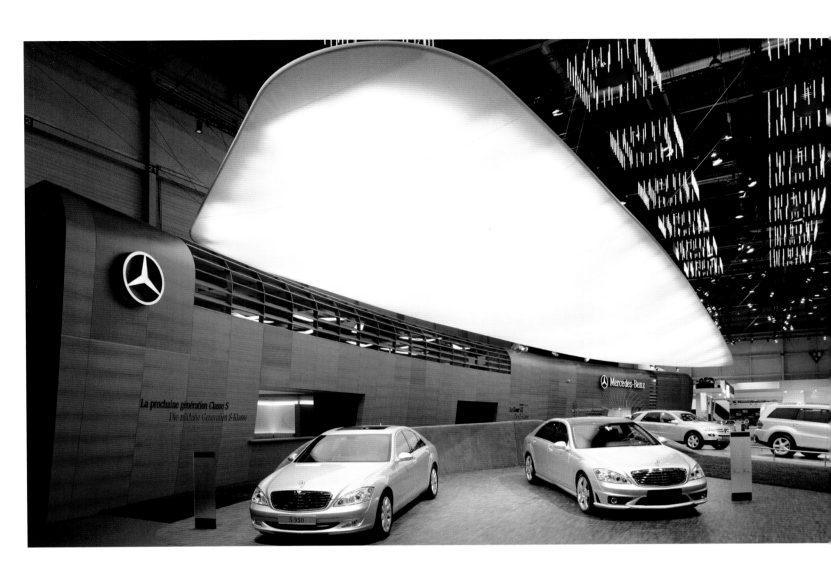

Year	**2006**
Location	**Geneva**
Trade Fair	**International Motor Show**
Exhibitor	**DaimlerChrysler AG, Stuttgart**
Architect	**Kauffmann Theilig & Partner, Ostfildern** **Project Manager: Lars Kruse**
Size	**2,900 m²**
Communication	**KMS Team, Munich**
Lighting/Technical Services	**TLD, Light & Magic, Wendlingen**
Structure Planning	**form TL, Radolfzell**
Graphics	**Stadelmayer, Kirchheim/Teck**
Stand Construction	**Raumtechnik, Ostfildern**
Photos	**Andreas Keller, Altdorf**

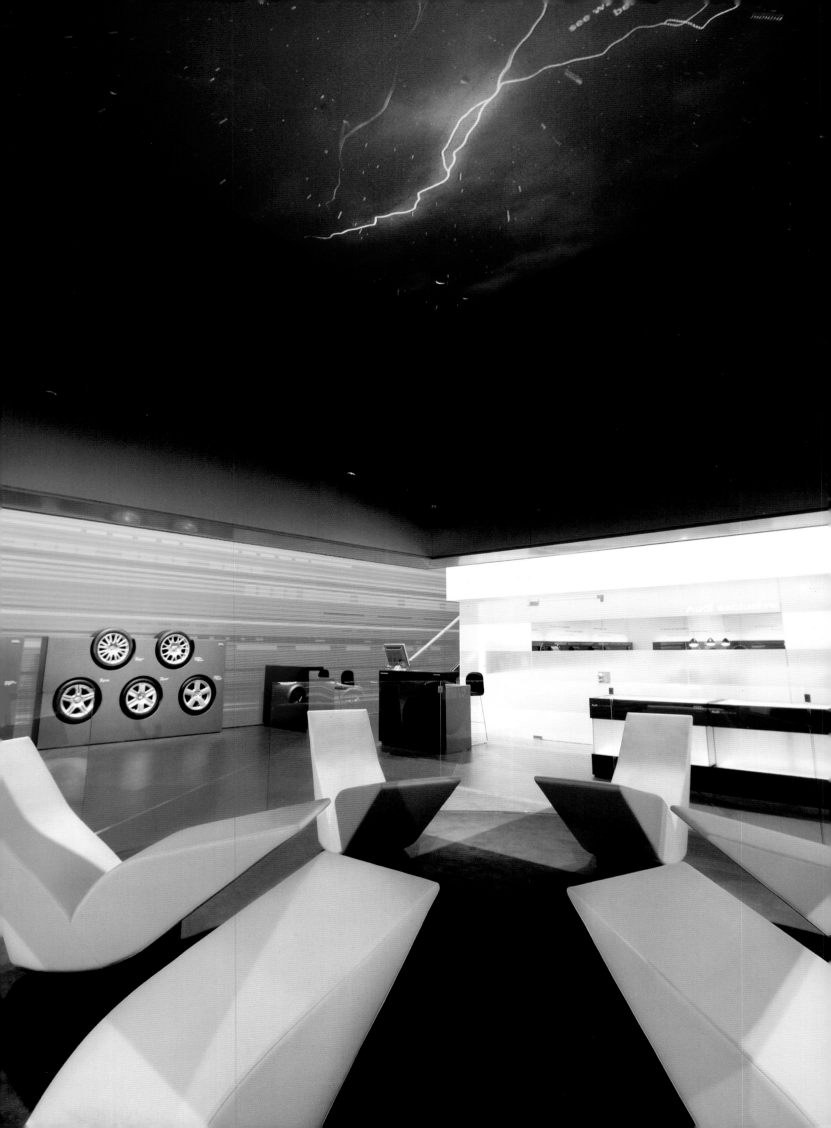

Twenty Five Times Four
Ein Vierteljahrhundert Erfahrung

Schmidhuber + Partner
and Mutabor Design
for Audi

Schmidhuber + Partner
und Mutabor Design
für Audi

Four-wheel drive for saloon cars has been at the centre of the Audi offer, alongside their technical excellence, since the first Audi Quattro appeared twenty-five years ago. This key fact is also at the centre of Schmidhuber + Partner's design for the Geneva Motor Show. The minimalist stand is open on two sides. The highlight of the whole consists in the set of four suspended backlit cubes along the end of the longer wall: the shorter wall is for a double level hospitality and office building. Each of these cubes frames a meeting area or a special facility, and the base of each cube is open: each one has its private sky, the setting for displays of images and information.

Seit der erste Audi Quattro vor 25 Jahren auf den Markt kam, steht neben technischer Exzellenz der Allradantrieb für Limousinen im Mittelpunkt des Audi-Angebots. Diese Tatsache wiederum stand im Zentrum des Audi-Auftritts, den Schmidhuber + Partner für den Automobilsalon in Genf konzipierten. Der minimalistische Stand ist an zwei Seiten offen. Highlight sind vier abgehängte, von hinten beleuchtete Kuben vor der Wand der Längsseite: Die Schmalseite nimmt ein zweistöckiger Büro- und Hospitalitybereich ein. Unter jedem Kubus ist Raum für Besprechungen. Die Kuben selbst sind unten offen und geben jeweils den Blick in einen „Himmel" frei, der als Projektionsfläche für Filmsequenzen, Bilder und Informationen dient.

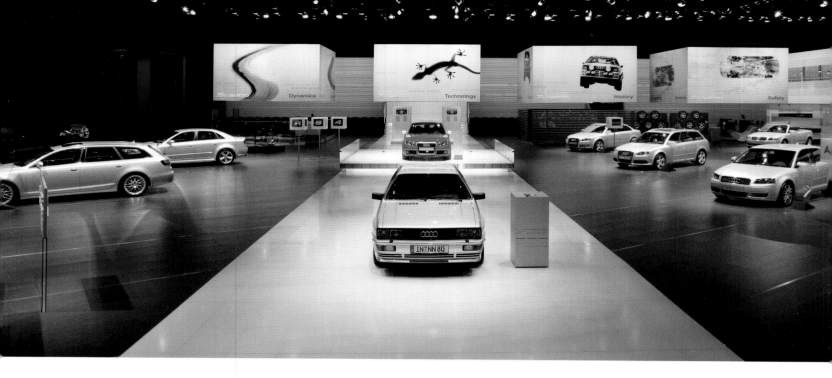

The transition from the public arena to the private space of the cubes is a clever echo of the exclusiveness of being behind the wheel of an Audi, while the size of the cubes emphasises that for Audi, detail is important. The use of a single colour, orange, together with the black and white overall pattern reinforces the central message, which is also conveyed by the use of images – a curving road, the tenacious feet of a lizard, the cars themselves – on the exterior faces of the cubes. The success of this stand comes from the designer not being deflected from the central message, that Audi was at the start of the four-wheel drive movement, and remains the strongest and most effective agent in it for saloon cars. The details, delivered with subtle and exotic touches in imagery and furnishing, do not detract from this but rather reinforce the centrality and power of the brand.

Der Übergang von der öffentlichen Ausstellungsfläche zum intimen Raum der Kuben spiegelt clever die Exklusivität des Audi-Fahrerlebnisses; die Größe der Kuben unterstreicht, dass Audi auf Details achtet. Der Einsatz von Orange als einziger Farbe neben dem schwarzweißen Gesamtmuster betont die zentrale Botschaft, die auch die Bildmotive an den Außenseiten der Kuben vermitteln: eine S-Kurve, die Haftfüße einer Eidechse, die Fahrzeuge selbst. Der Erfolg dieses Auftritts beruht darauf, dass die Designer sich völlig auf die zentrale Botschaft konzentrierten: dass Audi der Pionier des Allradtrends war und bis heute sein stärkster und effizientester Vertreter im Limousinenbereich ist. Die in Bildern und Möblierung mit subtilem, exotischem Touch vermittelten Details lenken nicht ab, sondern heben die zentrale Rolle und Stärke der Marke noch hervor.

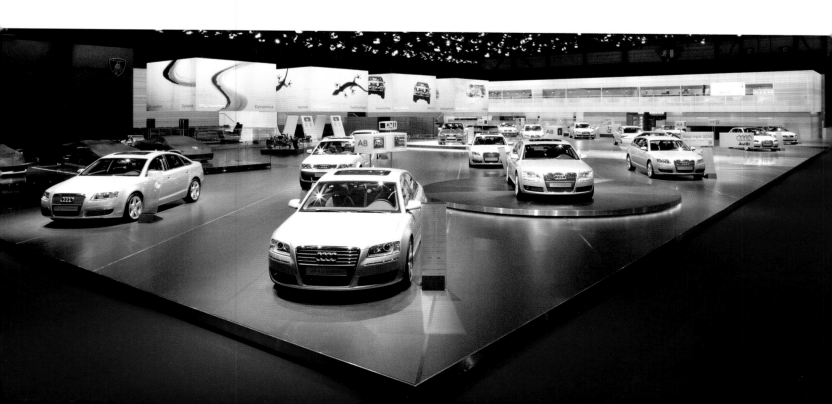

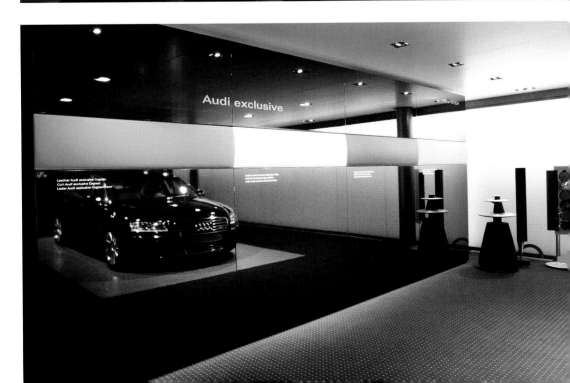

Year	**2005**
Location	**Geneva**
Trade Fair	**International Motor Show**
Exhibitor	**Audi AG, Ingolstadt**
Concept and Architecture	**Schmidhuber + Partner, Munich**
Concept and Communication	**Mutabor Design GmbH, Hamburg**
Graphics	**Schüttenberg, Dusseldorf**
Size	**2,935 m²**
Realisation	**Ambrosius Messebau, Frankfurt**
Structural Engineering	**3e Werner Sobek exhibition & entertainment engineering, Stuttgart**
Light Planning	**Four to One scale design, Hürth**
Show Light	**Showtec, Hürth**
Media Planning	**TFN, Hamburg**
Photos	**Andreas Keller, Altdorf**

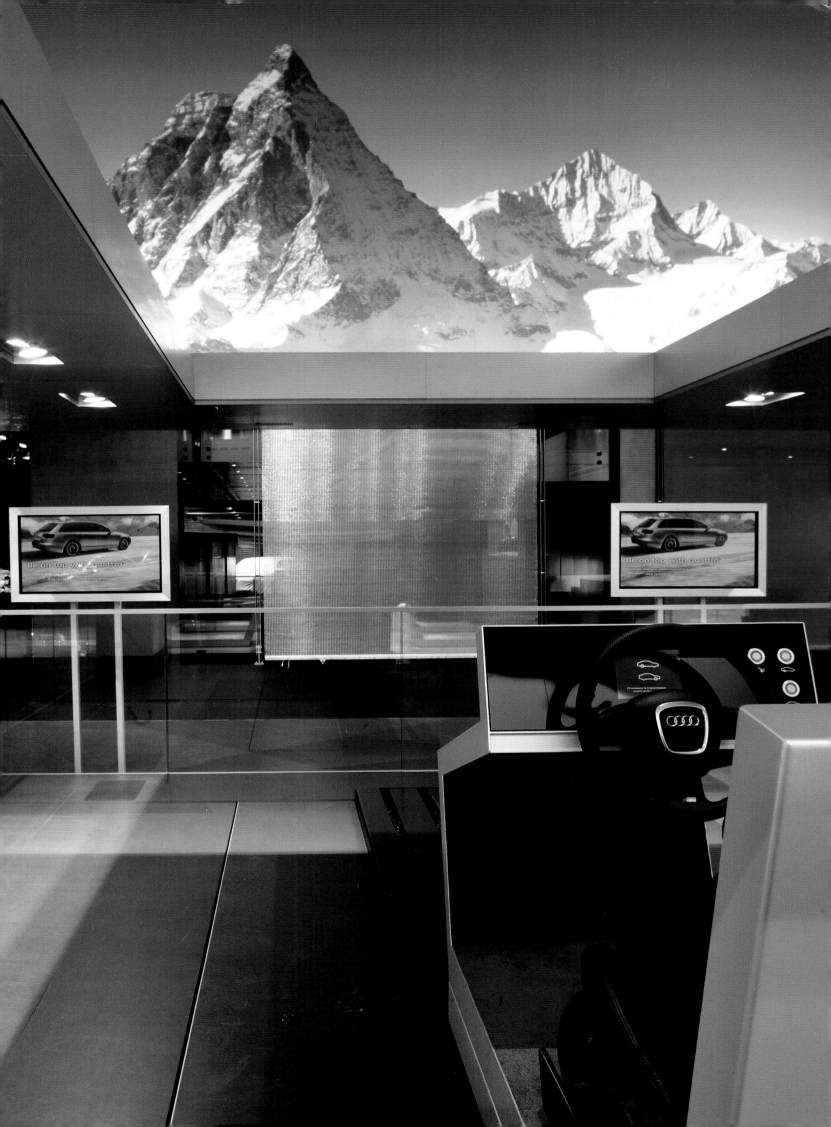

Websites

www.arno-design.de

www.atelier-brueckner.de

www.avcommunication.com

www.bangertverlag.com

www.braunwagner.de

www.bueroblank.de

www.danpearlman.com

www.d-art-design.de

www.demirden.com

www.designcompany.de

www.3e-stuttgart.com

www.eoos.com

www.gpjco.com

www.hwdesign.de

www.imagination.com

www.ine-ilg.de

www.juliezeldin.com

www.kms-team.de

www.ktp-architekten.de

www.kuhlmannleavitt.com

www.manss.com

www.maukdesign.com

www.milla.de

www.murayama.co.jp

www.remarltd.com/

www.schindlerarchitekten.com

www.schmidhuber.de

www.schusterjungen.com

studio2.thiel@bluewin.ch

www.tdm.nu

www.totems.com

www.ueberholz.de

www.veenstra-cco.nl

www.vrpe.de

www.zeeh-design.de

Acknowledgements

The publisher and author wish to thank those companies, architects, agencies, stand construction firms and photographers who have provided images and material and who have contributed towards the printing costs.

Dank

Verlag und Autor danken den beteiligten Firmen, Architekten, Agenturen, Messebauern und Fotografen für die zur Verfügung gestellten Bilder, Materialien und Druckkostenzuschüsse.

Imprint

Editing	Anja Schrade
	Petra Kiedaisch
	Beverley Locke
Translation	Birgit Lamerz-Beckschäfer
Design concept	Karin Skowronek
Realisation and cover design	Swabianmedia, Stuttgart
Cover photo	Werner Huthmacher Photography, Berlin
Photos on divider pages	p. 12: David Hiscock
	p. 46: Andreas Keller, Altdorf
	p. 90: ARNO ©/Frank Kotzerke
	p. 166: Imagination Ltd, London: Jason Hobday
Lithography	Undercover, Leinfelden-Echterdingen
Production	atio_druckkonzepte, Leinfelden-Echterdingen
Printed by	Raff GmbH, Riederich
Paper	Profisilk, 150g/m²

© Copyright 2006 **av**edition GmbH, Ludwigsburg
Publishers for Architecture and Design
© Copyright of photos with individual companies and photographers

ISBN-10: 3-89986-072-1
ISBN-13: 978-3-89986-072-6
Printed in Germany

Impressum

Redaktion	Anja Schrade
	Petra Kiedaisch
	Beverley Locke
Übersetzung	Birgit Lamerz-Beckschäfer
Gestaltungskonzept	Karin Skowronek
Layout und Cover	Swabianmedia, Stuttgart
Coverfoto	Werner Huthmacher Photography, Berlin
Fotos Zäsurseiten	S. 12: David Hiscock
	S. 46: Andreas Keller, Altdorf
	S. 90: ARNO ©/Frank Kotzerke
	S. 166: Imagination Ltd, London: Jason Hobday
Lithografie	Undercover, Leinfelden-Echterdingen
Produktion	atio_druckkonzepte, Leinfelden-Echterdingen
Druck	Raff GmbH, Riederich
Papier	Profisilk, 150g/m²

© Copyright 2006 **av**edition GmbH, Ludwigsburg
Verlag für Architektur und Design
© Copyright für die Fotos bei den Unternehmen und Fotografen

Alle Rechte, insbesondere das Recht der Vervielfältigung, Verbreitung und Übersetzung, vorbehalten. Kein Teil des Werkes darf in irgendeiner Form (durch Fotokopie, Mikrofilm oder ein anderes Verfahren) ohne schriftliche Genehmigung reproduziert oder unter Verwendung elektronischer Systeme verarbeitet, vervielfältigt oder verbreitet werden.

ISBN-10: 3-89986-072-1
ISBN-13: 978-3-89986-072-6
Printed in Germany